CONTENTS

PREVIOUS PAGES: Sculpture, Lionel Bawden from *The Monsters* series; three paintings from *Polychrome Poison* series, Peter Adsett; *Fish Basket*, Rosie Bindal Bindal

OPPOSITE: TOP ROW LEFT TO RIGHT: *Spanish Oak, Sierra de Gredos*, Robert Freeman; *Pentraeth Beach*, Helen Lopez; *Time Out*, Helen Lopez; *Aegean Goddess*, John Parsons.
SECOND ROW LEFT TO RIGHT: *Still Life with Frying Pan*, William Scott; *Gold Still Life*, Richard Winkworth; *Watching the Waves*, Mark Pearson; *Tomarillo with Limes on Black*, Lisa Dalton.
THIRD ROW LEFT TO RIGHT: *Chess Player*, Keith Banks; *Colle di Val d'Elsa*, Chris Lambert; *Jug and Lemons*, Abbie Young; *Bird and Nest*, Tim Nicholson.
FOURTH ROW LEFT TO RIGHT: *Morning Light Manhattan*, Michael Kidd; *Bowl, Lemon and Bean Pod*, Elaine Pamphilon; *Tulips on Silk Ikat*, Nigel Waymouth; *Poème sur la Colline*, Xiaoyang Galas.
BOTTOM ROW LEFT TO RIGHT: *Dos*, Muhadin Kishev; *Invierno Ruso*, Muhadin Kishev; *Festive Spirit, Rancho de Chimayo*, Evelyne Boren; *Tibetan Lotus with Dragonfly – from the Garden of His Holiness the XIVth Dalai Lama*, Jo Self.

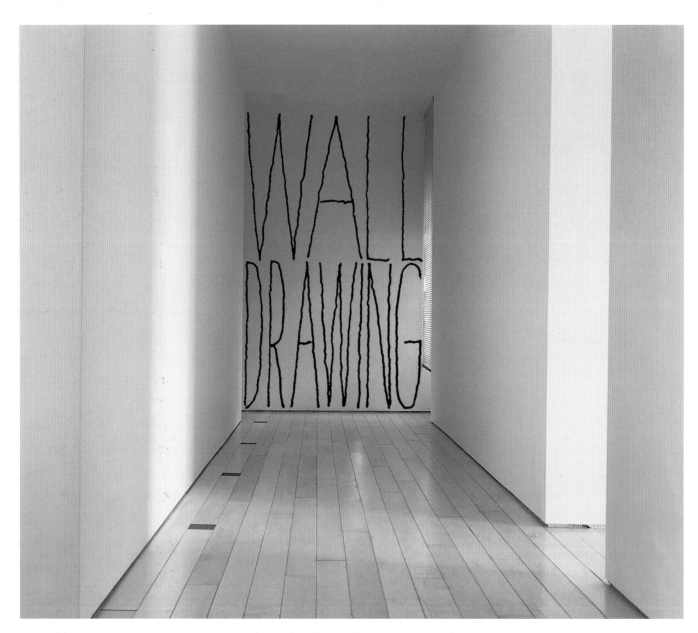

Wall Painting, Sol LeWitt

AT HOME WITH ART

A guide to understanding, collecting and displaying art

QUADRILLE

Tiddy Rowan

AT HOME

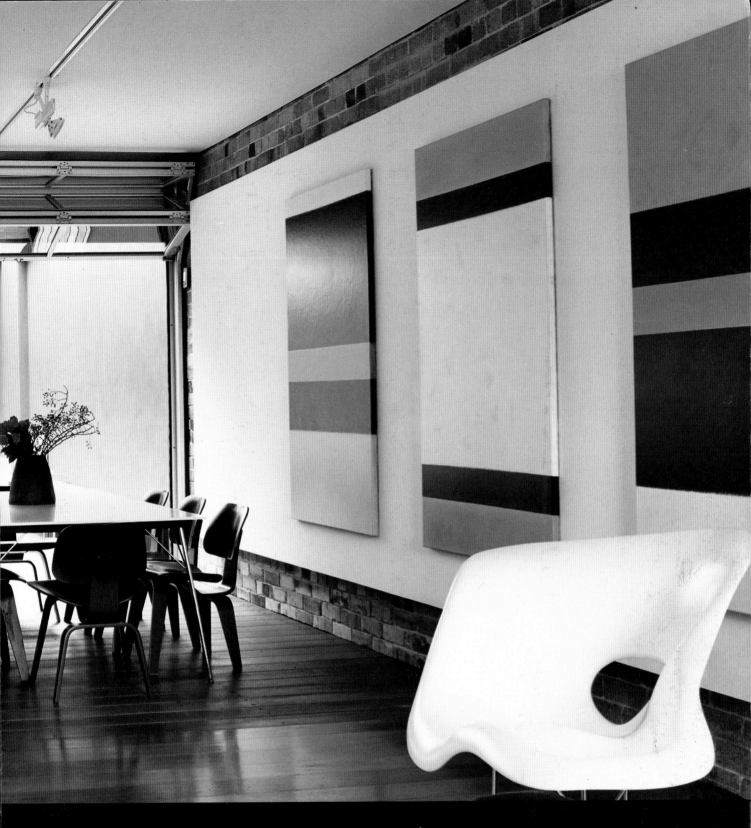

WITH ART

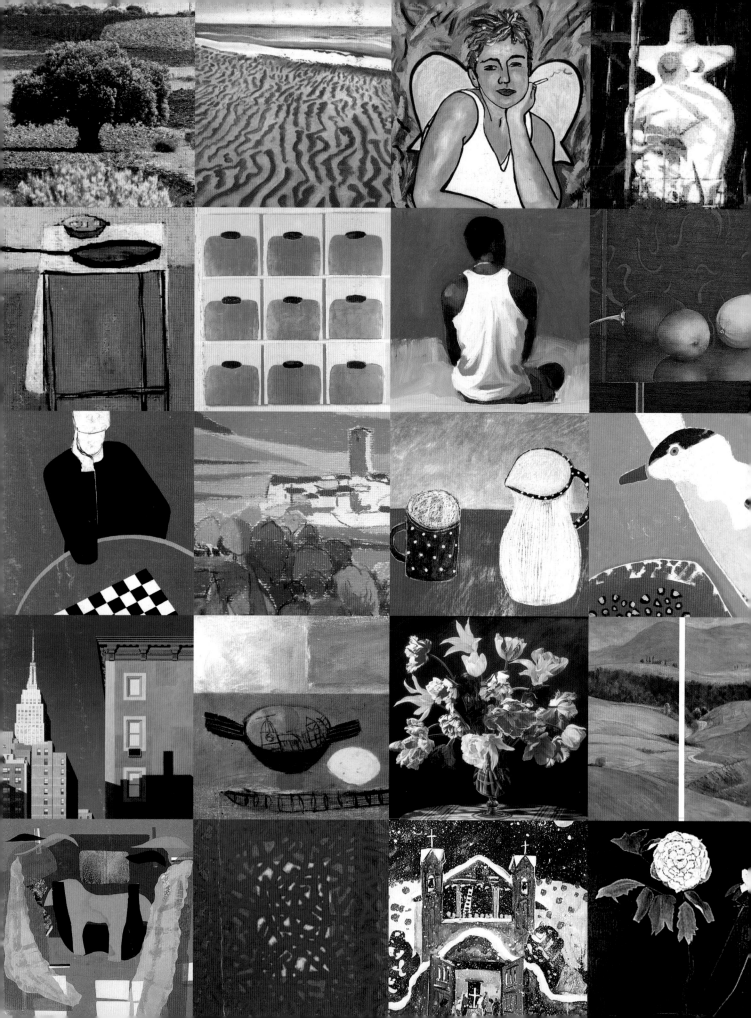

INTRODUCTION

Some art attracts us immediately, without any understanding of it, but other art, like people, takes time to get to know – and the relationship is often the deeper for it. Ultimately, art is a personal connection of discovery and appreciation, whether fleeting or lasting. If lasting, the art has 'worked' – it has transmitted something of the spirit or energy of the artist – in which case we may want to take it home so that it can continue to influence us, or in order to express something of ourselves through our display of it. There are no rules for liking or disliking – only guidelines for enriching the process, which is what I offer in this book.

My role as an art consultant involves matchmaking between artists and clients - art and homes. People are increasingly aware of the look of their homes and there is a proliferation of advice available on style, architecture, colours, furnishings and so on. But what I have noticed is that art sometimes suffers in the mix. People new to buying art, interested potential collectors, often find it confusing – the choices are so varied and huge, or they have difficulty finding time to research and source the art they will enjoy at home. Other interested art clients want guidance on how to get the best out of displaying art.

Recently, two clients moved house at the same time. In one case the art was packed up first and I saw the home without it. Despite furniture and other possessions still in place, the house suddenly seemed empty and bleak. The other client had moved the furniture out first, only the art remained in place – yet the home still had a sense of life. It reminded me that art is a great connector and that a house with art has a certain energy. It reflects the spirit of the home and the people in it.

I hope that by approaching art in different ways, as I have done in this book, readers will be inspired to look with fresh eyes and make new discoveries, whether it's re-evaluating the art they own or in sourcing new art. The book can be read consecutively, or like a book of recipes. It also offers guidelines on buying art and building up a collection and acts as a practical manual for displaying art, a reference for some art facts, and a source book for a selection of artists' work, galleries, fairs, art magazines, and websites. Whichever way the book is used, I hope it will stimulate thinking and enrichment, since art, undeniably, is conducive to happiness.

WHAT is art all about?

If art reflects society and the times we live in, then over the centuries it has told countless stories and described many changing patterns of history. Art has reflected religious zeal, rich patronage, the onset and development of industrialisation, the challenge of ideas, a return to the land, conflicts and war, the freedom and liberty of the '60s, material wealth of the '80s, space-age and internet travel — and now, in the twenty-first century, the shock of new art in a world rocked by violence and terrorism, polarised between wealth and poverty.

There is constant debate about what constitutes art, as well as what is good, bad or mediocre art, and how to define the differences. Art is subjective: within it lies mystery and beauty — and beauty cannot always be agreed upon. The work produced by an artist depends largely on, and will reflect, the character of that artist: powerful, sentimental, intellectual and so on. Technique and draftsmanship can be taught — but creativity is unique to the artist. Therein lies the mystery.

With all the -isms and schools that have formed throughout the history of art it seems that, unlike developments in science and technology, there is no era or period in art that can be said to be better than another. They are simply different. If art is an expression of the artist's creative energy or the conjuring of a primeval instinct to reify a person or object, then it is an expression uniquely personal to that artist.

Some artists produce work that is in the vanguard of the new, even the shocking, although in retrospect may not appear so. It's interesting to note from the present perspective that over half a century ago, artists were breaking through the traditional two-dimensional definition of painting by combining flat painted areas with three-dimensional objects, some of which were considered provocative. Robert Rauschenberg incorporated into his art a stuffed goat, a chicken and a dishevelled bed. And nearly a hundred years ago, Marcel Duchamp challenged taste-makers' conventional attitudes of the time by presenting a urinal as a piece of art (*Fountain*, 1917). Other artists do not want to shock — they simply don't shout so loudly. Embracing one kind of art does not automatically exclude enjoyment of art that sings to a different tune. The enjoyment in art is finding the tune you like.

In the home of Pino Casagrande (opposite) the owner has displayed an interesting mix of styles, creating a synergy with the commissioned painting by Sol LeWitt and the antique Roman sarcophagus beneath it.

OPPOSITE: *Untitled,* Sol LeWitt

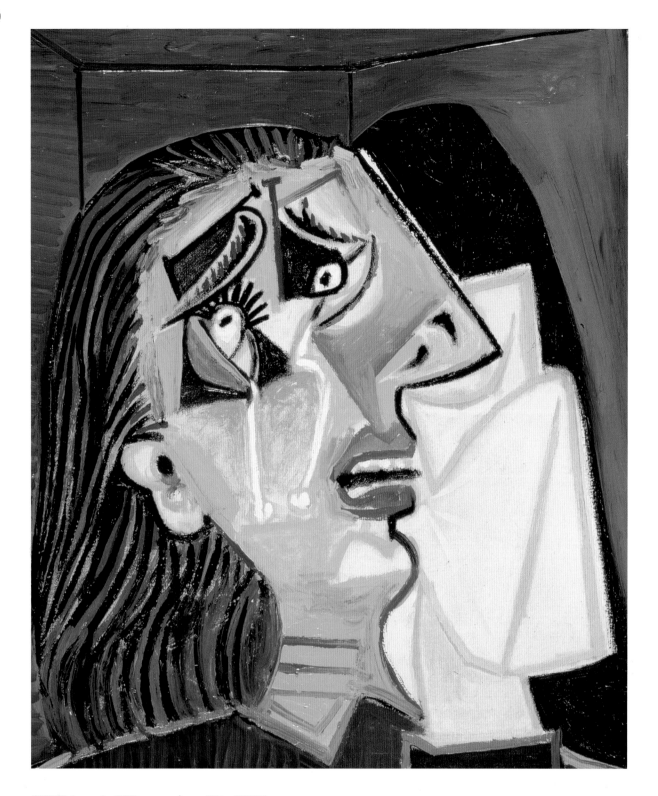

THE ART of seeing

A work of art is made for its aesthetic beauty or impact born out of a creative expression. It has form but no useful function. Within art is a language – consisting of visual icons and images rather than words, and via these images artists communicate ideas and transpose reality.

LEFT: *Weeping Woman*, Pablo Picasso
RIGHT: *Mona Lisa*, Leonardo da Vinci

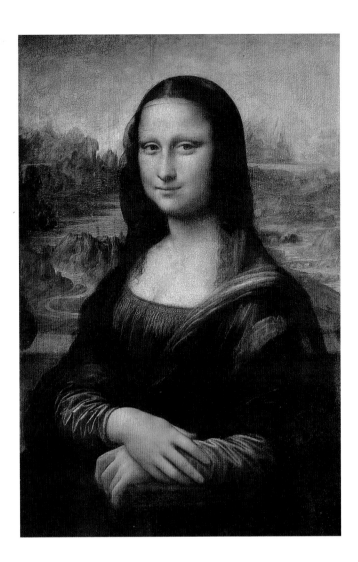

The way we see art is, to a greater or lesser degree, connected to how much we engage with the particular image and how its representation impacts on us. But first we have to look. The art historian E.H. Gombrich observed: "The true miracle of the language of art is not that it enables the artist to create the illusion of reality. It is that under the hands of a great master the image becomes translucent. In teaching us to see the visible world afresh, he gives us the illusion of looking into the invisible realms of the mind — if only we knew, as Philostratus says, how to use our eyes."

That's the key: using our eyes to discern — to really look at the expression in people's faces, to watch unexpected shadows cast on the wall when the light is turned out, to look at shapes in the clouds, and at the art all around us. The fun is to become aware of it, to use our eyes more keenly. If we do this consciously then we are developing a discerning eye. Take the *Mona Lisa* for example. It's an image that we have seen repeatedly. Even having seen the original in the Louvre and experienced the powerful

effect of the painting, it is hard to see it in all the various reproductions with fresh eyes. But take another look at the picture as if seeing it for the first time — from the folds in her sleeve to the curiously unbalanced background. Looking at her face is like looking into a living person's face: her eyes *do* mysteriously follow you wherever you are. Her whole pose is a combination of sadness and strength. It is a beautiful and mysterious painting, but its fame and overexposure are likely to create a weary response from us just because we have become accustomed to its repetitive image. So look again, slowly, and let her work her magic.

Picasso's portrait of a woman was originally considered shocking, but this painting, too, has endured by some collective consensus. Another iconic painting, it was initially a more difficult work to respond to because of the shock or surprise element, but gradually this portrait also worked its magic and to this day rewards the viewer (particularly those who take time to see below the surface) with a feast of surprises.

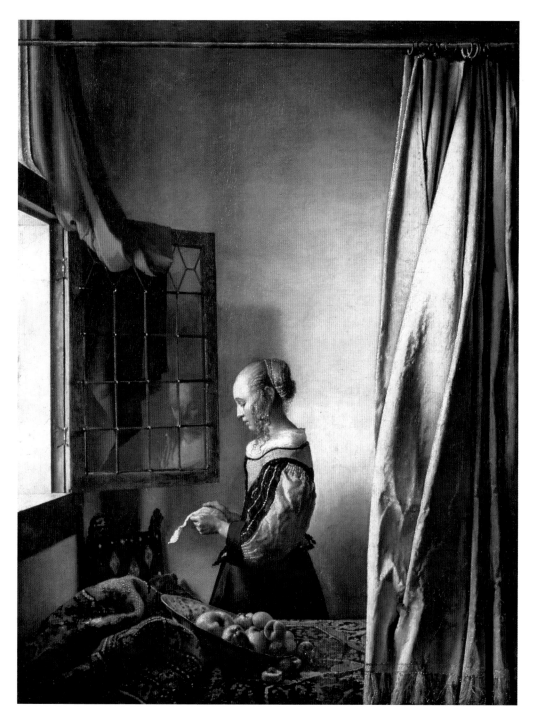

TRANSITION of themes

At a glance, the Johannes Vermeer painting (above), *A Girl Reading a Letter by an Open Window* (c 1647-9), might be overlooked by someone for whom 'old masters' do not appeal, or who is put off by the historical costume and styling of the character and the room. Nevertheless there is a story here – and, whether we know the full story or not, it becomes engrossing to consider what is being played out in a single painting.

*"Only through art
can we emerge from ourselves and know
what another person sees."*

MARCEL PROUST

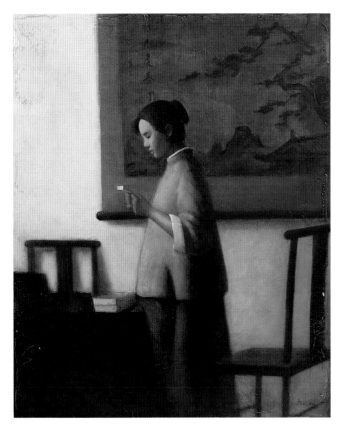

ABOVE: *Portrait of a Lady*, Yin Xin

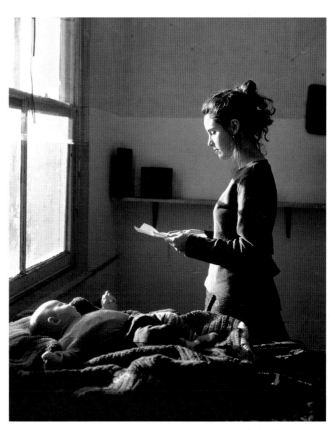

ABOVE: *Woman Reading a Possession Order*, Tom Hunter

The inspiration of this painting has led the contemporary artist Yin Xin to reconstruct the elements and retell the story in another time and culture in his painting (above left), demonstrating that the sentiment and the expression are described in a universal language without words. In yet another period and culture, Tom Hunter has also chosen this theme for his photograph of a young woman reading a repossession order on her home.

Look into paintings to allow them to tell their stories. Once this happens we connect with the artist and we start to appreciate the elements he or she has constructed – the atmosphere, the source of light, the tones and colours. This not only enriches our enjoyment of diverse art but can act as a link or a bridge between themes in historical art seen in museums and the art we choose to enjoy at home.

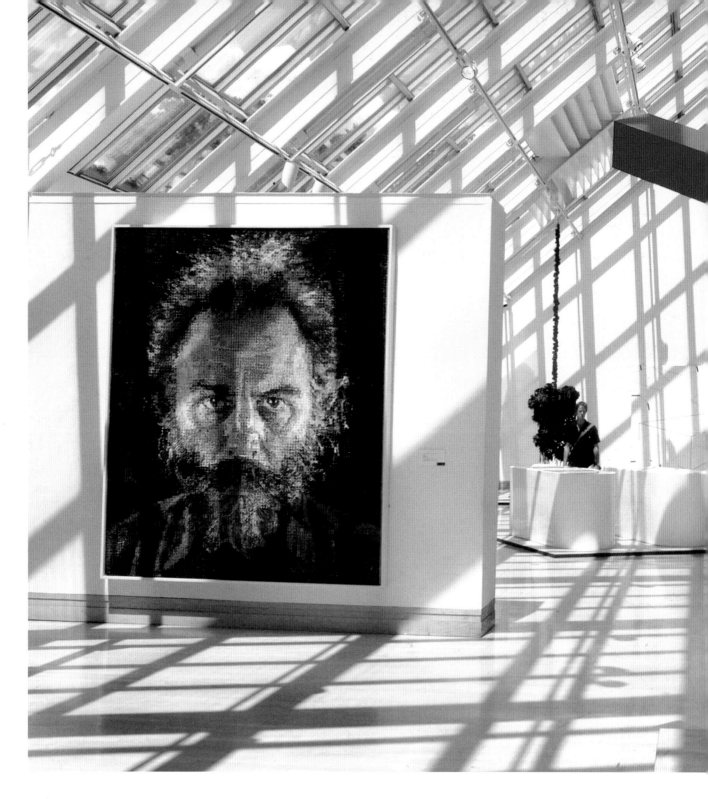

ART in the museum

LEFT: *Portrait of Lucas*, Chuck Close;
Untitled Sculpture, Joel Shapiro
Metropolitan Museum, New York

National art galleries and museums in each country display treasures, art and artefacts that reflect the culture and history of its people. Travelling exhibitions also help to give an insight into another country or culture. We go to view these treasures in order to be educated, to be enriched and to appreciate; but we don't come away from such an exhibition necessarily feeling that we want to, or even could, take home these works of art. Art on a large scale, priceless art, historical art, is to be viewed and enjoyed in the context of the museum. It is not the same as art that we might choose to live with – art that we can display and enjoy at home.

ART at home

There is a basic human instinct that leads us to adorn our homes. Despite a long history of wealthy art patrons and collectors, it is not always the case that famous or expensive art is best, and it is certainly not the only art. What is important, in responding to that basic instinct to adorn, is that we acquire art that we genuinely like and choose to have in our homes – bearing in mind that our art, as with everything we own and display, says something about us.

In the art world, as in any other, it is the celebrity and the sensational that get the attention of the media. It would be easy to fall into the gulf between this currently famous art – the big loud shark art that hits the headlines – and the art that we wish to live with.

Aesthetic confusion can inhibit an otherwise enthusiastic and potentially keen art collector into following a trend or keeping in safe and shallow waters. Our own personal make-up and character have already influenced a certain style and this same inbuilt natural selection process should

also inform our decisions when displaying art at home. Art we display in the home is, in any case, more inclusive. Art that we buy or treasure might happily cohabit with family photographs, postcards, children's art, film posters and so on. Our art becomes personal because our homes, to a large degree, are our private spaces.

Our choice of art and the way we choose to display it is also a form of communication and, as with any language, it is worth studying its meaning if we want to know what we might be saying through our art.

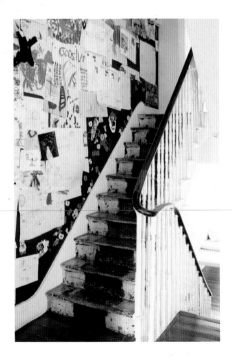 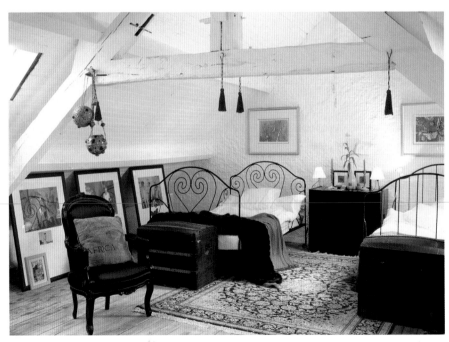

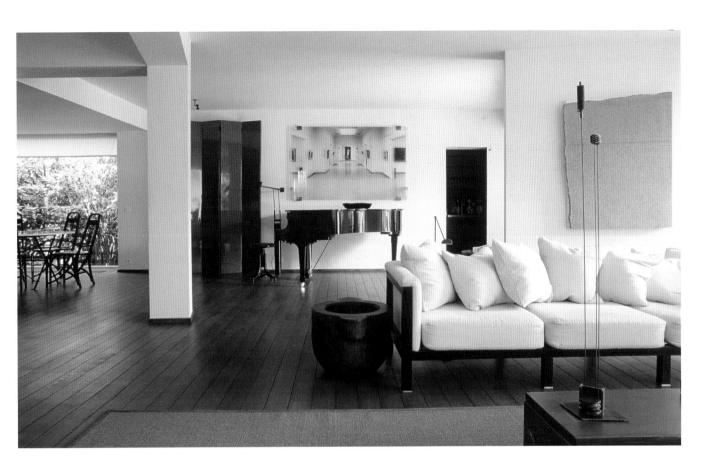

ART meets design

What we put in our homes divides loosely between function and form. Fine art is distinguished from design in that design suggests an underlying practical function or agenda other than having been created purely for aesthetic beauty. Good design improves the quality of our lives by combining a smooth function with good looks.

Designers and inventors produce ingenious ideas – often driven by the desire to improve the performance of a product or develop a response to a need or problem.

A truly great designer will combine aesthetic form with advanced technology. Design has evolved rapidly, to a point where it is not merely addressing the functional but also the aesthetic and sculptural roles that play a part in the finished look of the design. Good design, like good art,

is now accessible at every budget level. Looking out for classic products, designs and furniture as well as art when finding pieces for the home can provide great enjoyment, whether in flea markets, galleries, auction houses, on the internet or a combination of sources. In fact the broader the hunting ground the greater will be the personality of the mix. An eclectic combination of art and design in the home creates a unique and personal space. Function and form cohabit.

EVERYONE'S a collector

Unless you are starting an art collection from scratch you will already have inherited or acquired some pieces, which makes you a collector. If you do start from scratch and plan to buy art, then you are also a collector.

Collecting is a curious human habit, often starting in childhood with the acquisition of a particular brand of toy, sports memorabilia or doll; as adults the attraction of shells, pebbles – even handbags or shoes – reinforces our desire to surround ourselves with beautiful objects. Collecting art, or a particular genre of art, derives from this same root of interest.

To many people the concept of 'collecting art' is remote, but in reality 'collecting' is no different from 'buying'. Using the term 'buying' or 'shopping' immediately makes the activity more familiar and less intimidating. There are three main reasons for collecting: building a collection; buying art for love; buying art for investment.

Experts advise that the first step is to 'get your eye in'. This will lead you to discover what you really like and why; and as you learn you will become more discerning. Develop a habit of visiting galleries and museums. Remember, too, that you don't always have to make this a special trip. Little and often ensures that you can take in a lot in a short time, which exercises the natural selection process. Or you can find an artist or a work that arrests your attention and spend quality time with one piece. The added advantage of this process is that you have something pleasurable to do wherever you are, whenever you have some time to kill before an appointment or need a short break from work.

Looking at art in books, in magazines and on the internet will increase your exposure to it, but there's no substitute for seeing art in its three-dimensional form, so seek out original art wherever you can – in galleries, exhibitions, art fairs, art window-shopping and in other people's houses. If you develop an interest in art there is always a point of discussion, a conversation piece. Corporations often have art collections and since they have big walls can display large art; they are usually happy to show their collections to visitors. Find out from the receptionist who the curator of the collection is and ask if you can see it or have a guided tour.

"Appreciating art is about making a connection" says Will Ramsay, founder of the Affordable Art Fair (now in its seventh year and expanded from London to include New York, Melbourne and Sydney). "Always buy what you like, not what you think you should be buying." This advice is echoed by nearly all the gallery owners and art dealers with whom I have spoken.

Art as an investment is a relatively new concept. Historically, people bought paintings for pleasure, for status or as a commission to hang in the home, but not as a form of financial investment. Now, ever-increasing amounts of money are in circulation and abstract finance in the form of credit and credit cards is available to the masses, not just the few. So, despite the advice given above – to buy what you like – there is no denying that art on a big budget is big business. When asked on his retirement how the business had most obviously changed in the last forty years, a well-known art dealer said that when he started out, dealers would always visit a house by the tradesman's entrance. "Now they all arrive through the front door."

Art as business accelerated in 1967 when Peter Wilson, the then chairman of Sotheby's, created the Times-Sotheby's art indexes. 'Value' was given to art stock and thus an inherent investment quality, either real or perceived. This took art prices into the business section of The Times and then to other newspapers and financial magazines. The arrangement clearly benefits those in control of these purse strings, but there was and is no guarantee that the investors themselves will see a return on their money.

Since then a polarity has developed between those artists acquiring celebrity status as a result of being talked up in investment circles and those living on welfare. As the monetary 'value' of a piece of art does not necessarily reflect the calibre of the art, the result is massive uncertainty for many collectors as to what to buy or 'invest' in. The advice 'buy what you like' should therefore still hold as your guiding principle.

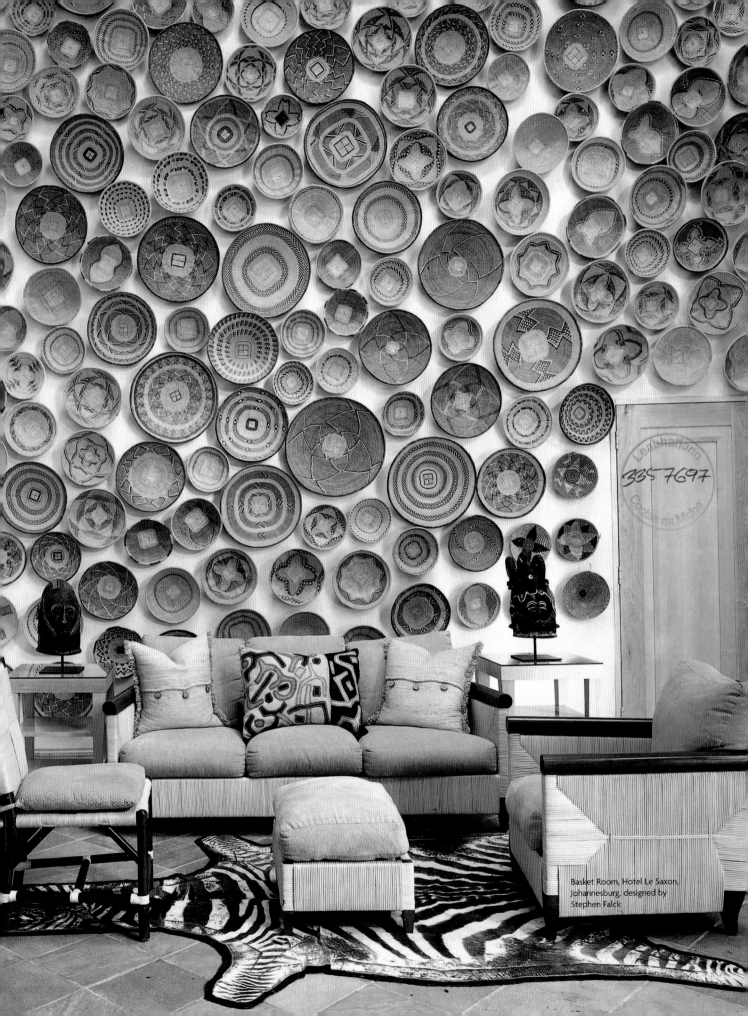

Basket Room, Hotel Le Saxon,
Johannesburg, designed by
Stephen Falck

WHY we choose the art we do

Your home is designed to give you shelter, keep you warm and give you space in which to function. The furniture and appliances you choose also perform a physical function. The function of your art, however, is connected with the mind and spirit. Humans have a deep-rooted need to display art of some sort. From cave to château, primitive hut to palatial mansion and all homes in between – their inhabitants have displayed artwork of varying tastes and budgets. It doesn't matter whether you have art covering every available wall space or you display just one piece that you love – but it would be an empty home that contains no art at all.

By the time most people have bought or rented their own home, they have acquired some art – chosen individually or with a partner, inherited, bought on holiday, received as a gift or selected as part of a collection. In reviewing the art we already own, we need to re-select through fresh eyes and with fresh ideas – and know why we want to keep it. If it no longer fits the new criterion, then we should let it go or put it away in storage. Make space for fresh art.

This chapter focuses on the aesthetics of art in the home – the creative response to all that you see around you, how to integrate art into your home to add interest, life, colour, expression, character and personality. In the same way we choose music, so we choose art. Maybe we simply like the melody (in art, the colours), or it reminds us of a special place or person (a landscape or portrait, even an abstract one), or it makes us feel a particular emotion (art, too, can evoke elation, thoughtfulness, calm, excitement, mystery). It also expresses to other people how we feel.

When an artist creates a piece of art, there is somewhere in that sorcerous process a spontaneous response to imagery. The imagery that is employed depends on the artist's influences and imagination. When we see or choose a piece of art that we like, it is because we are drawn to that artist's way of thinking and seeing and his or her use of those influences. They may be nostalgic or futuristic or provocative or ethereal – but in choosing that art we become, ipso facto, artists ourselves. It's as though we agree with what is being depicted – or that if we were to create a piece of art this would be the piece we would create. I have asked many artists what art they would buy themselves and, after a little thought, most of them have said that they would choose the sort of art that they themselves create. QED.

LEFT: *Bullseye*, Jill Swann

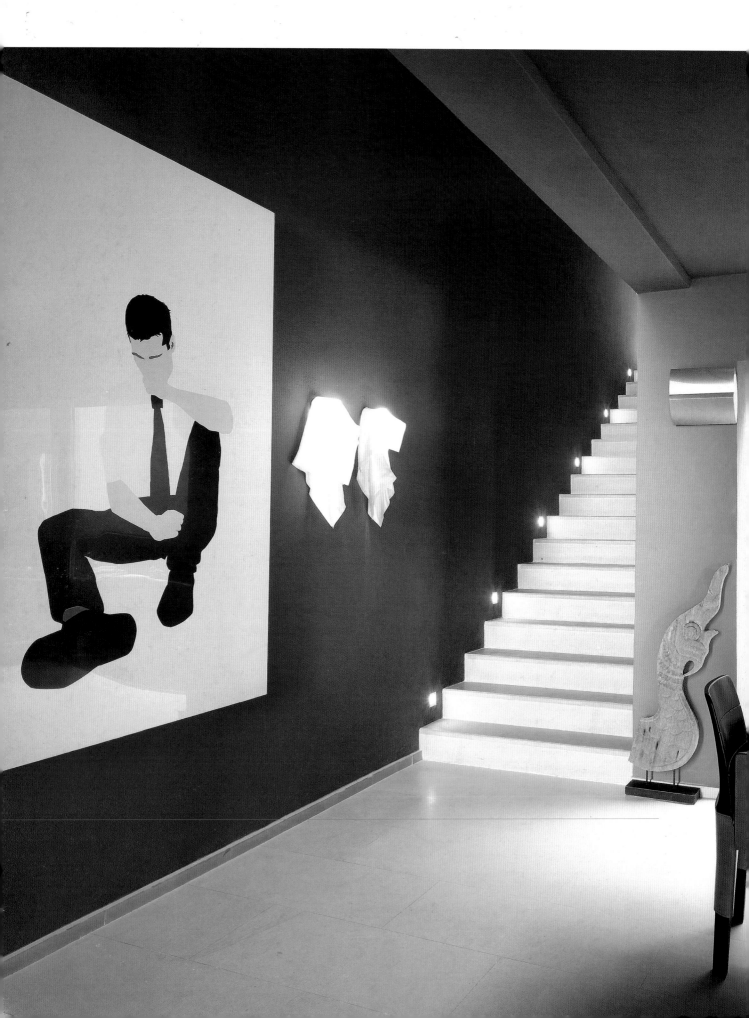

LEFT *Too Little To Try, No. 4*, Edd Pearman
RIGHT: *Trainers*, Leigh Mulley

"Art is a technique of communication. The image is the most complete technique of all communication." CLAUS OLDENBURG

WHY self-expression

In producing a piece of art, the artist is expressing his or her view of the world or part of it, either literally or through his or her creative imagination. So in choosing art for our home, we are expressing the same thing via the artist. Why we choose a particular piece, therefore, says a lot about us. It is a language by which we communicate to our family, our friends, our guests, our world.

Self-expression can be achieved by integrating a choice of art within your surroundings – or by combining the intended expression into a single piece of art. The significant and initial step is to know which part of yourself you want to express. Success or status? Spiritual or political awareness? A desire to be taken seriously, to be considered learned? A love of home and family?

To display a large painting that dominates the room already indicates a strong personality – someone not afraid to say what they think and

say it boldly. In this striking contemporary painting by Edd Pearman (left) the body language in the pose of the lone figure in space is expressive – he is seated informally, yet he is portrayed as thoughtful and smartly dressed. The immediate impression on entering the room is that the owner is confident and successful. Perhaps he/she is reflecting his/her own solitary habitat, or sending out signals to attract a potential mate? Maybe there is no reason other than the attraction of the painting itself. But how is it perceived by others?

EXPRESSING the feminine

Whilst the art displayed on the previous pages indicates expression of an angular, masculine aspect of the psyche, in the selection of paintings here the feminine side is more pronounced.

However artificial civilisation may become, women still generally have a deeper biological sense than men. They are programmed to have characteristics conducive to their roles as mother and mate and, consciously or subconsciously, feminine traits expressed are gentler, more yielding and softer than their masculine counterparts. Men and women both have masculine and feminine tendencies – some more pronounced than others. How these characteristics are displayed or perceived is transmitted via art as in any other outward manifestation. The social collectivism of the family unit can be redefined but there is no substitute for paternal-maternal instincts. These impulses, when expressed, are celebrated. Women, the female form and feminine characteristics are represented in our personal choice of art. Just as different languages refer to inanimate objects as being feminine or masculine, so, too, different characteristics are loosely defined as being male or female.

ABOVE: *Pink Tibetan Lotus – from the Garden of His Holiness the XIVth Dalai Lama*, Jo Self
BELOW LEFT: *Orchard Geisha*, Annik Le Page
BELOW RIGHT: *Sleepy Soul*, Zachary Walsh
RIGHT: *Flower 146*, Artcadia.co.uk

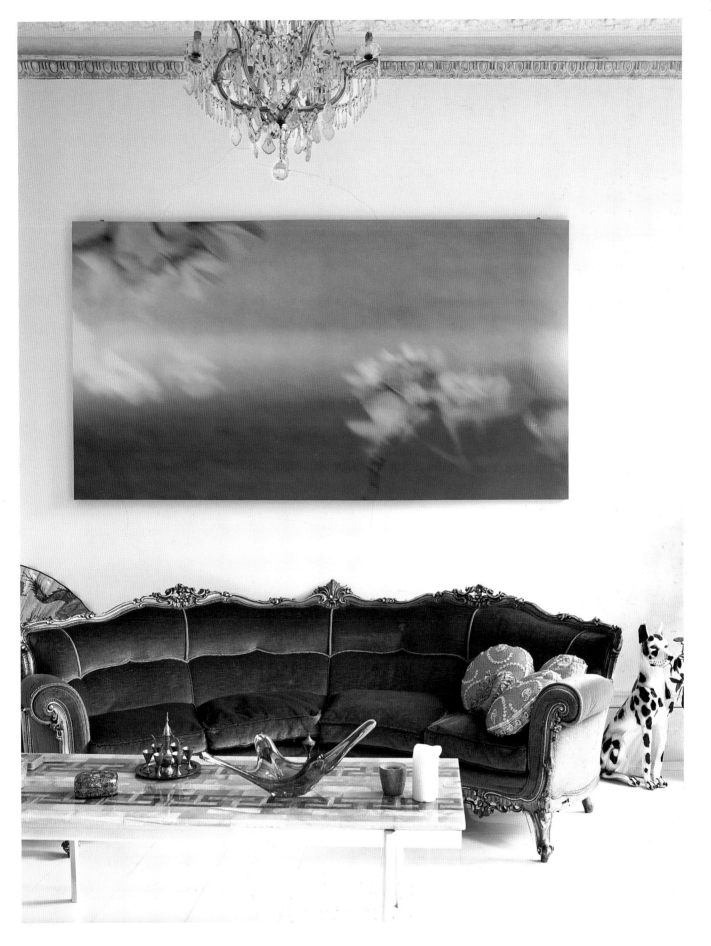

ABOVE: *Female Indian Construction Workers,*
John Dewe Mathews
BELOW LEFT: *Venice Wall,* Tiddy Rowan
BELOW RIGHT: *Funeral ceremony,* Melangi de Milingbi

ART of a traveller

The urge to travel, to visit places, people and cultures other than our own, is part of our natural inquisitiveness. Away from home we see ordinary things differently – a local hardware store, side street, service station, avenue of trees. There is no doubt that our outlook is broadened by the experience and our unjaded eye finds art that reflects this. One of the attractions of travelling is the moment of coming home. With these keener eyes our home becomes somewhere to re-create those places and cultures visited, so that the experience is ongoing and the influences persist.

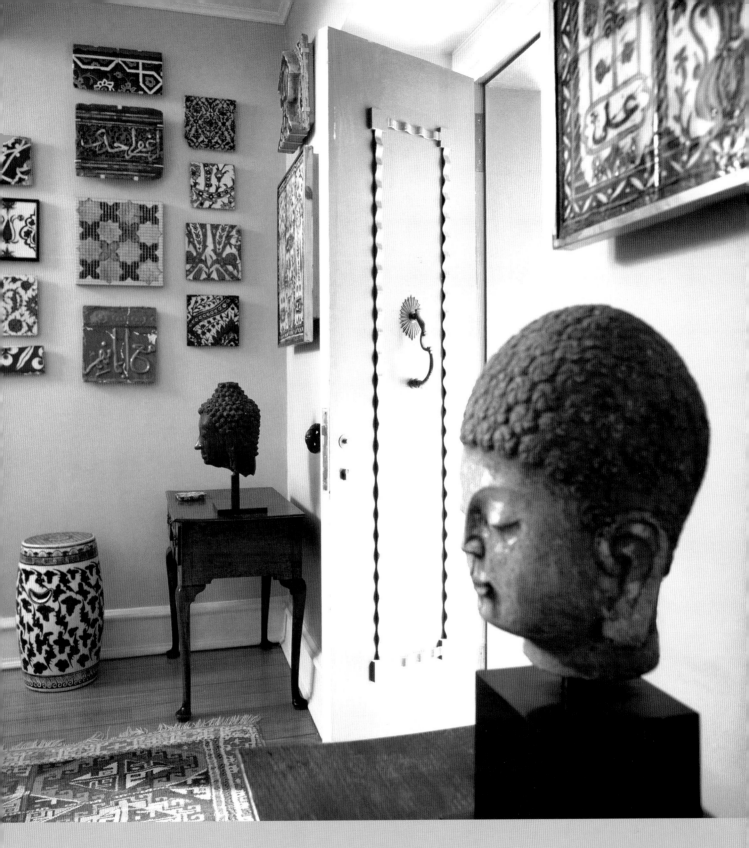

Actual traveller or not, creating your chosen world in a room broadens horizons and interest. If you were to make a point always of bringing home a piece of original art – a canvas, a print, a small piece of sculpture – you would soon accumulate a rich art collection to enjoy, each piece with a story to tell.

Don't forget, when looking at a work on canvas far from home, that it is relatively simple to have the canvas removed from the wooden frame. Roll it up for the journey and have it re-stretched once on home ground. Bigger or heavier pieces can be shipped; prints can be easily carried in a hard tube.

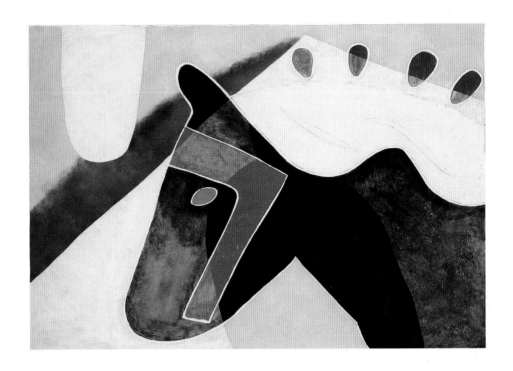

EXPRESSION of interest

So you have a small or large sum of money and have decided to buy a painting or piece of art. You have the blank wall – but you don't know what to look for. A good starting point is to say something about yourself. Use the blank wall as an artist would a canvas and express yourself.

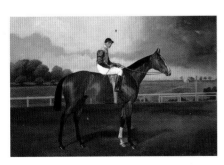

OPPOSITE: *Saddles*, Paul Tan
ABOVE: *Painting by Numbers No 5*, Tim Nicholson
BELOW: *Spearmint, Derby Winner, 1906*, Michael Heslop

Without even giving it a great deal of thought (in which the mind starts serious consideration), pinpoint something you spontaneously think of as an expression of your interests, your world.

As an example, in the room opposite the owner, whose interests include horse riding, has chosen a painting of saddles by Paul Tan. To continue the theme, a complement to the somewhat idiosyncratic nature of this work could be a painting such as the one above by Tim Nicholson from a motif familiar in his depiction of fairground horses. There is a playful light expression here – very different from another person's passion for horses, which might be more conventional, such as the painting pictured left in the style of Stubbs.

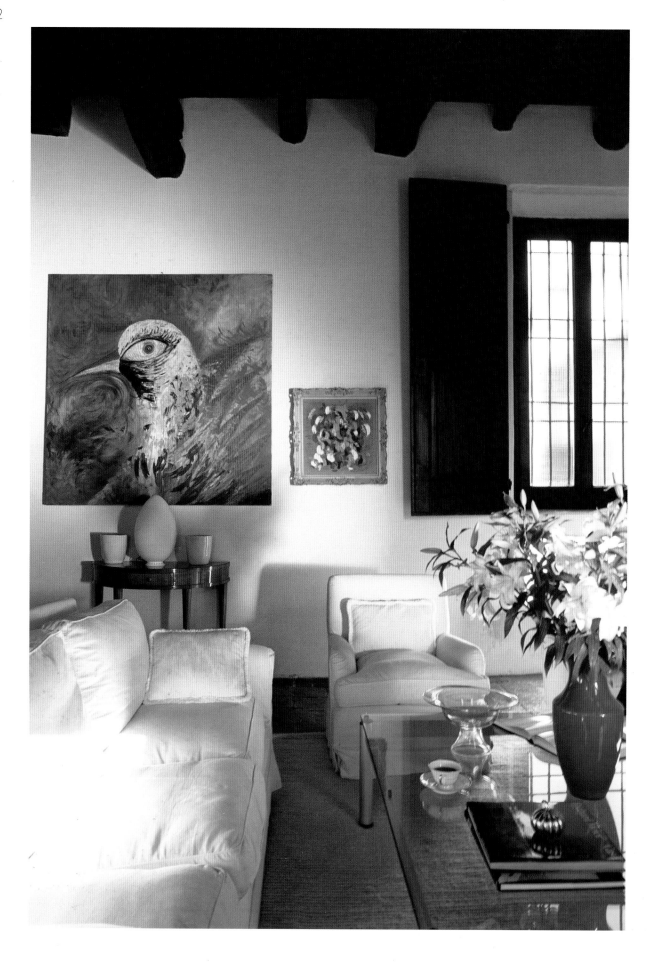

OPPOSITE: *Garuda*, Aldo Rota
BELOW LEFT: *Blue Bird*, Louise Belanger
BELOW RIGHT: *Zebra*, Charlotte Lyon

MAKING an impact

In the same way that an extrovert character makes an impact when entering a room, so a painting can have the same effect. In the room opposite, an otherwise simple setting is utterly changed by the impact of a painting that is loud and quirky but with definite character. The Japanese sometimes refer to different rooms by the subject of a principle piece of art displayed in it. Instead of living room, sitting room or drawing room, this room would simply be called 'the bird room'.

The symbolism of animals played a stronger role in primitive societies than in technologically developed ones. The Maya, for one, exploited the potential of a limited iconographic base that consisted of the animals around them. The contemporary painting by Louise Belanger (above left) was inspired by a design on an ancient piece of Mayan ceramic.

At some time in their lives most people have played the game of identifying themselves with a bird or animal. Another form of self-expression through art could be to play the game again to see what animal or bird appeals to your artistic taste. By including this concept in your choice, you are taking the art beyond surface interest and making it uniquely individual.

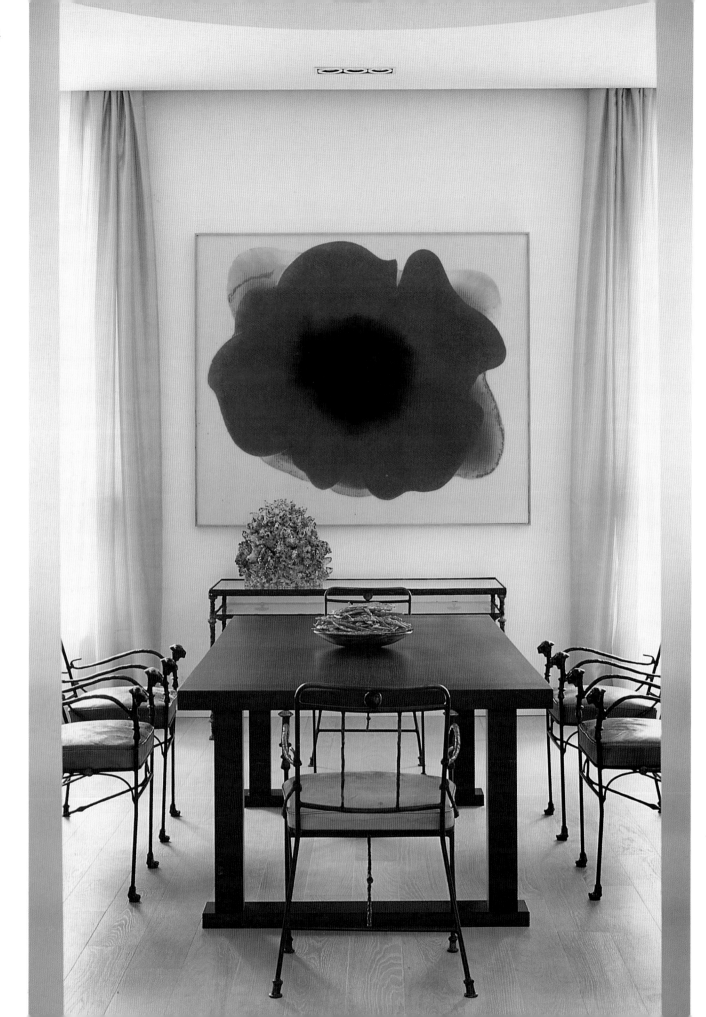

OPPOSITE: *Poppy*, Jose Maria Sicilia
BELOW: *Celebration*, John Eaves

ART to change your mood

Art acts on us subliminally as well as through our conscious will to 'look' at a painting or a piece of art. It follows then, that we can enhance or change our mood with art in the same way that we can with music. If we take an emotion or mood that we would like to feel often – joy, for example – we can select a painting that makes us feel this way. By actively selecting a painting for the purpose, it will achieve the desired effect.

The view of the painting in the room opposite can be enjoyed not just from sitting around the table in this Roman apartment. When walking past the open door, many times a day, the viewer cannot help but feel uplifted. Imagine the same space without the painting – the response would be emotionally silent.

In the painting above, the positive attitude of the artist John Eaves is expressed in a feast of colour. The composition and tempo of the painting is derived from his love of jazz music. Listening to jazz whilst he paints informs the feeling the painting expresses and, to look at, the painting can appear like visual music.

BELOW LEFT : *Harmony IV*, Gail Lilley
BELOW CENTRE LEFT: *Kyoto Garden II*,
Richard Winkworth
BELOW CENTRE RIGHT: *First Light*, Richard Barrett
BELOW RIGHT: *L'Abbaye à Lehon*, Patrick Haughton
OPPOSITE: *Piscinas II*, Daniel Senise

ART to calm

In parts of the home where you want to relax and unwind, aim to include as many elements as possible to achieve a sense of calm: comfortable furniture, soft lighting, the smell of fresh flowers, music – and good art to rest your mind and eyes upon.

Select a subject that is gentle and unprovocative. The deceptive simplicity of the arrangement of jars and bowls in Gail Lilley's painting (above left) belies a painting that is both strong and meditative. There are no sharp angles or bright colours to stop the eye's movement, but the attention is focused as the pearly earthy tones fill in the softly lit silhouettes.

Richard Winkworth's strong images also act meditatively, in the same way that a Japanese garden draws us in and contains our thoughts (above centre left). The picture by

Richard Barrett (above centre right) refreshes the senses, as though looking at a view through an open window. Patrick Haughton's study of a church (above right) reminds us why we stop to meditate on certain architecture before entering a place – this painting gives us that same sense of pause.

The physiological effects of colour are well known; they have the power to heal as well as to stimulate, so the colour palette plays a role here, too. Neutral tones, and soft hues of blue and greens are restful.

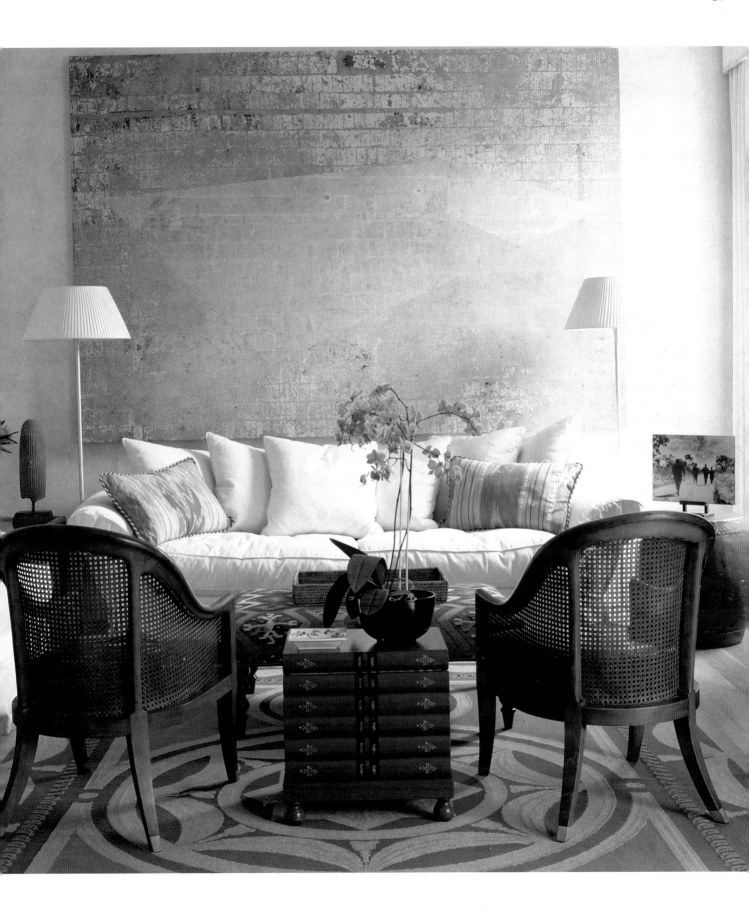

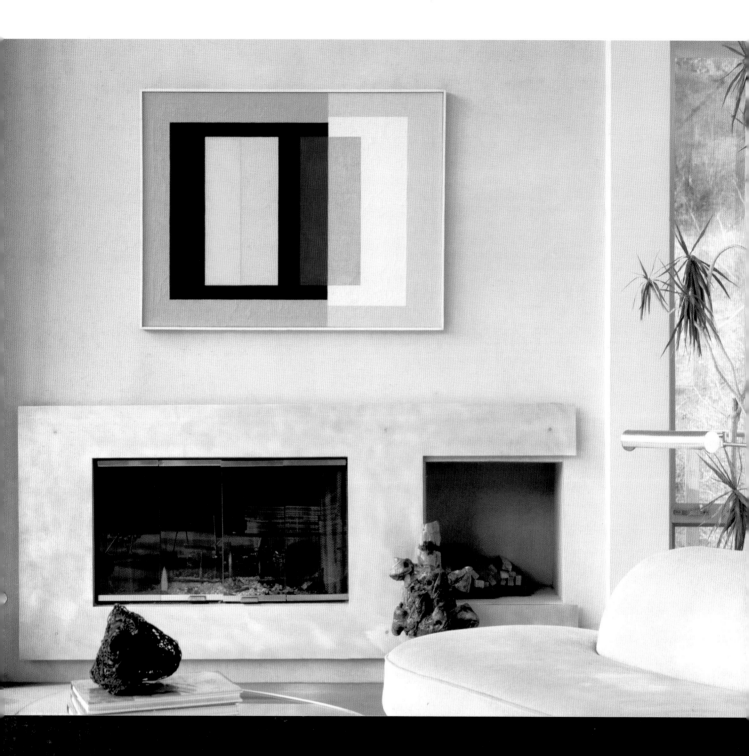

ART to stimulate

The artist Muhadin Kishev, who created the painting opposite, invites the viewer to evoke an imaginary tunnel disappearing into never-ending space. The mind is challenged by certain paintings which give the viewer a unique stimulus. Unlike a puzzle, which can be frustrating, a well-constructed abstract painting can have a positive and changing effect on us, as our response

BELOW: *Tunnels of the Mind*, Muhadin Kishev

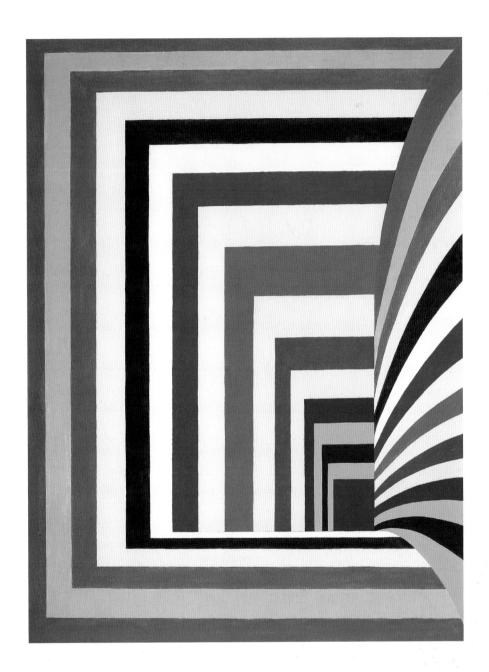

Nothing stands still for long. As we need to rest, so we also need to exert ourselves. Abstract art is a good reviver, stimulating the mind through its combination of shapes, rhythm and colour. The lack of any immediately recognisable image (as in a figurative, landscape or still life painting) leaves us free to exercise the mind.

In France, the scientist and aesthetician Charles Henry had studied colour dynamics and observed, in his *Cercle Chromatique*, in 1889, that red appears to move vertically upwards, blue horizontally from right to left, and yellow from left to right, illustrating the penetrating effect that colour has on our senses, whether we are aware of it or not.

ART to stimulate

SYMBOLS in art

Objects and symbols in painting historically conveyed a language representing ideas and emotions. Pictures of maps and scientific equipment indicated that the owner of the painting wanted to be thought of as learned and serious; jewels and lavish costume indicated wealth. Pineapples, once rare and exotic, were considered a symbol of friendship and indicated a host who offered fine hospitality. The motif is still seen on the finials and gate posts of old houses. Dutch masters in the seventeenth century expressed the opulence and hospitality of their patrons by depicting tables overflowing with fish and fowl, fruit and flowers, gold beakers and platters.

Materialism was no longer visually represented in quite the same way after Symbolism as an art movement shook up a traditional way of looking at things.

In the early part of the twentieth century, Wassily Kandinsky challenged formal interpretations; he and other abstract painters were concerned not just with the outward form of their work but the content, thus symbolism took on a new meaning. In an article which appeared in *Der Strum* (Berlin) in 1913, Kandinsky sums up his theory of art: "A work of art consists of two elements, the inner and the outer. The inner is the emotion in the soul of the artist; this emotion has the capacity to evoke a similar emotion in the observer. The inner element, i.e.

the emotion, must exist, otherwise the work of art is a sham. The inner element determines the form of the work of art." He believed that colour and form alone were enough to express emotion – that it was not essential to represent material objects, nature or figures. Kandinsky arrived at an understanding of form and colour through his initial studies in music, where mathematics and colour tones had their own beauty and order. He used form in painting in the same way that precise notes in music give form to an imprecise inner expression or emotion.

Symbols still abound, whether abstract or depicted. We can also make or interpret our own symbols and weave these into our personal language of art.

EXPRESSION global moments

War and despair; the hopelessness of hopeless voices, of misunderstandings that lead to hatred, divisions, destruction. Perhaps we need art now as we have never needed it before. In times such as these, we need the language of art where the language of words fails to unite us.

Picasso's *Guernica*, painted in 1937 after the destruction of the Basque town of Guernica during the Spanish Civil War, expresses the horror and emotion of war. Picasso, a socially conscious artist, said: "Painting is an instrument of war for attack and defence against the enemy". And again, when writing in *Les Lettres Français*, (Paris, 1945) and asked "What do you think an artist is?", he replied: "He's a political being, constantly alive to heartrending, fiery or happy events, to which he responds in every way. How would it be possible to feel no interest in other people?" The enemy in this context, as Picasso himself explained, is the person, or group of people, who exploits his fellow human beings from motives of self-interest and profit, as well as everything that threatens the freedom of the imagination and positive human endeavour.

Every era brings its own reasons for jubilation or despair. Artists, writers and musicians observe in their different ways. Art is a powerful communicator. Muhadin Kishev, a contemporary artist who grew up under Stalinist rule in Russia, makes this observation in his disturbing yet powerful painting (opposite) after the destruction of the World Trade Centre in New York, 2001.

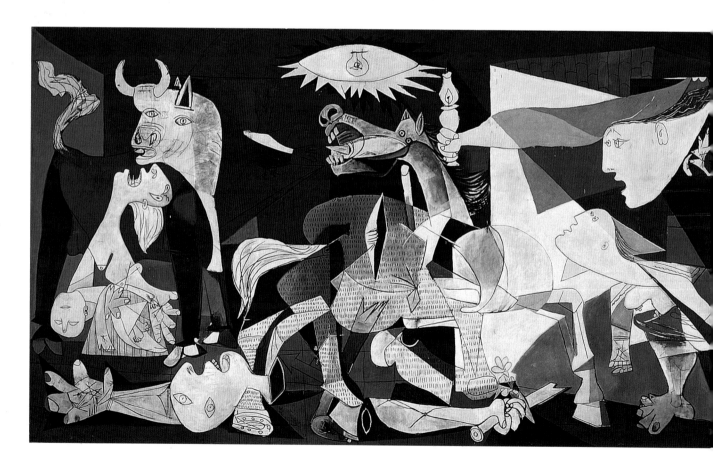

*"Art should be transgressive.
Life is not all sweet."* NICHOLAS SEROTA

LEFT: *Guernica*, Pablo Picasso
BELOW: *The Dark Dawn*, Muhadin Kishev

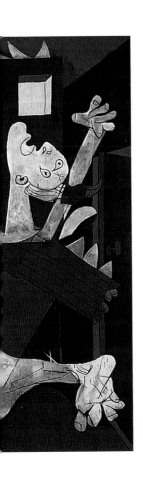

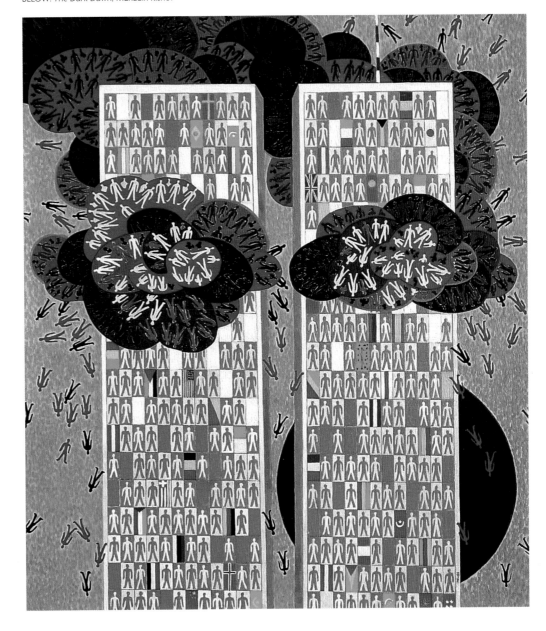

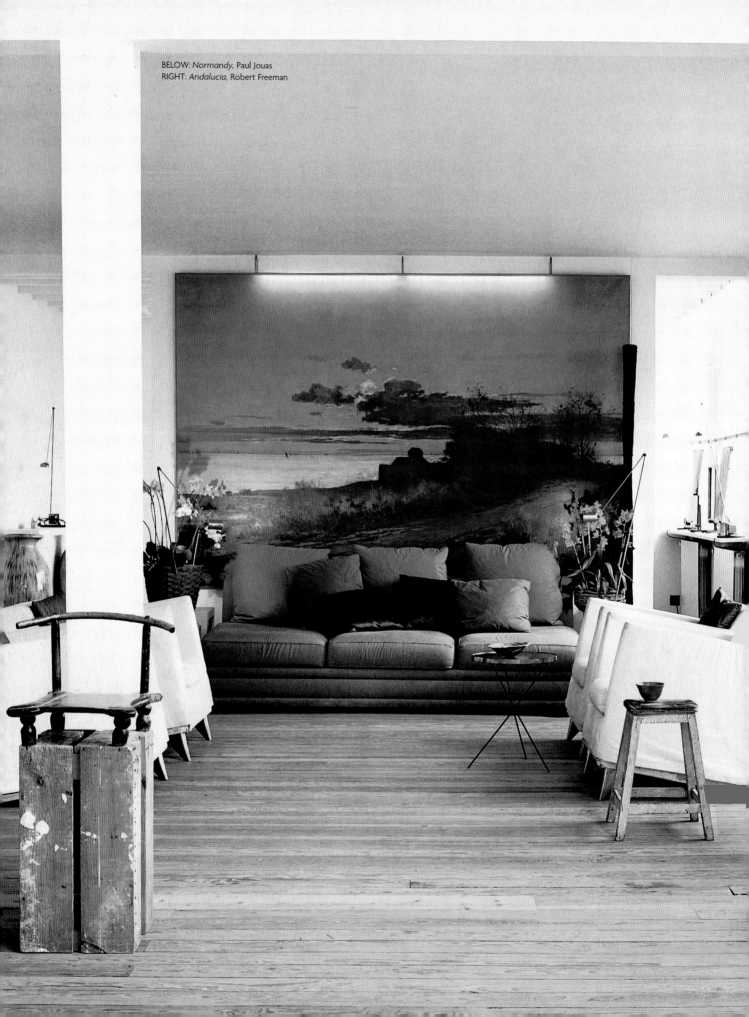

BELOW: *Normandy,* Paul Jouas
RIGHT: *Andalucia,* Robert Freeman

"Slow down and enjoy life. It's not only the scenery you miss by going too fast – you also miss the sense of where you are going and why." EDDIE CANTOR

SENSE of place

A powerful landscape picture can give us a strong sense of the place it depicts and is the next best thing to being there. Not only is it constantly rewarding to have a painting or photograph that gives us that sense of a particular place but other people who visit and view the art will share the experience. It is then like going for a walk with a friend and stopping to enjoy the same view together.

Close your eyes and think of a landscape or view that has a special meaning to you. For impact – big is beautiful. A large canvas will enrich the room and be enjoyed in different lights and from different perspectives, like the painting of Normandy by Paul Jouas in this Parisian apartment (opposite).

If there is a photograph that takes you to that place – consider having it blown up as large as possible. Talk to the photographer or the gallery where you bought it and discuss the options. The evocative photograph by Robert Freeman, (above), works at any size. To capture the dusty landscape, it was printed in sepia tones.

MARKING time in our lives

There is a place in the home for family photographs, images from childhood, sporting achievements and personal passions. They are a pleasure to have around you and a way for people to learn more about you when they visit. If a display of family photographs is too personal a statement, then choose a theme in selecting a painting or piece of art as a celebration or to mark an important occasion. A work of art denoting a similar theme could be an unusual gift to celebrate someone else's achievements.

OPPOSITE: *Violin Blossom*, Annik le Page
BELOW: *Newly Weds*, Tetyana Yablonska

"Painting is just another way of keeping a diary." PABLO PICASSO

HOW to develop your art personality

Consciously or subconsciously, each of us develops a style in the way we present ourselves with clothes, accessories, jewellery, choice of hairstyle and so on. Whether opting for a thrown-together look or sophisticated urban chic, what we wear and how we wear it contribute to the expression of our personality. When people come into our private space, our home further defines this sense of self. Not only does art enrich our lives but the way it connects us to other people offers another source of communication, describing another aspect of our persona.

This chapter is designed to give you some practical, as well as thoughtful, ideas as to how you can look at your art in different ways; whether you already have a collection or whether you want to begin or develop one. The objective here is to develop your unique 'art personality'. It will offer ideas on how to develop your 'eye' by seeing art in different places, how to start a collection, help define your collection if you have one, how to incorporate your own art and photography with that of your partner or children and how to source new work.

The number of visuals you have seen in your lifetime to date is too large to contemplate, but to stop and consider which of these images comes to the fore starts to concentrate the mental eye. Which particular paintings or pieces of art come to mind and furthermore which of those pieces would you like to have in your home? Can you visualise living with them or are you happy to see them at a distance, in a book or gallery? It is helpful to activate the 'consider and filter system' of what you have seen, what you like and what works for you on a living, day-to-day basis. Art is also a relationship.

Acquiring art is a formative way of developing your art personality. Once you actually have to pay for something it helps to concentrate the mind further in the selection. Whether a fledgling collector or one whose space outweighs budget, a good place to start is with an artist whose career is just taking off. Not necessarily straight from art school, nor when so established that their prices are prohibitive, but at an early stage, when the artist has the beginnings of a track record. You can have a shared enthusiasm with the artist in his or her development; your relationship is more one of patron than investor. Building a relationship with one or more artists further enlightens and enriches your own development in art appreciation.

OPPOSITE: *Untitled*, Anton Ferrieria & Connor

CONSIDER the art you have

Having looked at why we choose the art we do, and before acquiring new pieces, it is important to re-evaluate the art you already have. Whether you have moved to a new home, or are re-considering your art in its present habitat, there are many factors that will inform your decisions.

It is a luxury of time and space to be able to do this but wherever possible, early on in the consultation process, this is what I recommend a client to do. Go through your home and look carefully at every piece of art on display, considering how much you (still) like each piece. Now, look back through the last chapter at what the art might say or represent and decide how much you really like it.

Leaving the more fragile pieces of sculpture and ceramics where they are, take everything down from the walls and place it on the floor near to the wall on which it was hung. If there is anything on the floor that you don't like, or that no longer has relevance for you, put it aside. If there is a piece that you are not sure about or that you and your partner or others disagree about – put it in another area. Don't be ruthless and get rid of these pieces altogether at this stage if you can avoid it. If you are able to put uncertain pieces away or store them, so much the better – in another place, or at another time, pieces may renew their appeal. Now stand back and have a good look at the newly bare walls throughout your home.

You should now only have pieces on the floor that you want to keep. Do they enhance/complement the place where they have been hanging? If you're entirely happy with each particular piece where it was – then back up it goes and the rest stay on the floor. These then need to be allocated to new places – even temporarily.

WAYS to get your 'eye' in...

In order to maximise enjoyment from art, experts all agree that developing a keen eye is essential. Whether re-viewing the art you have, or sourcing new art, the following ideas are ways of exercising that 'eye'. The starting point in developing a good eye is in deciding what you like. Not what you think you should like, but what you really like.

In galleries and art bookshops – look through art magazines and see what catches your eye. See which artists are being written about and why.

Build up a file of artists who interest you, read about them, visit their exhibitions. When visiting an exhibition ask for the artist's statement and biography if you want to know how the art developed.

Find like-minded art lovers or people who share the same interest. It's a growing social activity – there are art tours, art holidays, art groups. Most big galleries organise evenings, talks and excursions (even dating evenings). It's a great way of meeting people and enlarging your social circle.

Cruise the galleries. Get to know those whose art interests you. Chat to the owners or their assistants and ask to be put on the mailing list for private views and information on new exhibitions and artists.

Use short time slots like lunch breaks or on the way home from work to drop into a museum or gallery. You don't have to spend hours or make a day of it (though that's fun too). Choose one painting or art work to go and look at and concentrate on that for ten minutes rather than try and take on too much visual overload at once. This is particularly relevant when taking kids.

If you have portable music, consider listening to music as you explore different galleries and museums. If there is a painting or a piece of art that you want to re-visit, change the music – jazz to Chopin, for example, and see what effect that has on your enjoyment of the art. Not only does it contribute differently to your senses but it blocks out distractions and focuses on a direct response.

Move art around and suggest with similar-minded friends that you swap art for an agreed period. Not only do you learn something more about your friends' taste and ideas but it opens up new possibilities before the commitment of buying.

Make some judgements for yourself. Make a point of finding some artists who are perhaps unknown or relatively unknown. Don't just stay in the safe water – get out of your depth a bit in your exploration. This is where spontaneity and exciting discoveries can be made. Art adventure!

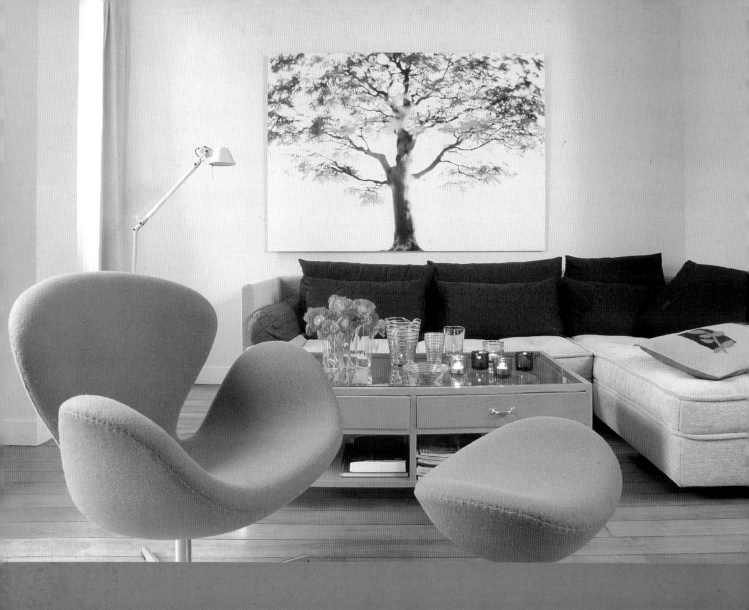

CHANGE of art

The look of a room, as well as the atmosphere, the feeling and the character of the place, can be completely altered by the choice of art placed within it. Where you hang a painting will also change its perspective. So – position, position, position. And keep your collection under review: because a painting starts off in one place doesn't mean it has to stay there. If you're tired of the way your home looks or you want a change of scene, try giving it an 'art lift' – it's simpler and considerably less expensive than changing the décor.

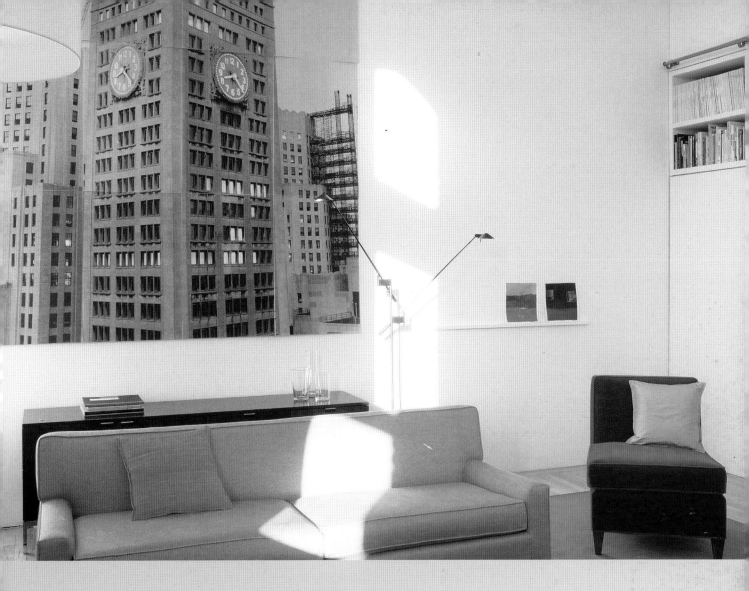

These two interiors, although similarly decorated in classic modern style, look quite different – the one resolutely metropolitan, the other softer and more relaxed. The art in these rooms also illustrates how a variety of moods, atmospheres or aspirations can be suggested. You can evoke a different look at either end of the same room or in other parts of the home. Moving art around also exercises our 'eye', our ideas and our varying responses to art.

"Art is the only way to run away without leaving home." TWYLA THARP

MIXING old and new

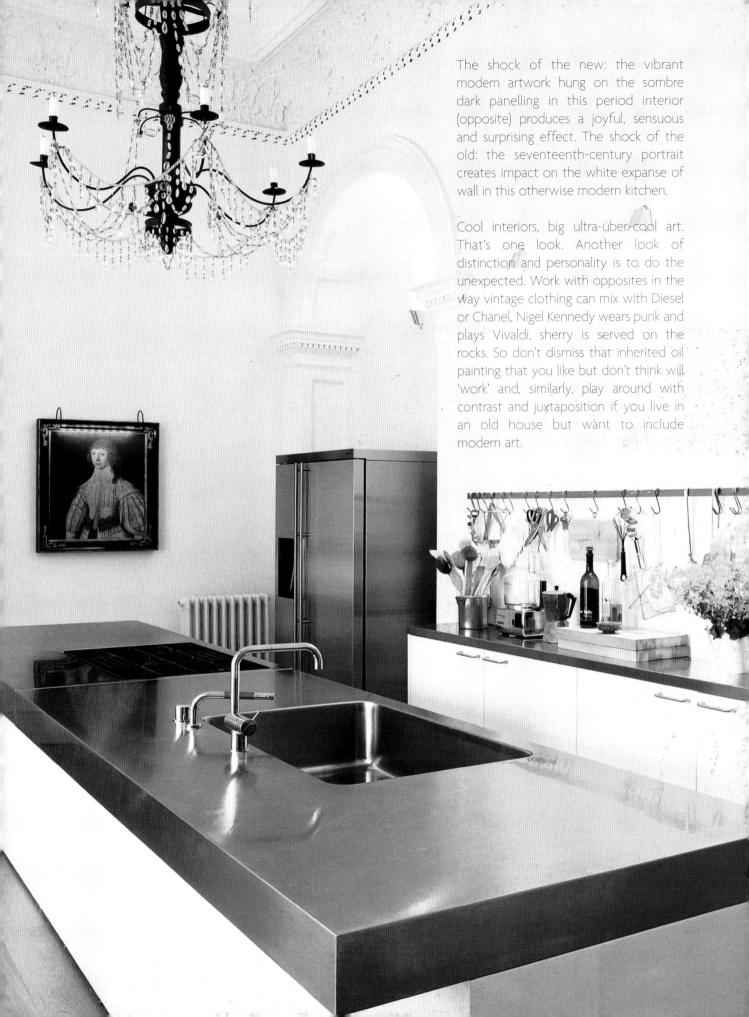

The shock of the new: the vibrant modern artwork hung on the sombre dark panelling in this period interior (opposite) produces a joyful, sensuous and surprising effect. The shock of the old: the seventeenth-century portrait creates impact on the white expanse of wall in this otherwise modern kitchen.

Cool interiors, big ultra-über-cool art. That's one look. Another look of distinction and personality is to do the unexpected. Work with opposites in the way vintage clothing can mix with Diesel or Chanel, Nigel Kennedy wears punk and plays Vivaldi, sherry is served on the rocks. So don't dismiss that inherited oil painting that you like but don't think will 'work' and, similarly, play around with contrast and juxtaposition if you live in an old house but want to include modern art.

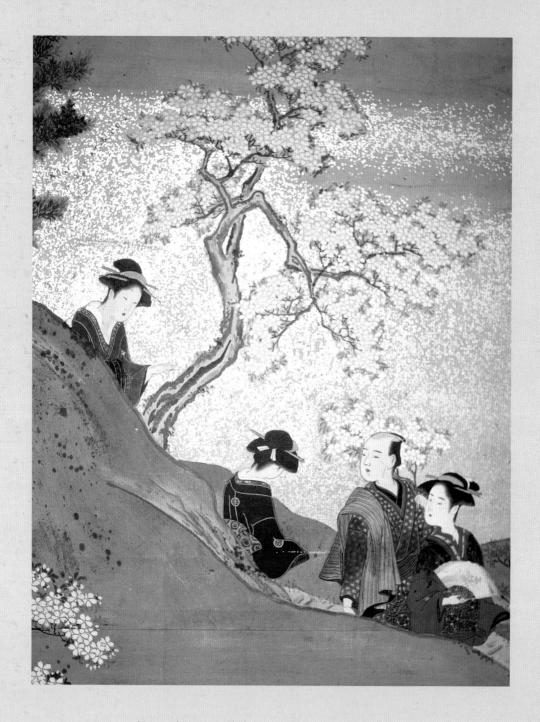

"Spring is the cherry blossom

Summer is the cuckoo

Autumn is the moon

And in winter the shimmering snow

is fresh to the eye."

EIHEI DOGEN (1200–53)

ABOVE: *Spring Blossoms*, Evelyne Boren
OPPOSITE: *Picnic Scene*, Hishikawa Moronobu

CHANGE of season

Originating in China, ceremonial tea drinking and Zen practice came to Japan in the twelfth century. Chanoyu, the tea ceremony, flourished in Japan in the sixteenth century under the aesthetic tutelage of the patriach Senno Rikyu. Scroll paintings displaying the seasons at the tea ceremony led to a long tradition of adapting the display of art to the changing seasons. With each new season, it became customary to change the display of paintings in the home and entertain guests with appropriately decorated ceramics and utensils.

In spring, a traditional feature in Japanese art is cherry blossom, because it is said to remind us of transience. Summer brings feelings of exuberance and energy, whilst autumn is associated with a slower pace and earthy colours. Winter, when nature is dormant, would be depicted in more muted colours .

This idea of reflecting the seasons with our art can work anywhere. As we change our wardrobe and furnishings to complement the change in temperature and light, then why not display our art differently? It gives us fresh imagery to contemplate in tune with the elements we choose to depict.

The photographs overleaf show how one room can evoke different feelings purely by changing the painting on one wall. Table settings and flowers in keeping with the season would enhance the effect.

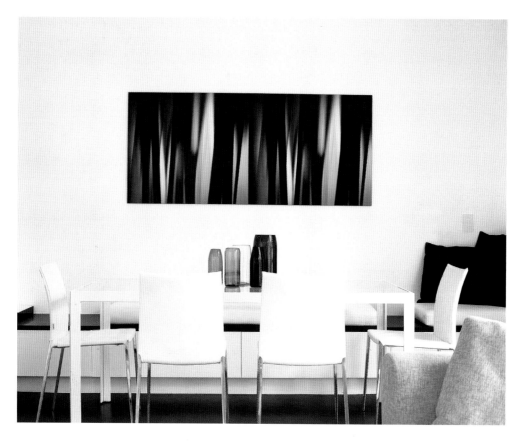

ABOVE; *Waves of Green*, Zara Hart
BELOW: *Dressed Overall*, Chris Lambert

ABOVE: *La Montagne Sainte-Victoire*, Carol Bruton
BELOW: *Nine Feathers*, Simon Averill

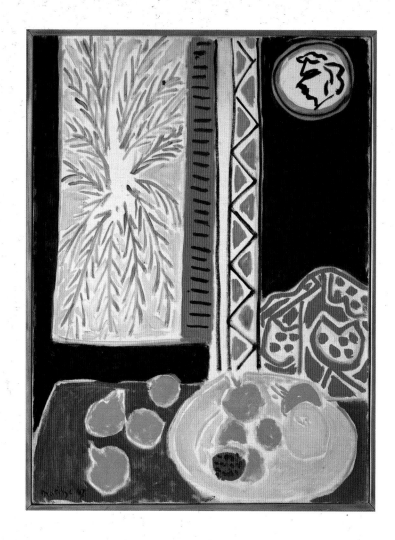

IF you like this picture...

This original Matisse would cost millions of pounds – way beyond most people's budget and, in any case, the painting would, sadly, probably be consigned to a dark, humidified strong vault. However, owning a piece of original Matisse is still surprisingly accessible, as is the case with almost all artists whose original work is highly priced.

"Art should be something like a good armchair in which to rest from physical fatigue." HENRI MATISSE

... you might like these

o Art on paper is a good way to build up a collection of work by well-known or collectable artists whose work you like. In the case of Matisse, you can own an original lithograph from the 1954 edition of his famous cut-outs. The plates for the prints were personally directed and supervised by the artist and his name is signed on the plate. These original prints can be bought for as little as £450.

o Another way of having the image would be to commission an artist to copy an original; these cost between £500 and £5,000 depending on the artist who does the copy.

o The cheapest way to reproduce the image at home is obviously to have a poster. Although posters can have a place in the home, generally speaking they don't have enough punch to hang in important focal places.

o Another option is to work out what it is you like about a certain artist or painting, for example a particular Matisse, and then to look for these dynamics, palette, expression and texture in other paintings – such as those shown above – amongst the wealth of original work on offer to suit practically any budget.

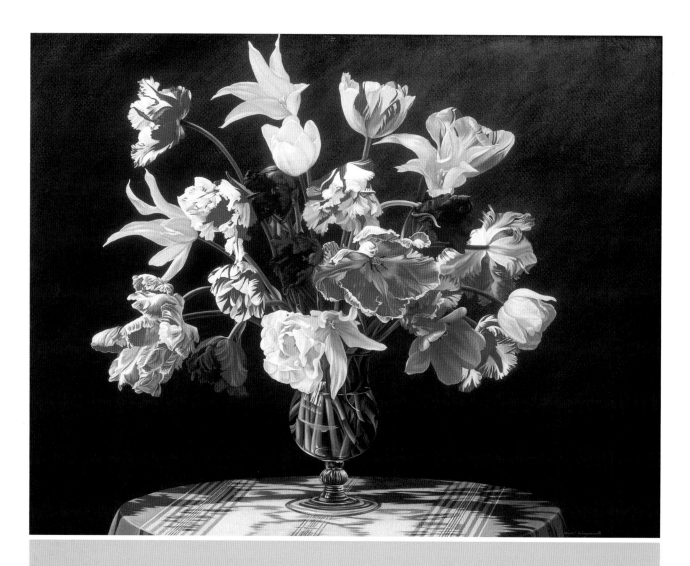

FLOWERS in art

In the sixteenth century, apothecaries and herbalists relied on paintings of flowers and herbs to identify plants used in medicine. The detail was vital and could make the difference between life and death, hence the development of botanical drawing.

By the time of the infamous tulip bulb crisis in 1637, new and rare flowers, like new and rare artworks, had become the status symbols of affluence and refinement; and this in turn created a market for high-quality botanical illustrations. It became fashionable for the rich or sophisticated to commission or buy paintings of newly pioneered species of flowers. This was especially evident when a variety of flowers were painted in an arrangement that never existed – since the plants and flowers depicted all flowered at different times.

An inherent love of flowers continues to rank highly in our choice of art. Whatever your taste and budget, you can enjoy seeking out an arrangement and medium to suit you.

OPPOSITE: *Tulips on Silk Ikat*, Nigel Waymouth
BELOW LEFT: *Tulips*, Georgia O'Keeffe
BELOW CENTRE: *Cala Lilies*, Nigel Waymouth
BELOW RIGHT: *Orchid*, Bill Pryde

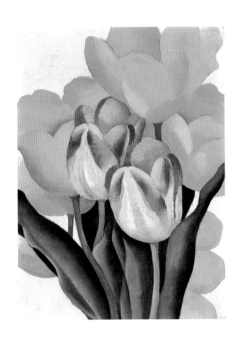

CHOOSING a genre

Historically, subject matter in painting tended to biblical or mythological stories or allegorical scenes. Division into categories of painting – still lives, landscapes, portraits, botanical paintings and so on – developed as a result of changes in society at different periods.

In the seventeenth century a decrease in religious painting and its patronage in Holland, following independence from Spain, stimulated development in what was later termed genre painting. This, essentially, refers to painting that reflects everyday life and its setting, including conversation pieces and *genre* portraiture. The main characteristic of *genre* painting in this context is that it does not represent idealism but reality.

Genre in a more literal meaning refers to a choice in art, a variety, flower painting being one of them. Finding a genre that appeals to you can give a unifying meaning to a collection. Within any genre there is an infinite amount of artists from which to choose. At large art fairs or whilst gallery hopping, it can be helpful to search out a specific genre – it helps concentrate the eye in an otherwise potentially overwhelming display or choice.

"*There is no must in art because art is free.*"

WASSILY KANDINSKY

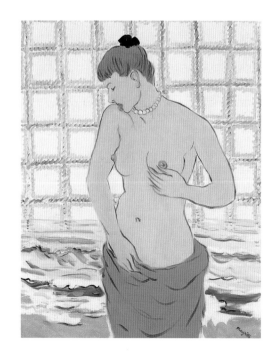

ABOVE: *Collage*, Nancy Howard
RIGHT: *The Pebble*, René Magritte

CREATE your own art

Another way of including more art in your home, without spending a fortune, would be to generate it yourself. This has the added bonus of allowing an outlet for your own inherent creativity.

In the bathroom featured below, the owner had been given an orchid and decided it needed a more contrasting backdrop than the pale wall. By putting a plain painted red canvas behind the orchid it immediately created the illusion of a piece of three-dimensional art.

Aspects of your life can be woven into a collage. In her Mexican-style kitchen, artist Nancy Howard has included pieces of art, memorabilia and photographs, including those of her parent's wedding in Cuba, into a piece of original wall art.

Paintings are copied for many reasons – not just to recreate a painting for pleasure, but also for insurance purposes, or to replace an original if it has been damaged beyond restoration.

There is, it is true, nothing like the real thing, but the real thing is not always affordable – as in the case of the René Magritte painting (opposite). This copy was painted for a client who loved the original and chose to commission a painted copy to hang in her bathroom rather than buy a reproduction poster.

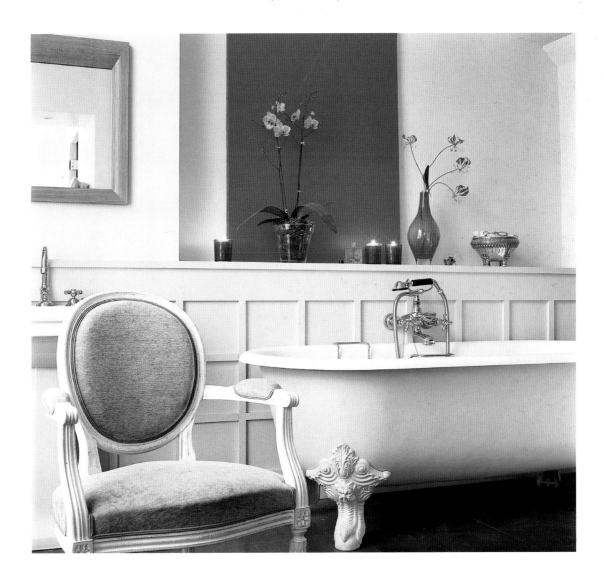

MEMORIES

Personal treasures come in all shapes and sizes and are too often hidden away in boxes and lofts.
Combining selected treasures to weave into a piece of art gives them new life. An anniversary or
special occasion could be commemorated by the commission of an original piece. Give the artist
symbolic objects and ideas – even memorabilia to make the piece three-dimensional. The medium
can be as varied as the subject: painting, photography, sculpture, collage or mixed media.

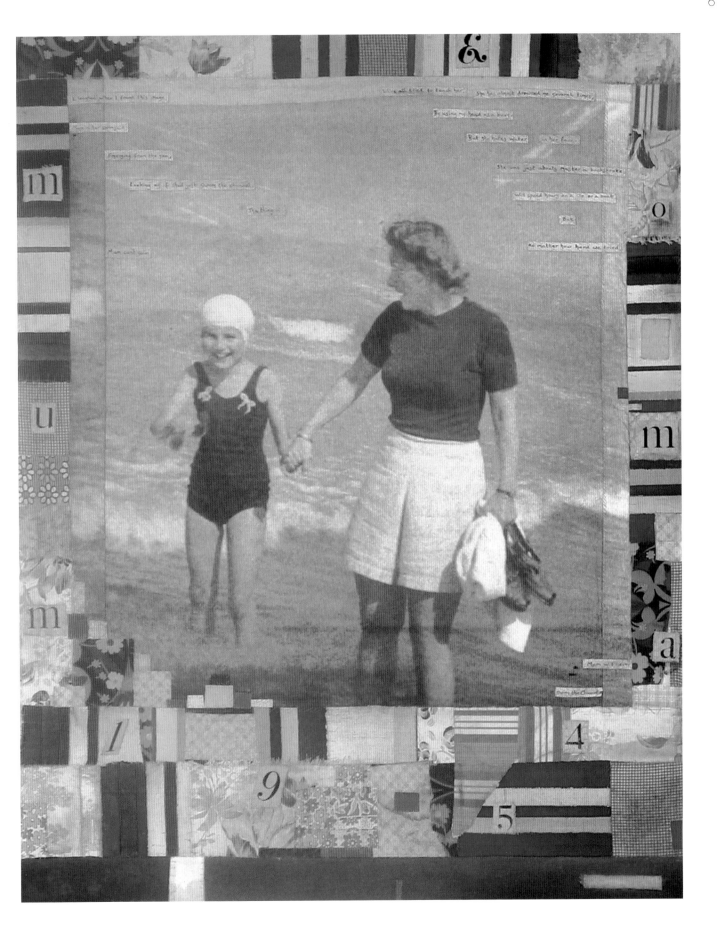

COMMISSION a portrait

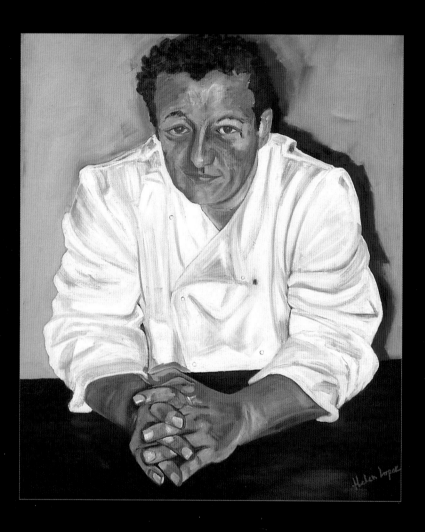

In commissioning a piece of art you are gaining something unique and personal. There is no limit to the way in which the subject can be represented (except budget and imagination). Unless you already have a clear idea of the style you like, or you have a particular artist in mind, the best way to concentrate your search is by going to as many contemporary exhibitions as possible – the internet and catalogues are fine for reference but there is no substitute for seeing live art.

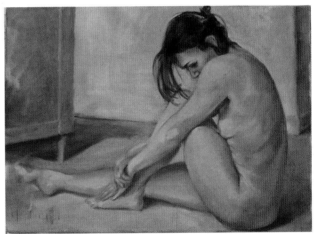

TOP LEFT: *Watching the Waves*, Mark Pearson
TOP RIGHT: *De La Huerta Dogs*, Lisa Dalton
BELOW LEFT: *Sanjay and Rinchin*, Nigel Waymouth
BELOW RIGHT: *Nude No 3*, Sally Miles
OPPOSITE: *Chef, Beaumaris, Anglesey*, Helen Lopez

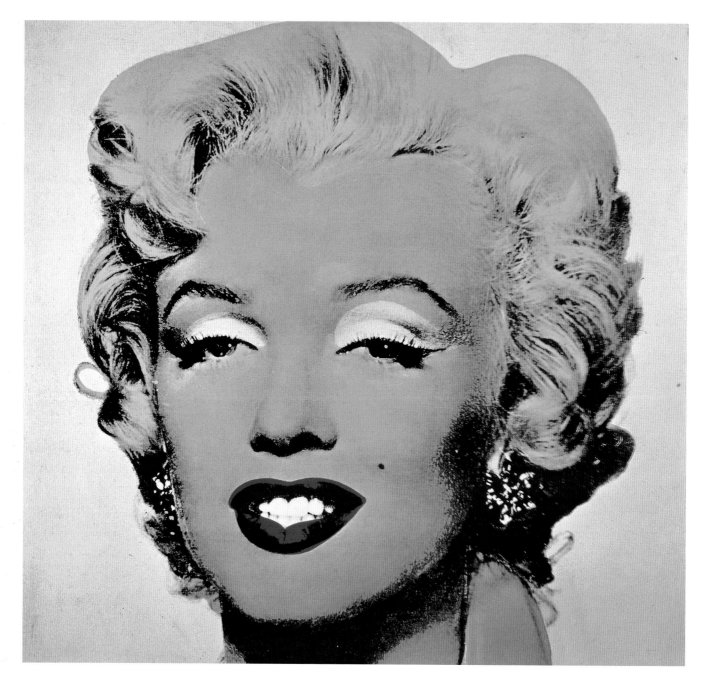

ABOVE: *Marilyn Monroe*, Andy Warhol

CREATE digital art

If artists have any responsibility to reflect the times they live in, then Andy Warhol, American artist and one of the creators of Pop Art, certainly did that. With his iconic figurative images of Marilyn, Liz and Elvis, and his realist images of Campbell's soup and Coca-Cola bottles, Warhol transformed the hot date of graphic design into a consummated marriage with art.

Digital art has been around for about fifty years – since designers have had access to computer programmes central to their work. Some of the pioneers in digital art were not primarily artists, but their visual explorations became vital to the medium that emerged. Software for computer-generated graphics gradually became available and attracted artists who could create original art works in the medium. The art form continues to grow alongside the development of computer technology and software.

There are programmes now available by which you can transform your own digital photographs, either taken by yourself or commissioned, into an original portrait influenced by the style of Andy Warhol, as in the portraits on the wall above.

CREATE snap art

Everyone has photographs of friends, family, homes, travels – of people or times in their lives that are important. The art of the photograph itself depends on the skill and the artistic eye of the photographer. Most photographs taken for love or fun tend to be put in albums or displayed in small formats. Much greater impact can be achieved by scaling up selected images. The end result is a work evoking a different kind of response.

The large-scale photograph in the room on the right creates a contemporary and personal take on the tradition of displaying ancestral portraits. Taken with the intention of becoming a wall piece, the owner asked a friend to take a photograph of her with her two daughters playing in the park. The pose was deliberately kept natural and the blossom was included to give the effect of floral wallpaper.

A local high street fast-photo shop did the processing on a type of foam board that is usually used for exhibition displays. Her advice is to blow everything up large (this is reproduced on three panels, each 240 x 90cm) and not to worry about the quality, in fact the grainier the better – think pointillist/impressionist. Close up, you will see bite-size images, but when you step back the joy of a complete picture presents itself. Black-and-white will always look stylish.

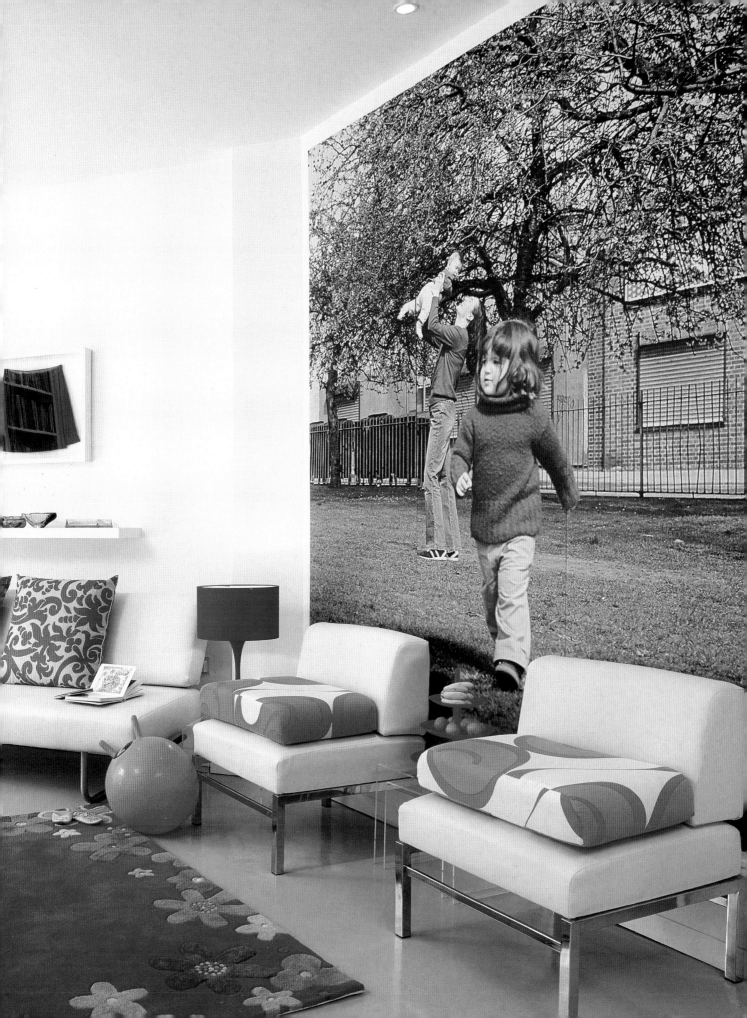

WHERE we put our art

Displaying art on a grand scale in opulent interiors has been a feature in wealthy society since the Renaissance, when domestic interiors reflected cultural expression. Nobility and art patrons vied with each other to commission and display art. At the beginning of the nineteenth century the British architect Sir John Soane combined his architectural flair with an art collection influenced by his years spent in Italy and set a new benchmark in integrating art in the home. By the end of that century, rich Americans were displaying their newly acquired wealth in lavish houses epitomised by the Vanderbilt family homes in New York and Newport. The twentieth century modernist movement, and developments both political and technological, led to the notion that collecting art could have other, more philosophical motives than showing off wealth or social status. Whilst displaying art at home on a grand scale remains the domain of the very rich, collecting and displaying art as a means of embracing new ideas and expressing personal taste is now within everyone's reach. Art can be anything we want it to be – simple, sophisticated, intellectual, emotional.

Art is to be lived with and the main criterion for collecting and displaying it is enjoyment. Each of us has needs and desires, but there are basic spaces we all require: a space to sleep, a space to prepare food, a space to eat and a space to wash. Other living situations include places in which to greet and entertain; to study and work; to relax, read, listen to music or watch television; to share with children and where children can play.

Tolstoy believed that the primary function of an artist is to express and communicate emotions to an audience. "To evoke a feeling one has experienced oneself, by means of movements, lines, colours, sounds or forms so as to transmit this feeling – this is the activity of art." The spaces in our homes are for feelings as well as functions, and our choice of art can inform and determine these feelings.

This chapter gives some advice about how to sort out which art goes where. Each area of the home is considered in terms of its function. Of course there is an overall flexibility – the laptop can go to bed, you can sleep on the sofa – but as a general guide this is to help concentrate on the different impact art can have in these differently attributed spaces. Alongside the function of each space, consider the atmosphere or emotion you would like to evoke in each place – restful, joyful, stimulating, inspirational and so on. Nowhere is off limits for art – displaying it, even in unexpected places, gives personal expression to your home.

OPPOSITE: *With Out Title,* Miguel Macaya

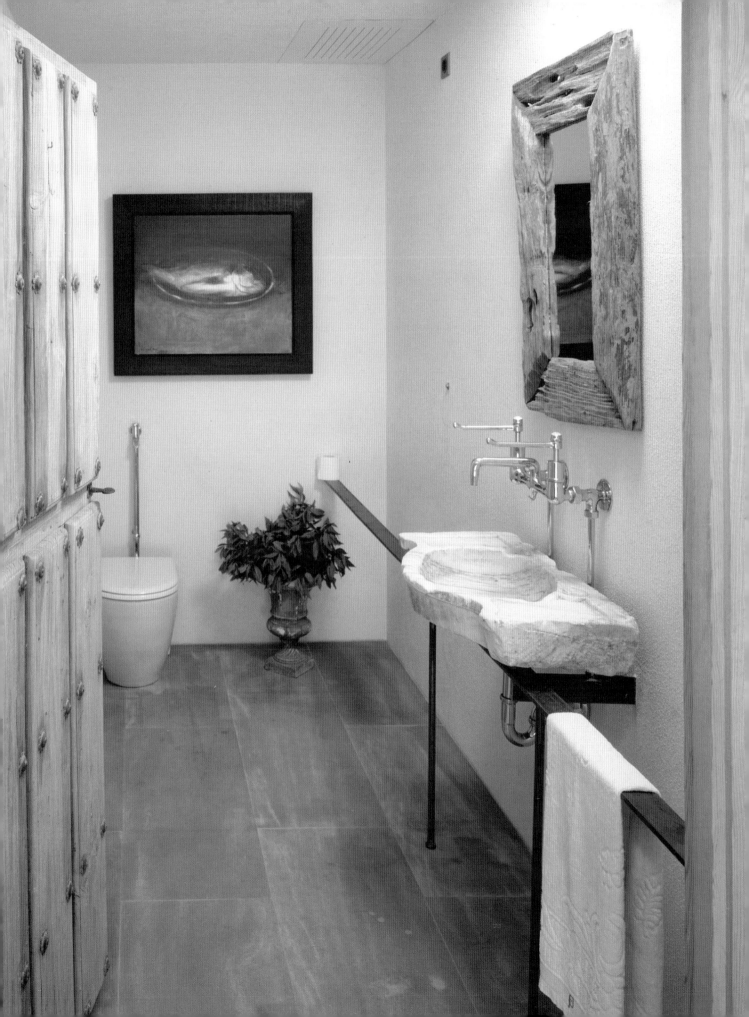

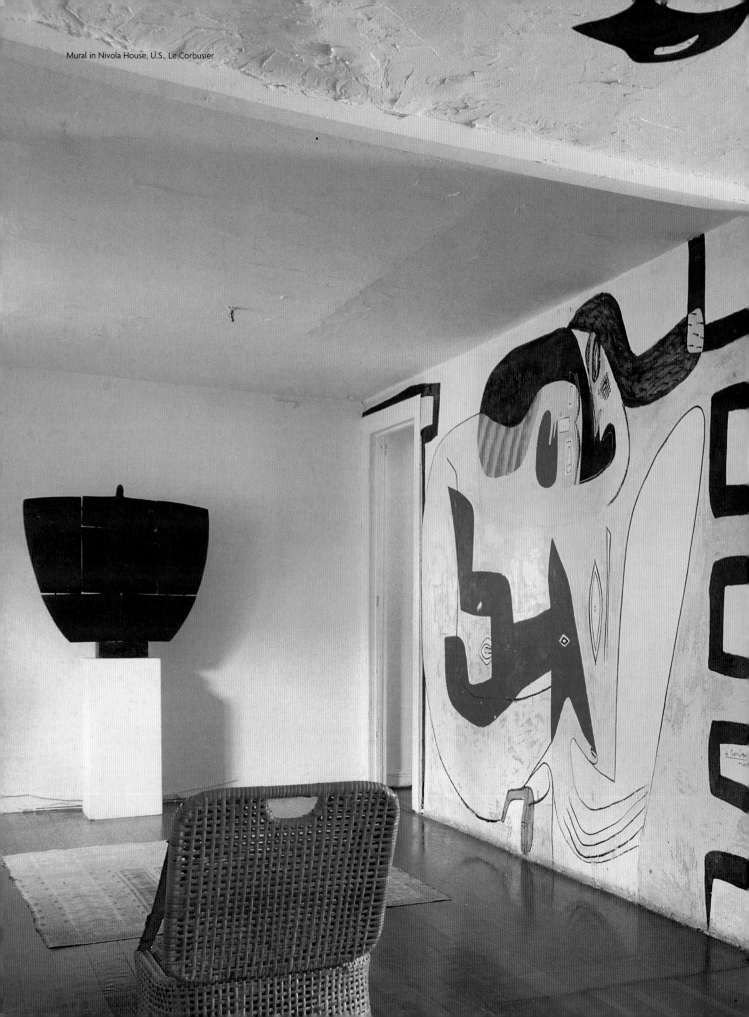

Mural in Nivola House, U.S., Le Corbusier

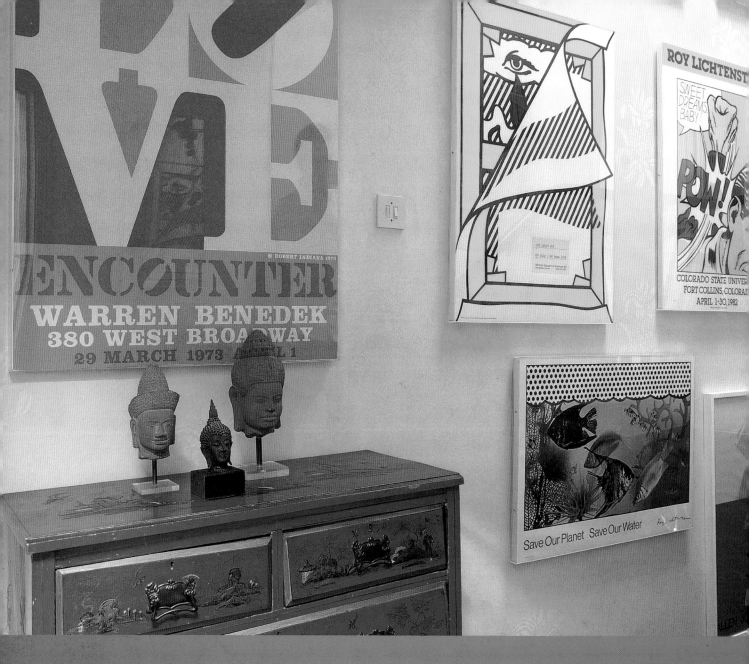

GREETING spaces

There are some points to consider about halls and other entrance areas. Since they don't count as contained rooms it would be easy to dismiss these areas merely as transient places in the home. But no matter how tiny or how palatial the space that greets you as you step inside someone's home, this is the first impression you have of that person's private space.

In contemporary western culture, the hallway is a place of greeting (and farewell) and as such, despite its relevance in creating the warmth of your hospitality, it is not a place where people linger. In Japan the traditional home had clear guidelines for displaying art or artistic elements such as the all-important flower arrangement or 'ikebana'. A visitor who called unexpectedly would probably decline an invitation into the home out of politeness, so the hallway would act as a half-way house. For this purpose a piece of significant art would be displayed here.

In general, the objective is to create an ambience of the kind of hospitality you wish to communicate; your choice of art will be indicative of your style. Try to keep a clear bit of wall space here so that at least one painting, piece of sculpture or group of pictures can be displayed. Not only is it one of the first things to be noticed when entering a home – it is also the last.

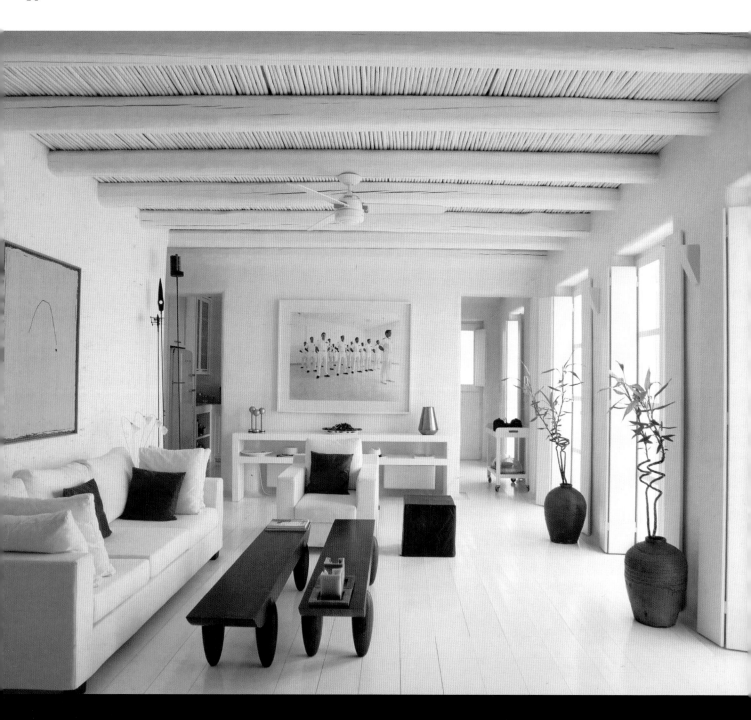

FOCAL points

The wall or area opposite the entrance of a room is the most important focal point so should be the first to consider, but, if taken up by windows or some other obstruction, the only appropriate

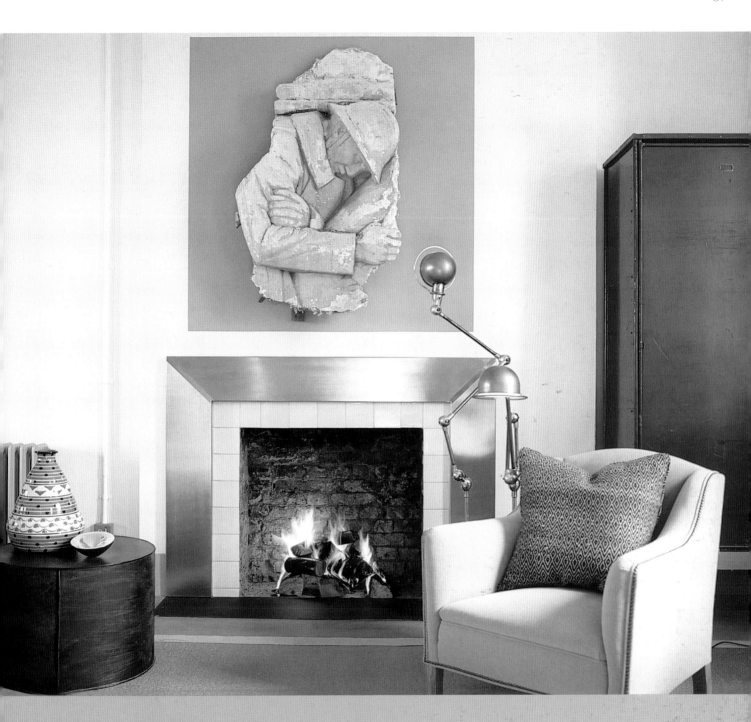

Traditionally, the area over the fireplace is a strong focal point, not only visually but because people gather around it. If the fireplace is used there is the possibility of smoke or great changes in temperature, which could affect an unprotected piece of art. Consider changing the art, so that in summer a more fragile piece of art can be placed here and in winter a more robust piece.

Having identified the focal point in any room, the choice of art will follow. In these two very different examples, both focal points are used to good effect. At the end of the room on the left, the large painting has movement in it, which gives the room a lively feel and invites you in. On the right the art and its complementary furnishings are evocative of a mood; the relief has interest and is a conversation piece – as all art can become when it is expressive and prominently displayed.

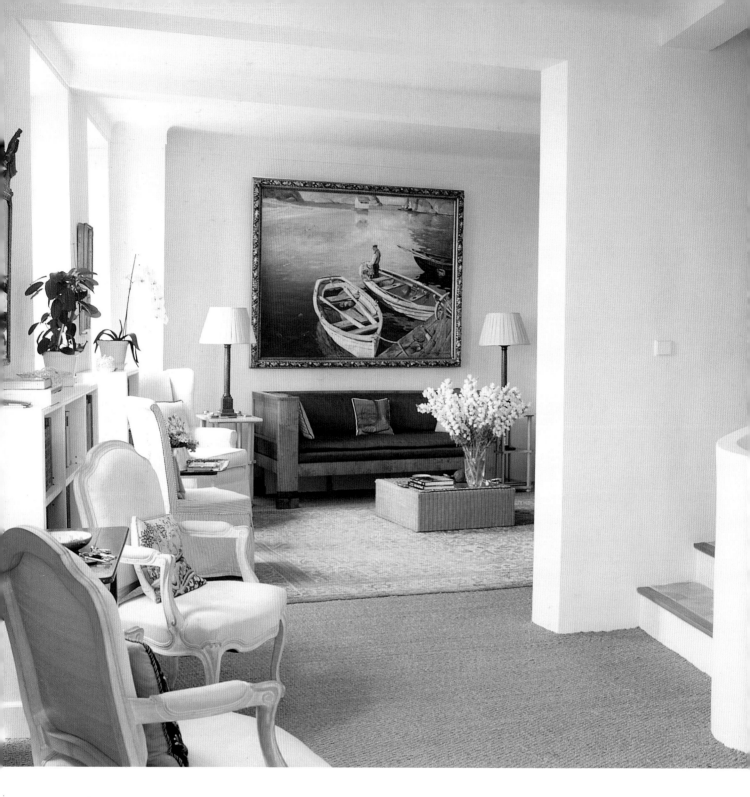

ART to draw you in

When glimpsed through an open door, or at the end of a corridor, the impact of a painting can draw you in like a welcome. Art will entice you for different reasons: atmosphere, mood, subject matter, colour, texture or material if it is sculptural. These are all aspects to consider when deciding where to place your art.

RIGHT: *Three Shapes on Light Red, January 1962,* Patrick Heron

The permutations of a painting itself are myriad – the effect can change according to our mood, depending on the light on the day or time of the year, or from natural light to artificial light. In the dawn, light blue is the first to show its hues and reds tend to stay dark longest. It is fascinating to enjoy all these changing aspects of a painting and another point to consider when placing it.

It is also rewarding to see further into a painting to which we are initially drawn. To understand something of the artist's intent is to share in this expression when putting it in the home. Other people who visit our homes will enjoy seeing the painting or piece of art through us.

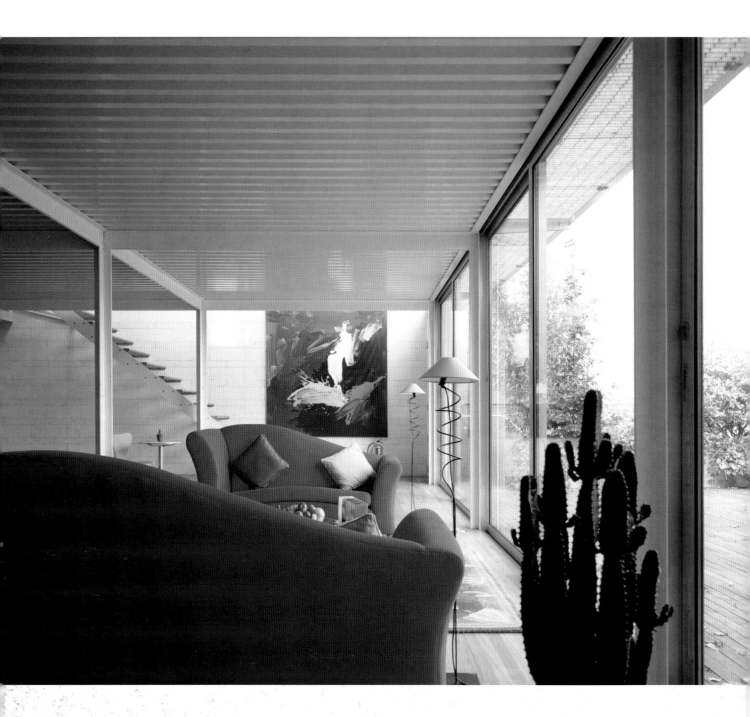

BRINGING the outside in

If you are fortunate enough to have large windows and expansive views, or wish to integrate the area outside with the space within, then you need to balance the interior and exterior so that they complement one another. If you only focus on the view, then in the evening when it is blacked out you are left with a less rewarding interior.

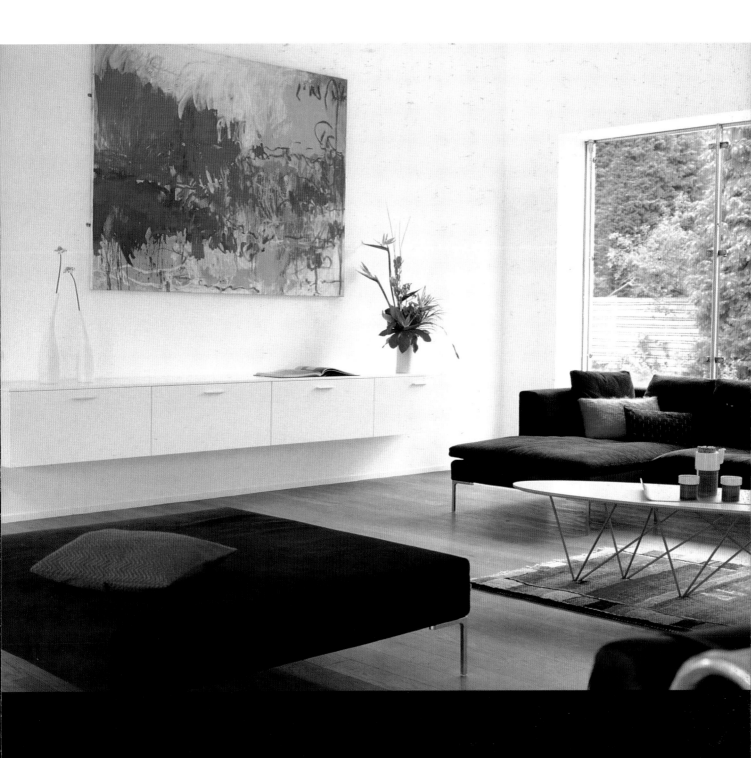

Conversely, if the work of art is fragmented, or too small, it can fight or be lost next to a large windowed view. The painting in the interior above has wonderful natural light from the large windows and no cluttered view to fight with, allowing the viewer's attention to focus on the image itself before being directed outside. The painting in the living room on the left is well displayed at the bottom of an airy, light staircase, where its colours harmonise with the furniture and the vegetation outside.

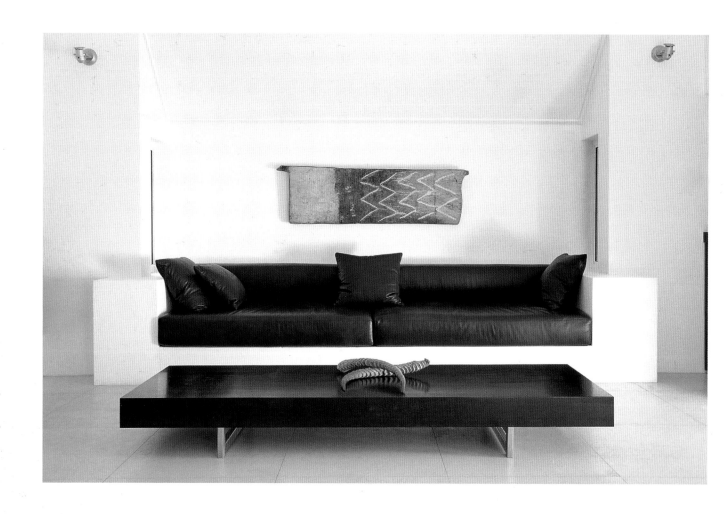

POINTS of view

The perspective of a room will alter depending where you place your art. Paintings will show different facets according to the light, the scale of the room and what is placed around or next to them. When a painting or a piece of art is in the 'right' place it adds to the harmony of a room.

Where possible, follow the proportions of the space that a wall provides. The central position of the piece in the room above is pleasing because it follows the lines of the architecture. The wall, and the room itself, have become an extended frame to hold the carved wooden door from Mali hung horizontally above the sofa.

There is variety in the positioning of the pieces of art in the room opposite. Attention has been paid to viewing

positions as well as to the scale of the room. In this case the painting behind the sofa would not have worked as well in the centre of the long wall. Instead, it has taken up a natural space described above the table, where it can be viewed close-up from a standing position as well as enjoyed from the chair opposite.

As we take time to read or listen to music, so we can take time out to enjoy our art – in different lights and moods.

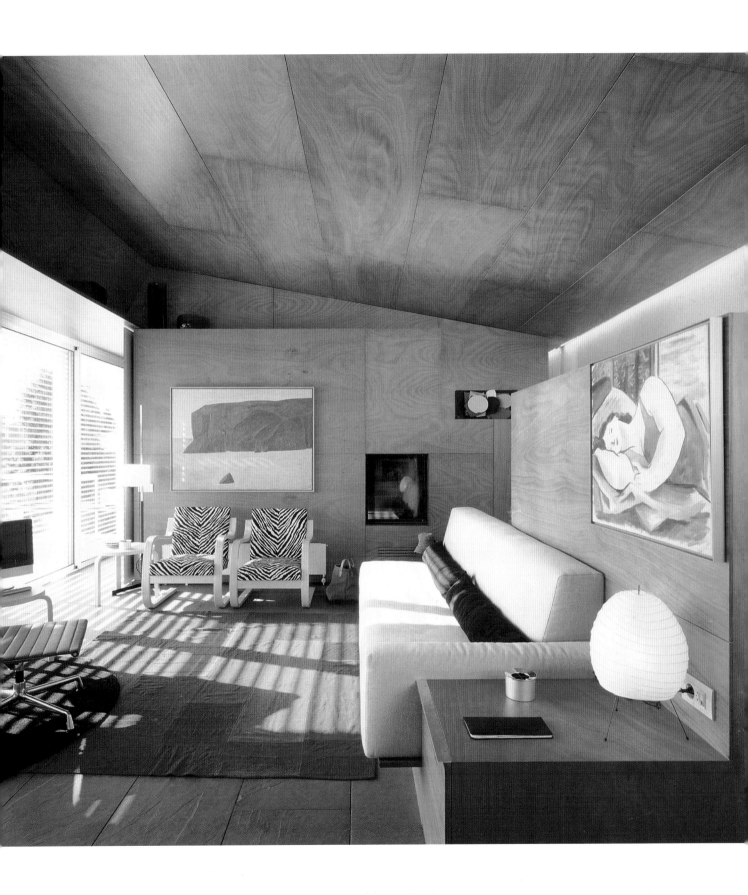

LEFT: *Ascending and Descending*, M.C. Escher

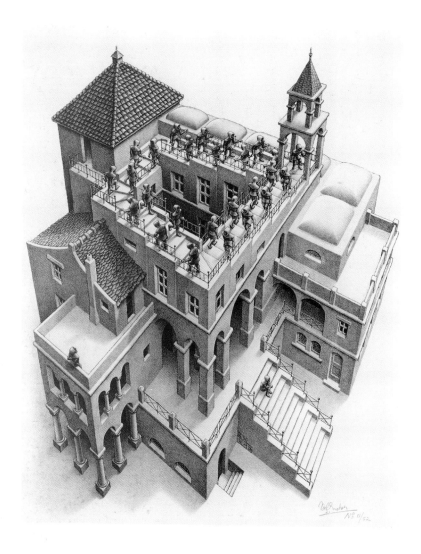

ART to think on

Some people do warm-up exercises for their minds before starting an intense piece of work. The right side of the brain deals with instinct, emotion and intuition; the left side, with intellect, language and reason. A piece of art such as the engraving by M.C. Escher can be enjoyed on many levels: as an intellectual puzzle as well as an image on which to meditate.

In general, education favours left-brained modes of rational thinking through logic, analysis and accuracy. In order to develop more 'whole-brainers' (and therefore more balanced individuals) in society, schools and colleges need to give extra weight to right-brained activities by teaching skills in subjective thinking, imagination and creativity. One way to do this is through a better understanding and appreciation of the arts.

Accessing art via mathematics (and vice versa) is a fascinating route and furthermore forms an axis between the right and left brains. To see this in action we can study the visual portrayal of mathematical analyses, such as the art in the picture opposite. The precise images of mathematical notions in quantum mechanics, deterministic fractal geometry or tridimensional displays of random intertwinings are as complex as they are beautiful.

"So let us then try to climb the mountain, not by stepping on what is below us, but by being pulled up by what is above us: for my part, the stars."

M.C. ESCHER

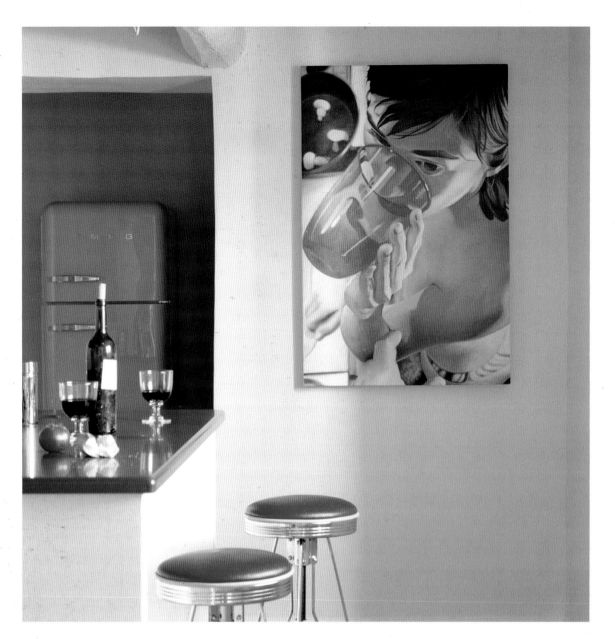

ABOVE: *Que Tens Sed*, Josep Moncada
OPPOSITE: *Orchard Tambourines*, Terry Frost

ART to cook with

Feast your eye as well your palette. The atmosphere in the kitchen is usually informal and in most houses it is the heart of the home, but with all the activity and equipment in them they can have an air of clutter. It's a great antidote, therefore, to find a space that can be dedicated to art.

Seek out art that reflects the atmosphere you wish to create or enhance. You might find this in the colour, movement or .texture of a piece – it might be in a figurative painting, a still life depicting food, or an abstract piece of art. Alternatively, you could recreate the atmosphere of another place, or the kitchen's decoration could be influenced by the work of a particular painter or painting.

BELOW LEFT: *Harmony I*, Gail Lilley
BELOW RIGHT: *Gold Still Life*, Richard Winkworth
OPPOSITE: *Seed*, Richard Larsen

ART to dine on

When people move to the dining area the table is usually laid and groups gather to eat, drink and be merry. An air of conviviality can be greatly enhanced by art works that reflect the hospitality of the home; they can also stimulate good conversation.

Consider the ambience you would like to create when selecting your art, whether sourcing new work or moving your own pictures around. When trying out work to hang in a certain place you can use a photograph to see how it will look. This can be particularly useful when you can't position the actual painting in situ. Take a photograph of the work and print it out in standard format, then stand at the entrance to the room, hold the photograph at arm's length against the intended wall and close one eye. This will give you an idea of how the painting is going to look when hung.

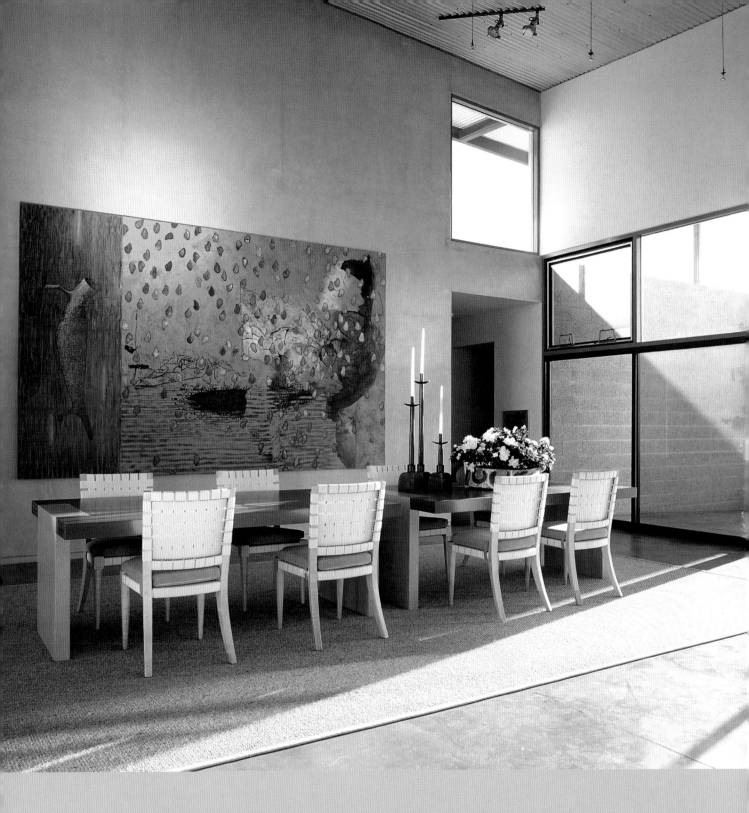

"If music be the food of love,
then art is the wine of life."

(Apologies to SHAKESPEARE and RICHTER)

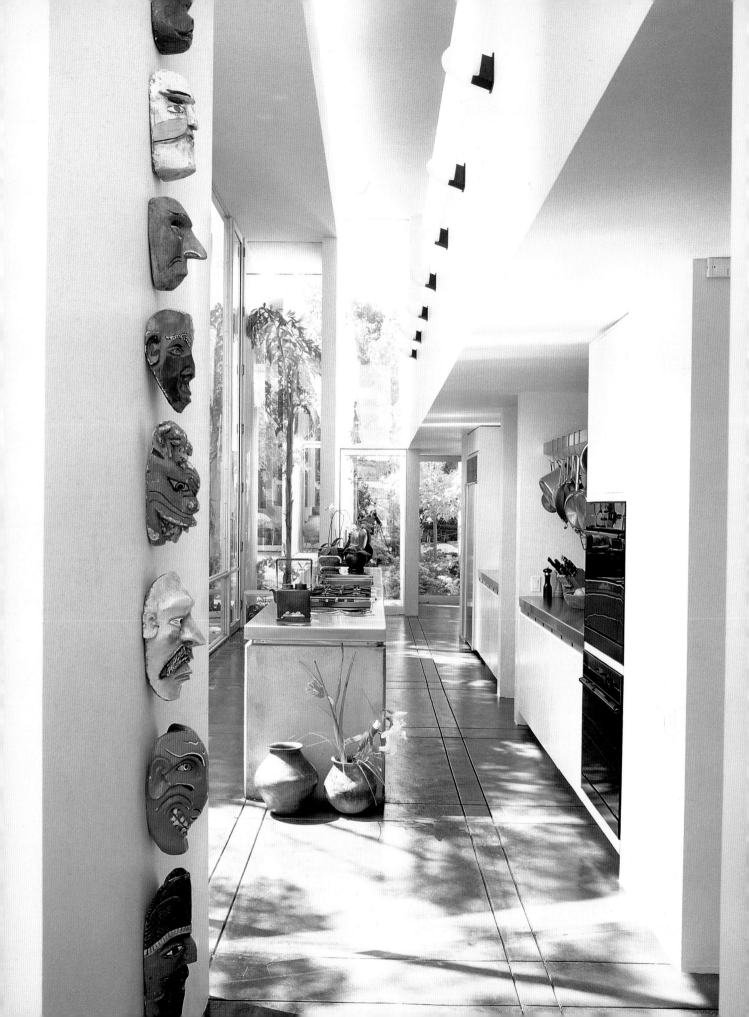

NATURAL gallery space

There are places in all homes that offer a 'gallery' space. Corridors are an obvious choice, though sometimes overlooked because of the lighting. Even without natural light, lighting can be introduced to extend the home gallery. The temperature tends to be cooler and there is less chance of direct sunlight, so corridors can also be a good choice for more delicate works. The size of paintings displayed depends on the width of the corridor, how far you can stand back.

Ideas for these spaces include a collection of personal memorabilia, the work of a particular artist, a themed collection in a particular style or genre, or children's pictures. The owner of this house in California (left) has a collection of folk art from different countries; the walk-through to the kitchen provides a natural display space.

When visiting galleries, see how work is displayed that might suit your own space. Pick up postcards of paintings you have enjoyed. Visual reminders are another way of educating your natural 'eye', of selecting what you like. When it comes to sourcing new work you will have useful information and ideas.

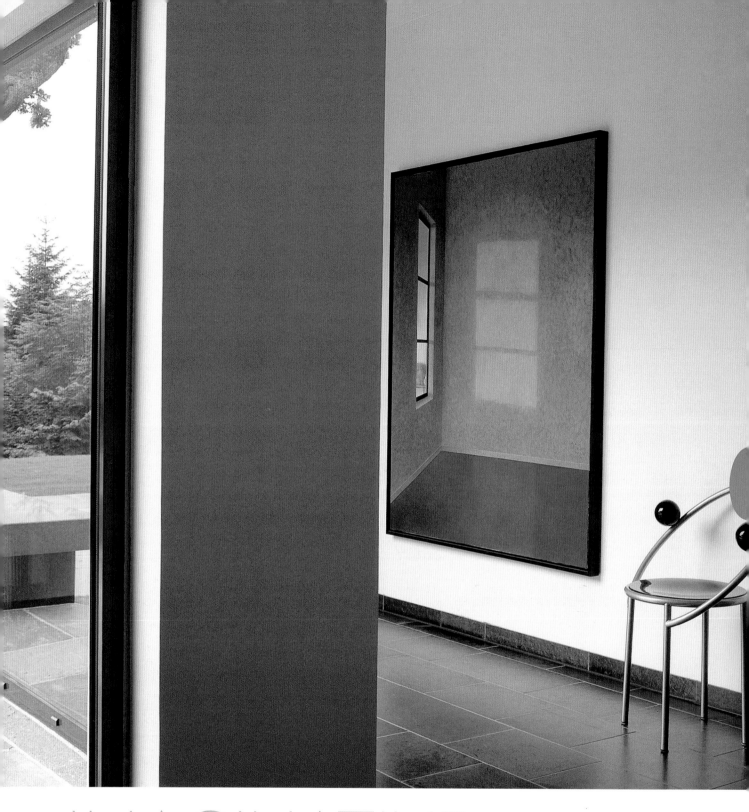

IMAGINATIVE placing

Mystery in art provides fascination: the meaning does not always need to be apparent and a search for significance is not necessary in order to enjoy such paintings. Sometimes it's good to allow the mystery to remain, enjoying the strangeness as we do in our dream world.

"Art evokes the mystery without which the world would not exist." RENÉ MAGRITTE

OPPOSITE: *The Dead Past Lives Again*, Ida Lorentzen
RIGHT: *Empire of Light*, René Magritte

The painting in the architectural space opposite is beautifully positioned to show off its perspectives and shadowing. At first glance it is hard to see where the fantasy of the painting and the reality of its setting divide. In the evening, when the natural light has faded, the painting takes on some of the elements that are in the painting above, in which night and day are curiously combined in one image. It is rewarding to play with perspective and light within the space and architecture in our homes. Art can give this emphasis.

O︎N the move

Stairwells offer another natural gallery space both on side and facing walls (see also page 130). Two very different styles are shown here, but in both cases the space is used to good advantage. An additional benefit to putting art in such spaces is that it causes the viewer to take the stairs at a slower pace.

The antique piece (left) gives wit and aesthetic drama to the staircase in this Parisian home. The photograph (above) is a softer and more informal approach – a happy reminder of a child's early steps. When choosing art to put alongside staircases, in stairwells or on landings, consider also the change of mood from floor to floor.

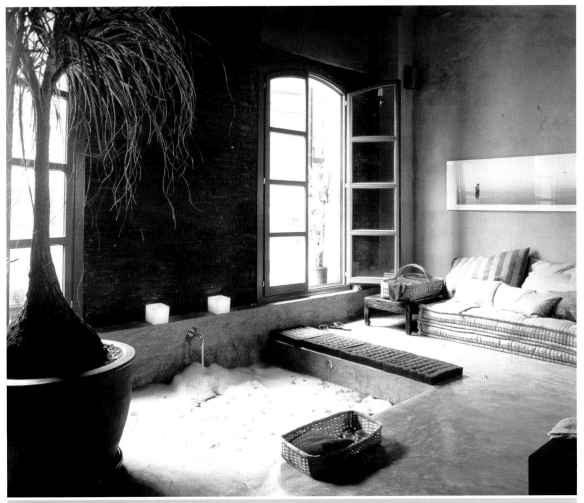

o Since the atmosphere will have a high water content, frame the pieces well. If they're paper, use archival quality mounts and seal the backs.

o If the art work is made of porous material, such as a plaster or collage, it would be best to add a coat of polyurethane.

o A practical and artistic option in a wet room would be a commissioned mosaic to take the place of traditional tiles.

ART to soak in

When choosing art to place in a bathroom, decide what this particular room means to you. Is it a shared family bathroom? Is it your private spa, a haven within which to escape and meditate? Is it a wet room or sports refresher with power shower? Or perhaps it is the master bedroom's private bathroom – the perfect space for a commissioned nude of your wife/partner/husband.

A bathroom has an obvious association with water that could be reflected in the choice of art, as in the two bathrooms shown here, where black-and-white photography is used to good effect. Whatever you choose, don't miss the opportunity for a wall of interest or originality. After all, the *Mona Lisa*'s first owner, François I, hung Leonardo da Vinci's famous painting in his bathroom.

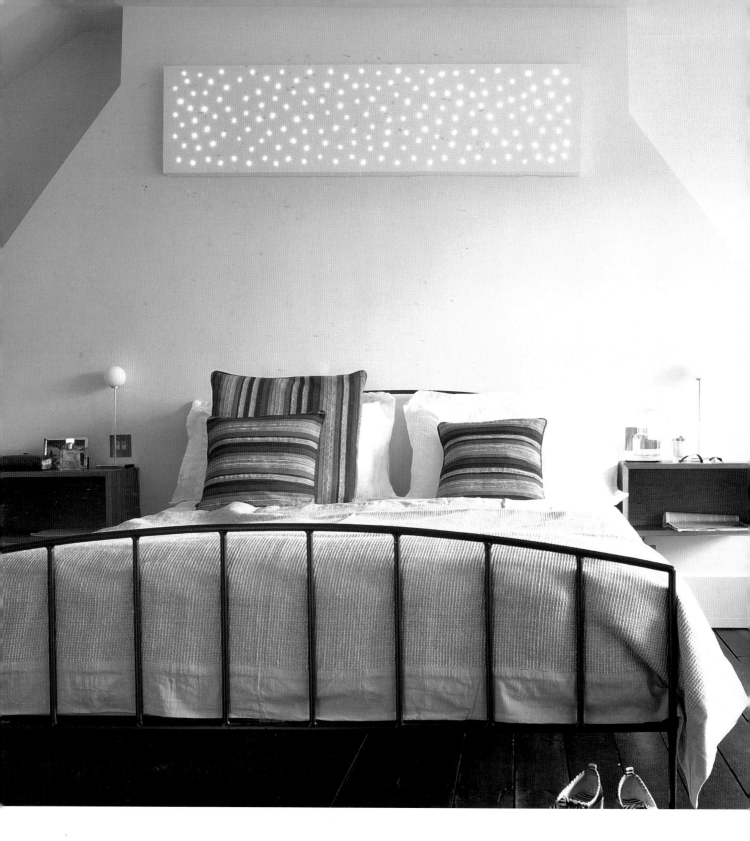

ART to sleep with

Mood and ambience combine to help us relax and sleep. Choose art that invites you in and helps you shut out the day – art that can glow, even in the dark.

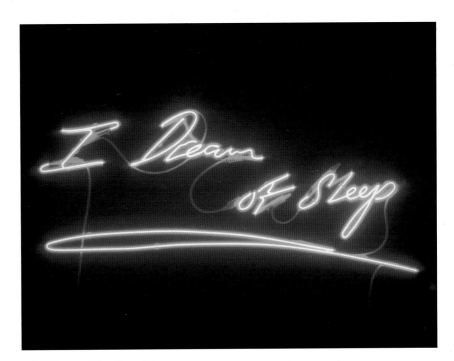

ABOVE: *I Dream of Sleep*, Tracey Emin
OPPOSITE: *Supporting Brothers*, Mike Speller

Tracey Emin's neon sculpture (right) is as inspiring as it is beautiful. The sculpture in the bedroom (left), provides shape and texture. The changing light through the night and early morning provides shadows and different images, making the art unrestricted in its appeal.

RIGHT: *Blue Angel*, Marc Chagall
BELOW: *The Sleeping Gypsy*, Henri Rousseau
OPPOSITE: *Dreaming Girl* (in the style of Picasso), Holly Freeman

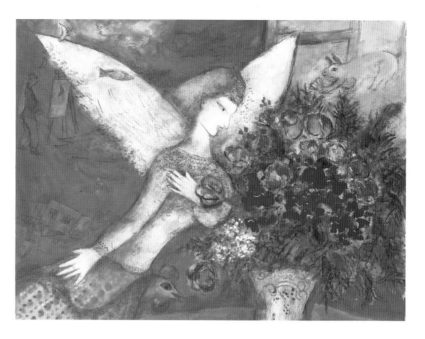

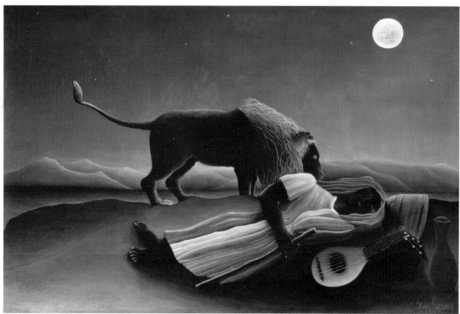

ART to dream on

When dreaming, the body, mind, and spirit are unified. Dreams provide us with insight into ourselves and a journey of creativity, magical thinking, and exploration of the unconscious; a journey into a world where the rules of reality do not apply.

People in primitive societies were unable to distinguish between the dream world and reality. They not only saw the dream world as an extension of reality, but that the dream realm was a more powerful world. Artists connect with this realm through their creativity and so, via them, do we. Choose your art to choose your dreams.

"*We are such stuff
As dreams are made on and our little life
Is rounded with a sleep...*"

WILLIAM SHAKESPEARE, *THE TEMPEST*

ART of the senses

Exquisite, softly lit art can create an ambience of sumptuous relaxation. If the room reflects the art in texture, sound and smell you will have a place of tranquillity and sensuality. Appealing to a combination of senses will achieve synaesthesia – a sensation produced in a part of the body by stimulation of another part. No place here for pressures of work and life. This is a care-free zone.

BELOW TOP: *Life Study of the Female Figure*, William Edward Frost
BELOW BOTTOM LEFT: *Earth Goddess*, John Parsons
BELOW BOTTOM RIGHT: *Red Hill, White Shell*, Georgia O'Keeffe
OPPOSITE: *Still Life with Lillies*, Steve van der Merwe

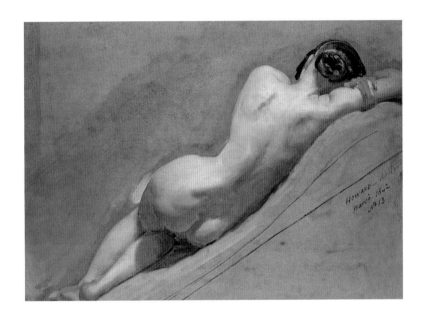

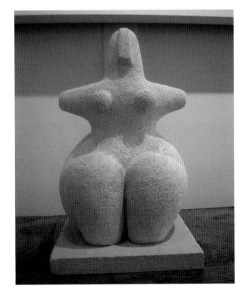

"Fine art is that in which the hand, the head, and the heart of man go together."

JOHN RUSKIN

TOP: *The Leopards*, Daphne Stephenson
BELOW: *Jungle Jet*, Jacques Coetzer

ART for children

In the same way that children are influenced by sounds, music, films and light, so art also makes an impression on their developing senses. The art in children's rooms is what they look at when waking and before sleep; it is also associated with parents and play. So choose art that will inspire, amuse and/or inform a child and make a conscious or subconscious impression on them. Here are some factors worth considering when putting art in a child's room.

o Involve the child in the choice of art. It is a way of helping them learn to express themselves.

o Make a large board for pinning up pictures that they can select from magazines and other diverse sources. Encourage them to produce their own art. Some pieces can be pinned on the board. Help them to choose one or two key pieces that you will have framed or displayed. The framing, presentation and hanging will lift it from being perceived as classroom art and this can often inspire a child to develop artistically.

o Children's art is revealing and appealing because it is unselfconscious in its simple expression of their view of the world.

o Encourage good art from the start – especially from generous godparents and friends who are interested in art themselves.

HOW to display your art

Our homes are like extensions of ourselves and, as we dress our bodies, so we dress our homes. When we look at pictures of interiors we see static images frozen in time and space. Our homes are not like that, they have life and energy observed as we move through the space, whether it's a single studio room or a house made up of many different rooms. Art displayed in a gallery or museum is designed to be seen sequentially and from one vantage point – usually standing. At home, as we move around, we see art in different places, in changing lights and moods, from different positions: sitting, standing, lying down. You will want to integrate your art into your home to give variety to the functional aspects of life, adding interest, colour, expression and personality.

A painting, photograph or piece of sculpture that you felt strongly about in the gallery or exhibition space may look very different when you get it home. It has a different environment and surroundings to fit into. It is not always possible to take a piece home to 'try it out' but, if you are in doubt and it is feasible, don't forget it is an option that most artists or galleries would accommodate. If you're in love with the piece it will find a place – but don't be disappointed if it doesn't immediately work in the way you had anticipated. It's just a question of moving it around (or moving other things around) until it does.

I had a client with a couple of pictures that they loved. When they moved house they wanted to hang them in the living room as before, but they no longer seemed right there – the light was all wrong and the strong whites in the pictures didn't work on the off-white walls. They were disappointed, but we found a perfect spot for them on an upstairs landing where the light flooded in and bounced off the lighter walls. The pictures were 'saved', the client was happy to be reconnected with them and, because they were now viewed from a standing height, they saw aspects of the paintings that they hadn't seen before.

There is art within art, and the art of displaying art at home can become an art in itself. The key to a great collection, or to an interesting display, stems from developing a strong personal preference. Living with art is the best way to develop and inform the choice. The chapter that follows contains guidelines and practical tips to help you give your art the good home it deserves. There are no rules here – merely ideas to be considered where helpful.

OPPOSITE: On wall: *One Against One*, Michal Rovner; centre on chair: *Oscar Levant*, Richard Avedon

CONSIDER your space

In the same way that it is helpful to stand back to take in or appreciate a view or a large painting, it is also helpful to stand back and look at your home space with fresh eyes. Take some time to consider each individual space; then see how they connect together to form one integrated whole. Then you can decide how best to display your art.

Making a wall plan This is probably only relevant when you are putting up paintings or artwork for the first time or in a new home – blank walls. Gather together the different paintings or other artwork you have chosen to go up on a particular wall or area. Lay them on the floor in front of that wall in an arrangement you think works. You can move them around without unnecessary drilling and hammering until you find what works best. Stand back and look at it from different angles in the room. Go and have a cup of tea or lie in the hammock and come back to it afresh. Then draw up a chair and look at the wall space where the assembly of pictures or picture is going to hang, and move the chair to other spots in the room where the art will also be looked at from sitting. Look at it from a standing position and from where you come into the room.

Landscapes or pictures with perspective can be viewed more distantly, but smaller pieces with detail need to be accessed. Don't put these too high or on a wall with a deep piece of furniture in front of them. It's good to be able to get close up to look in detail at some pieces. And don't forget – just because there's a space you don't have to fill it. (Unless you're going for the purposeful 'as much as you can hang on the wall' method which can look great, but you might not want to do it throughout the house.) Music needs space between the notes to make the notes make sense – so it can be with art.

You might want to play down other elements to let the art do its magic. A room crowded with too many colours, patterns and small objects will detract from the art and stifle it. Wallpaper, especially dramatic or patterned wallpaper, is not ideal for displaying art. If you are keen to have wallpaper, consider limiting it to one wall. If the room is small, don't let the pattern become overwhelming. This way there is still an opportunity for art to be introduced at a later stage.

Even if you choose the crowded wall look, breathing space can be created by the occasional use of a broad white or light-coloured mount to surround a particular picture or photograph. Even an oil or acrylic painting (not normally glazed) if left unframed could be mounted on larger white boards before being hung – for instance on a bare brick wall, or on other absorbing or conflicting colours or textures (see pages 2-3).

Making a photo montage plan This can either be done with a digital camera or a film camera. If it is done digitally, first photograph the interior, then the intended art for that space, load onto your laptop or computer and then open the images in Photoshop. Depending on your computer abilities you can then move things around until you have the finished wall or interior with all the art in the optimum position.

If using a camera with film, photograph your wall, interior space or room. Photograph each item of art – paintings, sculpture etc. Have the interior image printed and photocopied onto an A4 sheet. Similarly print and photocopy the art images, making sure that the art images are in proportion to the interior. Then cut out the art images and move them around on the blank wall or within the interior (in the case of sculpture) until you find the arrangement you like.

Making a mood board If you've moved house or want to redecorate completely, you could make yourself a mood board. This is something that interior designers often create as a way of putting together all the essential elements and colours in a room.

Make your mood board with a piece of (soft) board – painted, or covered, white. You can keep your plan flexible by pinning your choices up, and moving them around. Catalogues and magazines are good sources of inspiration along with photographs of your own furniture and other key pieces to go in the room.

If art generally, or a piece of art in particular, is going to star in the room, then include a picture of this on the board. Build up what appeals to you in colours and furnishings according to where they are located in the room – the choice of flooring or carpet at the bottom, wall paint or paper choices and curtain materials to the sides and top and particular furniture and art pieces in the middle. Keep each sample roughly in proportion to the area it covers – the wall and floor coverings will be greater in area than the curtains and soft furnishing material. If the art goes in first it could help simplify the choice of materials.

OPPOSITE: *Fishermen Cleaning Nets on Aldeburgh Beach*, Jane Wheeler

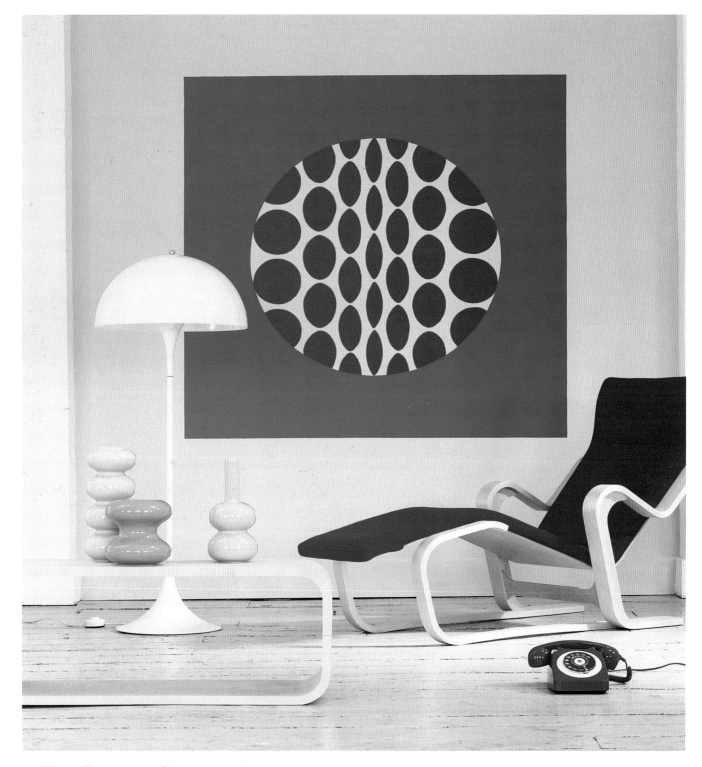

COLOUR schemes

Should art dictate the design and colour of rooms, or the other way around? Some artists might hope that a piece of art will determine the look of the room and that the new owner will redecorate but, although designing the decor to suit the art can produce wonderful results, it isn't often practical, especially if you keep adding to your collection. The objective is that the two concepts – the art and the design of the room – come together, that the whole thing 'works'.

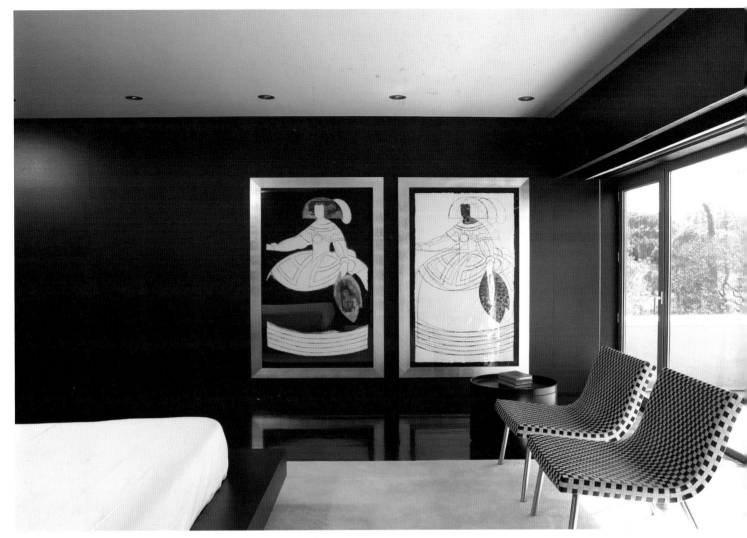

OPPOSITE: *Mural*, Sacha Cohen
ABOVE : left print: *Reina Mariana, III*, 2001; right print
Reina Mariana VIII, Manolo Valdés

White The reason that a lot of keen art collectors paint their walls white is for the same reason that art galleries choose white – all art looks good on it. For some people white throughout is a mantra wherever they live or move to. But it doesn't suit everyone and there are still ways of making sure that the art is displayed to its best advantage.

Colour is very personal – it is emotive not logical. With or without the use of a mood board, consider the colours that you like and why. Which colours make you feel happy – which colours make you thoughtful or sombre? Relate colours to different emotions – feelings you have had at particular times in your life. It helps you to have a relationship with colour – some thoughts as to why certain colours are favourites.

Strong colours work better in south-facing rooms or rooms in the southern hemisphere. North light tends to dull strong colour and this can have the opposite effect to the intended one. If you have chosen a rich Mediterranean blue to paint the walls of a small north-facing bedroom you will be disappointed by the difference in tone. This in turn will affect the art, because colour bounces light around or absorbs it.

Bold colour can work – if it is done thoughtfully and selectively. A small room – a study or small guest room, or even one wall in a room, alcove or corridor – could be boldly painted. Chinese red is a beautiful and dramatic backdrop for art – especially for black-and-white photographs. Yellow works in the light of a hot climate but, again, can be

difficult in a north-facing light. It can work well if used with discretion – perhaps balancing it with a white wall to reflect light onto it. The direction of light plays a very important role when selecting colour.

The colour emphasis in the otherwise monochrome interior on the left illustrates the dramatic effect of extending the colour in the art out into the furniture in the living space. Instead of competing with the art, this section of the room harmonises with the power of the painting.

In the bedroom above, the colour palettes in the etchings are sympathetically reflected in the design of the room. The impact is strong and restful, but above all gives the art space in which to live.

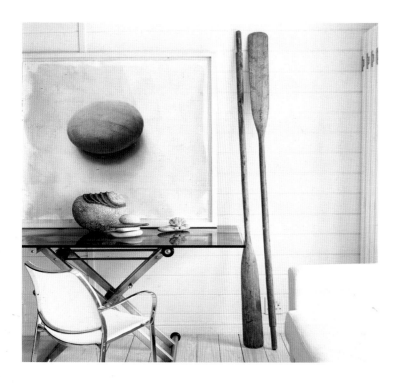

HOW TO MAKE
your art feel at home

When planning your art display, or introducing a new piece, make sure the art 'feels at home'. This is not as odd as it sounds. Combining the joy felt in first seeing the individual work of art with the elements in your home creates a harmony of living.

Change of scene When you see art in the gallery, or wherever you choose to buy it, you are seeing it in one setting; when you get it home it will, in some way, look different. Often art looks smaller when you see it again at home. This is because it has to integrate with other art, objects and furniture.

All homes are given an extra dimension by having art in them, and art is personalised by being in a home. The other contents of the home also have an impact on the art – the permutations are endless. Taking a particular painting or work of art and placing it in a hundred different homes would give the art itself a hundred different perspectives.

Echoing something from the art itself will quickly give it the right setting. Relating to the subject matter in the painting with objects,

ceramics and sculpture when planning how to display it will integrate your art.

Colour Integrating art through colour is another way of making the art 'feel at home': echoing blues and greys for marine subjects, subtle greens and earthy colours around landscapes, bolder colours for abstracts in aspects of soft furnishings and objects.

Pairing Some paintings fall naturally into a pairing. When putting two paintings together in such a pairing, look at the two as though they were one whole piece. There is usually an obvious left and right defined by weight or colour. Bold colour and strong shapes delineate the two outside edges. Figurative work, portraits and animals prefer to look at each other. If only one of a pairing is a portrait, then give the subject something to 'look at'.

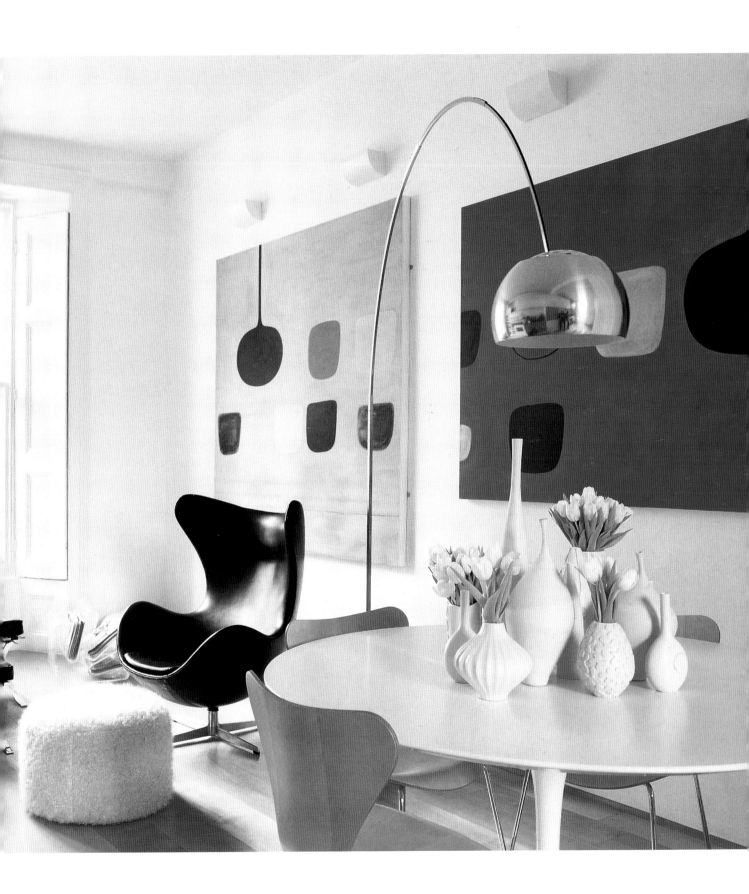

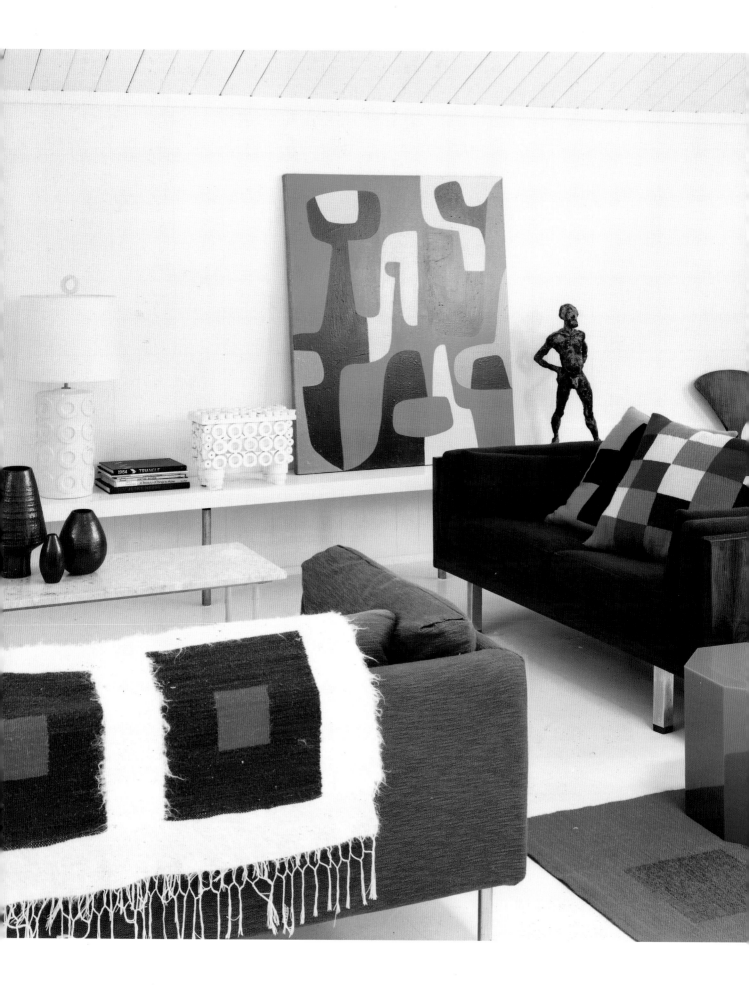

OPPOSITE: Painting, John Paul Philippé

INTEGRATING your art

A themed approach, if handled well, can create a cohesive look; one way is to assemble art, textiles and furniture from a particular period. The hallmark of a good collector is the development of a strong personal preference.

At some time or another we have all come across people who are fascinated by a particular place or period and their homes reflect this, whether it be classical Roman, American 50's, German Bauhaus, English country house, or minimalism revisited. The owner chooses to integrate the domestic space in a unified personal preference. This is the opposite of eclectic collecting.

In the past, homes conformed to the style of the day – there was less choice because there was not the accumulated wealth of diversity

that has come with each new age. Time was when successive generations lived in the same house for long periods of time and the interior and its art rarely changed. With an increase in disposable wealth, homes and interiors are now more often prone to change.

With the advent of 'style', the home is now keenly seen as an extension of personal expression. An interest or love of a particular era concentrates this expression, as in the case of Kettle's Yard, created by Jim Ede (overleaf), which resulted in an innate sense

of sympathy between the occupier, the art and the architecture of the home he lived in (since when it has become a museum gallery).

Whatever the cost and however beautiful a home is, those that stand out are the ones that contain close associations with a particular time or person. After the people themselves, art makes that association. Follow your heart in creating a harmonious mixture of art and-life. Above all, your home should make you happy.

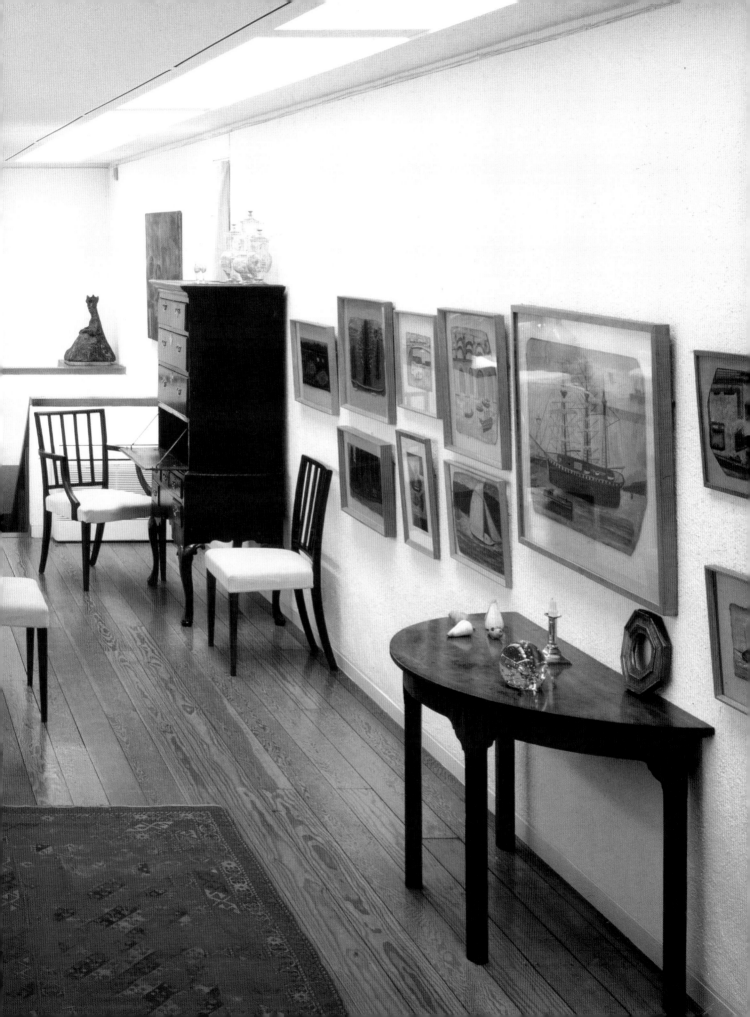

HANGING practicalities

Once you've decided what to hang you need to know where to hang it – and even whether to hang it! Putting different art pieces together needs some thought. But if each piece has been selected with a unifying eye, then the resulting collection will come together. Good groundwork and thoughtful selection will give you the confidence. Each display will be different, but here are some guidelines to consider.

Function Before deciding on the display arrangement from an aesthetically pleasing perspective you should also consider some functional factors, especially if you have valuable pieces of art. Oil paintings and acrylics are harder wearing than art on paper and will therefore pose less of a problem.

Outside walls which take a battering from the weather can become cold and damp inside – even with central heating. If hung on these walls the picture could attract mould. This can be avoided by tilting the picture slightly and putting a slice of cork (from a wine bottle) centrally under the bottom edge to keep it in that position. This usually makes the picture hang better anyway. It is also a useful device when deflecting the glare of light through an opposite window onto glass.

Watercolours and photographs can deteriorate or fade under constant sunlight and white paper will turn yellow. This is especially important to avoid in countries where prolonged, strong sunshine is a factor. A rotation system of hanging, so that nothing stays too long in one vulnerable place, can be a solution.

Doorways Don't hang pictures where an open door will obscure them. It's easy to arrange a room with the door closed, forgetting that the space behind it becomes hidden unless the door is always closed. This would be a good place for a hanging (textile), however, since it is a more natural extension of the doorway and they are usually less fragile than glazed pictures.

Small pictures Avoid putting them on the wall above large pieces of furniture – not just for scale but because you can't get close to them to view or look at in detail.

Fireplaces may be a hazard to one homeowner because they are open or smoke with the wind in certain directions. To another homeowner a fireplace (and the space above it) will be no problem because it is either not in use or houses a gas fire. The active chimney breast can be a focal point for a change of art according to the seasons – finding more or less vulnerable pieces depending whether the fire is in use.

Be cautious with what you hang over active radiators in the same way as over fireplaces. Incorporate these in your changing picture scheme; this way, no picture has too long in a hotspot and when you move it you have the opportunity to inspect for any dust or damage. The same goes for pictures continually hung in strong sunlight – especially works on paper and photographs.

Bathrooms and kitchens can also be troublesome if steam and condensation are a factor. Don't be put off displaying in these areas, just be aware of the conditions. Consider putting more durable art there, especially art on glazed tiles and mosaics.

Collections other than paintings need to be considered as well. Woodcarvings, folk art, textiles, hangings and even rugs all have a place displayed on walls. Places that are too awkward to accommodate a framed picture might be ideal for a piece of three-dimensional art or a quirky carving.

A hanging doesn't always need a flat wall space behind it; for instance, where a wall recesses under a sloping roof, a hanging can be suspended over this otherwise wasted wall.

Hanging devices When buying or acquiring art it is easy to overlook installation requirements. Have a look for the hanging devices and, if there are none, ask the dealer or person from whom you acquired the art what would best suit the piece. This is especially relevant when dealing with pieces other than framed pictures.

Don't worry! These are all practical considerations and, whilst caution is beneficial to fragile art, nevertheless the enjoyment of art should not be forsaken due to over-concern.

Before conservation became an issue, art was happily hung wherever it was best suited – and more often than not it survived. I'm sure Monet, given the choice, would rather his art were hung in a light and lively home than relegated to a dark 'safe' vault. A happy balance is the objective.

OPPOSITE: *Sex*, Morag Myerscough

HANGING aesthetics

Consider the juxtaposition of artworks. For instance, if you were to take five paintings from a wall and rearrange them in different combinations you would achieve five different effects. Some art falls very naturally into groups and some art needs plenty of space and needs to stand alone. The subject and personality of the art will inform these hanging arrangements as well as your decision as to whether to hang thematically.

Themed collections can have great impact and look stylish: a series of architectural prints or botanical pictures for example – all framed uniformly. But they are also more formal. This is something to consider when deciding where to put such an arrangement. Dining rooms and corridors work well – or a more formal drawing room if that is your style.

Mixing A more informal result, and a very comfortable one, is a real mixture of art – selected from different sources, artists, countries, as well as children's art, your own art, the art of friends or inherited art. If it is all brought together through your interests and expressions, then the result will work. Each piece will have a part of your life as the connecting theme.

Subject matter An informal mix can also be interesting if arranged around a theme (but not in a uniform series). For example a wall of pictures influenced by a love of the sea, landscapes, family portraits, animals or art that is local to where you live.

Plain, dark walls can take bolder pictures such as oils and acrylics, or tribal art.

Older rococo frames, ornate frames and frames chosen for impact to complement strong pictures will work well here.

Plain, light coloured walls suit pastels and watercolours and more delicate work. Avoid a frame that is in too harsh a contrast with the delicate art/wall colour.

Large, bare walls look best with one very large piece, or a mixture of large and medium-sized pieces. Small pieces on their own will look lost or unimportant.

Wallpapers can be a challenging background for displaying art; and patterns are more difficult than stripes. The bolder the pattern the more it is likely to fight with the art. It is important therefore to give the art as much blank 'space' (in the form of a mount surrounding it) as possible between it and the wallpaper pattern.

Large, bold paintings need enough space to be able to stand back from them. They don't work so well for this reason in fairly standard or narrow corridors. But, surprisingly, they don't have to be in large rooms – a large painting can work in a small room. If the painting is very large, and the room small, the painting can have the wall to itself, which can be very effective. The reverse does not apply – small paintings by themselves get lost on a large wall.

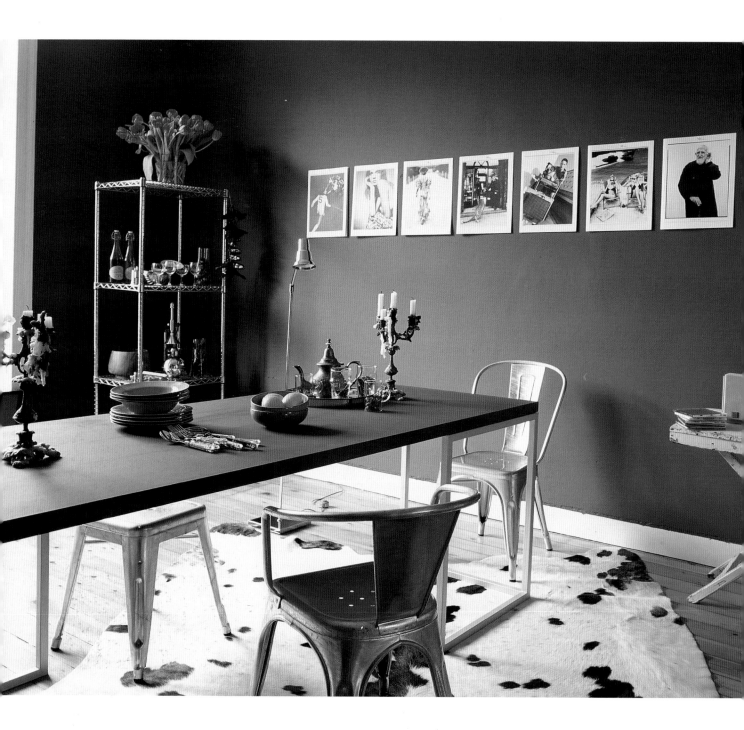

HANGING in groups

If you are putting more than one picture up on a wall, then how these pictures relate to one another creates its own dynamic. They may be united in subject matter, or frame size, but bear in mind that a symbiotic grouping is more effective than a random one and will have a more harmonious result. There are many permutations, but here are some guidelines to consider when hanging pictures in groups.

Same size Unless you have decided to hang them unevenly on purpose, then for a group of pictures of the same size keep the spaces even. This cannot be hit and miss – a little time with the tape measure is essential. A variation on the carpenter's adage is: measure twice – hang once.

Straight top line Keep the top of the pictures in a straight line – pencil, masking tape, spirit level and tape measure are useful tools, as are lengths of string or a laser line leveller.

Centre focus Placing a larger picture in the centre of a line of pictures gives some movement to the arrangement – if the space is conducive – for example over a bed as in the picture below.

Different shapes and sizes. If pictures are of varying shapes and sizes and you wish to hang them in a line, another option would be to take the centre of the picture as the alignment guide.

Or, hang a large picture in the centre and even rows of pictures either side equal to the depth of the main picture.

Squared up As an alternative to a line of pictures the same size – place them in a square or rectangular setting.

In a child's room or kitchen, clothes pegs on rows of string can hold pictures – prints, photographs, or children's art. The wooden pegs are not damaging to the paper (artists often use this method when hanging up their prints to dry) though you wouldn't want to hang anything very delicate or too precious this way.

Framing a group For a general group of mixed picture sizes – make an imaginary wall frame, or mark out an area large enough to take all the pictures, and place the pictures within this – putting the largest pieces on the outer edges of the 'frame' and add the smaller pieces in the central space.

In the shape of a cross Create an imaginary cross on the wall and place the largest pieces below the horizontal line, balancing the smaller pieces above it.

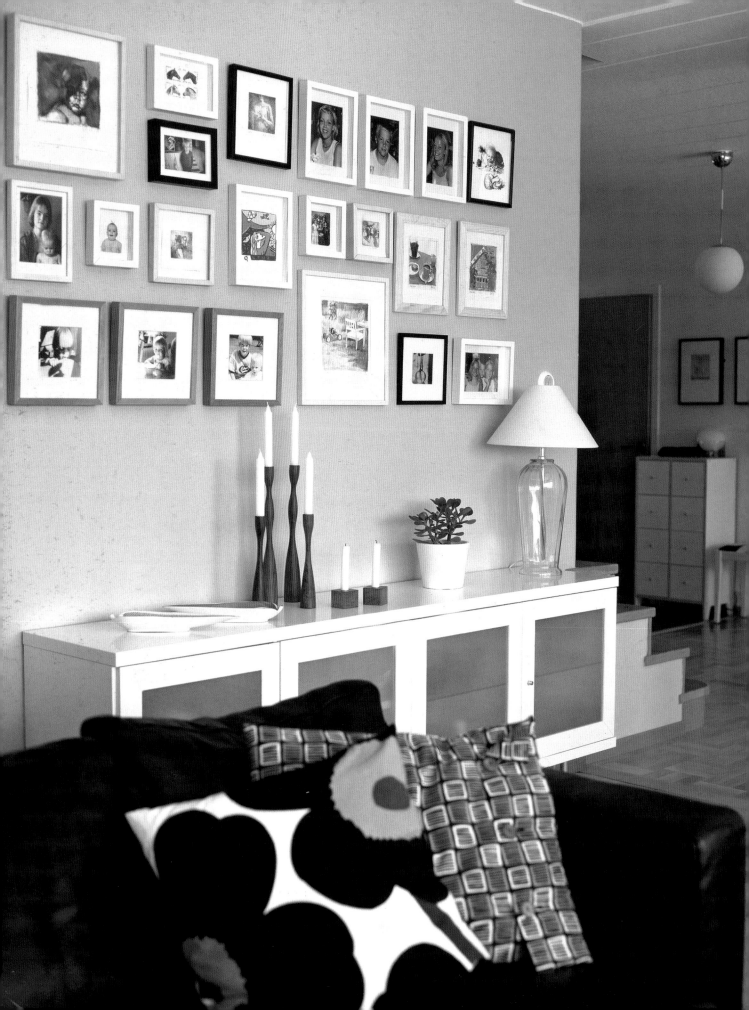

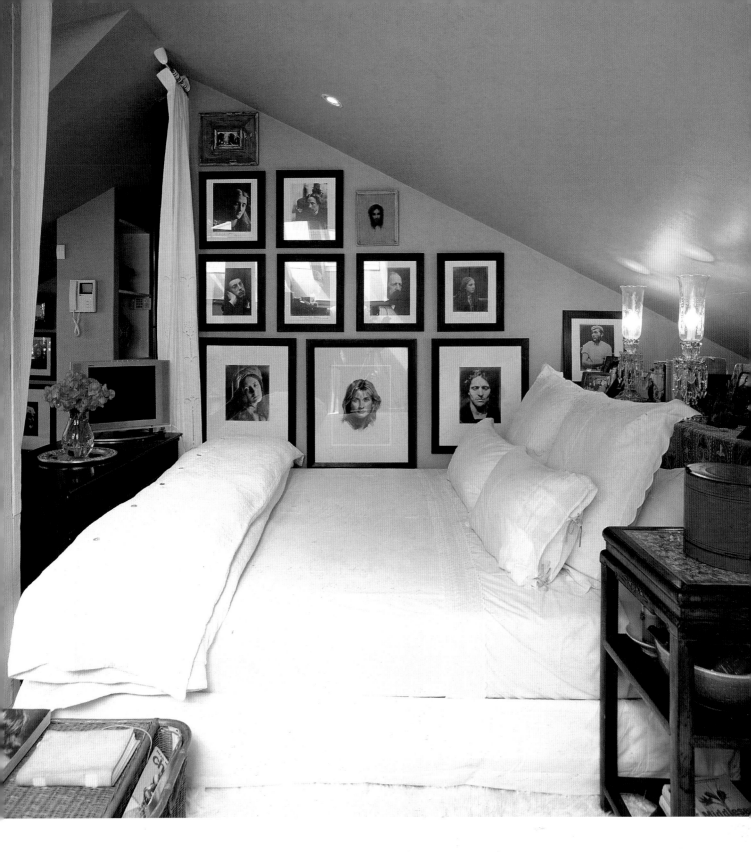

Parallel lines On the wall in the room opposite, two objectives have been achieved: a clean line keeps the first row of pictures aligned by their tops, and a similarly clean line above the cabinet keeps the bottom row aligned. This is not a random arrangement, but one achieved with accurate planning.

Awkward spaces It would have been easy to overlook the opportunity for displaying pictures on the wall in the bedroom above. This collection of portraits not only fills a difficult space to great effect but also provides an interesting subject for reflection.

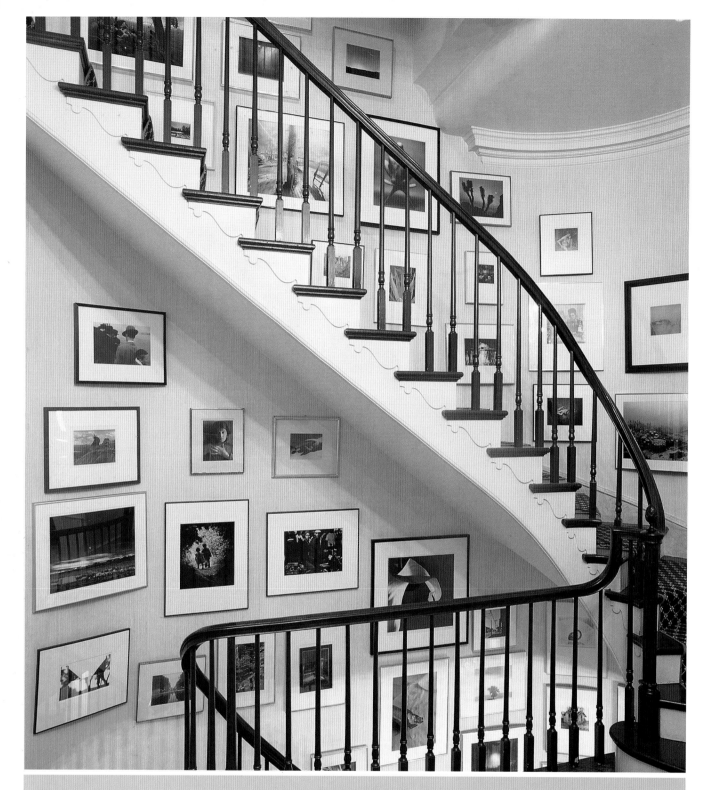

Take the stairs

A staircase is often another wasted opportunity for picture hanging. If used, it not only becomes another 'gallery' wall space, but also links the house together – keeps the art flow. If the pictures here are to be various sizes, start with the largest one on the centre of the staircase wall and work outwards either side of this. Keep an imaginary line running through the centre of the pictures and parallel with the line of stairs. If you don't have enough art to fill these walls this can be a good place for family pictures and photographs, even framed press cuttings or achievement certificates, leaving more 'important' walls free for favourite pictures.

HOW to hang a picture

It is perfectly possible to hang a picture on your own, especially if it is neither large nor heavy. However, it's more fun and easier with someone to help. If the work of art is bigger than one person can lift and hold, or if you are planning a group display – then recruit a couple of helpers.

Assemble your tools There are some useful tools available to help with the wall fixings. Especially handy is a multi-sensor live wire detector, battery operated screwdriver, hands-free laser base leveller, and tack hammer with claw. All these are available from hardware stores. If you are making a mark on the wall use a very light pencil, but make sure it can be erased or washed. Otherwise use tiny strips of masking tape that peel off without damaging or permanently marking the wall.

Wall strength Check the wall that you are planning to hang the picture on. A structural wall (i.e. brick, concrete) will require heavy-duty concrete nails. A panel or partition wall will only need standard picture nails, but won't be able to take a great weight. If in doubt, take advice from your hardware store or framer.

Screws The most usual hanging device is a pair of screw-eyes in the back of the frame, screwed in a third of the way down on either side. These come in different sizes so make sure the screw length of shank suits the thickness of the wood.

To start the hole for the screw, you will need a gimlet (bradawl). This looks a bit like a screwdriver but has a long sharp needle-like point that with pressure and turning creates a small hole, enough for the screw to then 'engage'.

An additional pair of screws can be attached for security so that if there should be a weakness, or if the picture is fragile or very valuable, the 'safety' pair will catch the picture before it falls.

D-ring Another heavy-duty hanger is the D-ring on a metal tab attached to the back of the frame – also in various sizes.

Mirror plates These were traditionally used for mirrors because of the weight of glass. They are strong and will also hold the picture flush against the wall. The plate (one on either side of the frame) is attached with screws – one onto the back of the frame, and two into the wall. This part of the plate is visible (usually brass). They can be recessed into the wall and plastered, then painted over. For security, the plate method is best – but bear in mind that not only can the burglar not move it easily, neither can you. Once it's up it's up – this is not a painting to move around on a whim or even to ring the changes of season with, so be sure you're happy with its position.

Stringing Don't use garden wire or string but special picture cord or wire. I prefer the cord because it is nicer to handle, and it has a very slight 'give' which can be useful when only a fraction of a millimetre is needed in lowering a picture. Whichever you use – don't pull so tight that it strains the screws.

Find the right height If you have done a wall plan or arranged the pictures on the floor and decided which picture is going to go where, then ask your helper or helpers to hold the picture so that you can stand back and determine the right height. The basic guideline is that the centre of the picture should be at eye level for an average height person in standing position. But this rule will vary according to the place in which it is to be hung. In the dining room, for instance, the view from a sitting position will take priority. In a bedroom, from a lying position, and so on. On the whole, pictures tend to be hung too high. It is better to look directly at a picture or slightly down at one, than to have to look too far up. Once you've decided on the position, make a light pencil mark on the wall in the centre of the top of the frame.

Once the cord or wire is attached to the screw-eyes, hold the cord taut (as though you were going to lift it up at the apex of the cord) and measure the distance between this point and the top of the frame. Then measure the same distance down from your mark on the wall and make another small mark. Allowing for 'give' in the wire or cord – put the nail in a couple of millimetres above the hanging spot. Drive the nail in at a slight downward angle so that the wall takes some of the weight of the picture.

Tip: If the wall is old or crumbly, put a piece of tape over the spot where you are going to put the nail in. This will absorb the initial impact of the nail.

If the picture is still not at the right height for your liking, you can loosen or tighten the wire or string on the picture rather than move nails and disturb masonry.

Alignment Hang the picture so that it's straight. A small spirit level on top of the frame will help you. Bear in mind that not many rooms have precise right angles and lines of ceilings and floors vary, especially in older houses, so don't try and line it up with floor or ceiling lines.

Tip: To keep the picture aligned, especially in a group or on the stairs where they may get brushed against, put a small piece of double-sided tape or blu-tack on either side of the inside bottom of the frame against the wall. This can be washed off or lightly painted over if the arrangement is later moved, but can save a lot of time spent constantly re-aligning pictures.

Use the corner of a clean eraser to remove any light pencil marks that might show.

Stand back and admire.

NOT just hanging

Walls enclose our space as well as acting as backdrops for art. Giving attention to this spatial awareness reminds us that although most pictures are *designed* to hang on the wall, this does not mean that they *have* to hang on the wall.

Leaning If you want a more informal approach to displaying, and you like moving pictures around, then you might be a 'leaner'. Lean a painting on the shelf over the fireplace, on a simple wicker chair or, in the case of a very large unframed canvas, against a bare wall (see page 122) for an informal effect. By moving pictures around to different parts of the house you get a change of perspective on the painting as well as the room or space you put it in.

Propping Another informal way to display art is to prop pictures on a shelf, either on their own or integrated with pieces of sculpture, ceramics or books. A narrow shelf

about 7.5mm deep (with a lip or moulding to stop them slipping) can be fairly easily mounted along a wall – perhaps even the length of a wall where there is no interruption. This is a new take on the 'picture rail' and, once in place, pictures can be moved around easily without ever having to nail or drill the wall again.

Artist's easel This is another way of creating an impermanent display. Not only can the picture be changed but the easel itself can be moved around. Old ones can sometimes be found in antique or junk shops, or new ones bought in artists' supplies shops. They are usually made of pine and can always

be painted or treated to suit your taste. A picture propped on a chair also has an artist's studio feel to it – though for this purpose a wicker seated chair or textile covered seat is best, to prevent the picture from slipping.

Non-slip If pictures are perched on a slippery wooden shelf, or floor surface, a couple of small picture tacks can be gently tapped in at an angle in front of the pictures to prevent them from slipping. A small piece of blu-tack under each corner would have the same effect, but in both these cases discretion is the key – make sure the anti-slip device does not show.

CHOOSING a mount

A mount, also known as a mat, is the backing and surround on which a picture is displayed. The mount protects the art work from the front and supports it from behind. Its primary use is for works on paper: photographs, prints, watercolours, drawings.

The choices of mounts are many and varied both in texture, colour and content. With the possible exception of mass-produced reproduction prints it is always advisable to choose an archival material for the mount. The mounts that come with pre-made frames are unsuitable for anything of value since they can contain acids or chemicals that are harmful for the art. The mount material should be acid free, lignin free and pH neutral. The most common and least expensive of the archival mount materials is a cotton matting. But always talk to your framer or gallery for advice specific to the art work you are going to mount.

Single or double The print or artwork will be 'sandwiched' between the backing board and the front mount which will have a 'window' cut to frame the image. With photographs it is considered better to use a double mount to ensure that the emulsion does not stick to the glass in humid conditions. A double mount is also advisable for charcoal, pencil, and pastels so that there is no chance of contact and smudging.

Colour This is a matter of taste and impossible to advise on a general basis. However, if in any doubt I would go for a warm white plain mount (but not cream or magnolia which can look dull if not absolutely

the right shade). If a colour mount is preferred, then be sure to choose it in relation to the picture and not to the colour decor of the room setting. Like for like is a good starting point – earth tones for landscapes, blues for marine images, pastels for pastels and bold for bold.

First choice If you have bought a print or work and cannot have the piece framed immediately, it's still a good idea to have it mounted for safekeeping. A long time in a cardboard tube or lying without adequate protection will lead to wear or tear.

Don't be stingy with the mount – I think a print or photograph needs room to breathe. It not only gives the art piece importance but also lets it stand on its own and distinguish itself from other surrounding artwork or decoration. This is especially important if the subject matter itself is 'big' or has movement in it. Obviously don't go too far the other way so that the picture is lost. It's a question of balance – but I would prefer to err on the side of generosity with the mount then have it too 'tight'.

Proportions As a rule of thumb: for a square picture – make the margin of the mount deeper at the bottom than the sides or the top. For a portrait (vertical) shape the

top margin should be wider than the sides; for a landscape (horizontal) shape, the side margins should be wider than the top. The ideal proportions of 1:1.62 in a rectangle have been considered visually most aesthetic since originally constructed by the Greek mathematician Euclid and used by architects. Artists, too, took note of this perfect proportion – in Van Gogh's picture *Mother and Child*, for example, the Madonna's face fits perfectly into this 'golden rectangle'.

Adhesive If you're constructing the mount yourself, make sure that spray adhesives are not used to attach the art to the backing board. It is a short-term solution for preventing the art from buckling, but over time the spray adhesive (or any non-archival adhesive) will dry out and the art work will tear away from its base. Eventually, it will also discolour or stain the art work. A rice paper adhesive, wheat starch paste or linen tape would be a better choice.

Tape If using tape it is only necessary to attach it along the top of the art work, allowing the piece to contract and expand hydrodynamically. It is worth noting that in Europe the attention to archival mounting and framing, though better than it used to be, is often not to the same standard as it is in the U.S.

GLAZING

2mm picture glass is the normal thickness used in picture framing. If the intended picture is very large, or particularly long, it may be advisable to go for a thicker glass – to 3mm to avoid distortion.

Non-reflective glass Where strong reflection, glare and light bounce are unavoidable, non-reflective glass or a substitute offers a good solution. Its main function is to deflect light – and so it is used to minimise glare from artificial light, sunlight

and reflections. But non-reflective glass can be disappointing – the overall effect is a slight blurring and tends to deaden the effect of the very light the painting is giving out.

Tilting Alternatively, to counteract the effect of reflection from an opposite window – try raising the bottom of the picture slightly by placing an appropriately cut cork between the picture and the wall. Even a slight tilt can do the trick without upsetting the hang of the picture.

Plastics such as Acrylic, Plexiglass, Lucite and polycarbonates provide materials that filter out harmful ultraviolet light for conservation purposes. They're also lighter than glass and not as fragile.

Non-slip When choosing a material for photographs, pencil, charcoal or pastels – it is advisable to use glass, as acrylic can produce a static charge and lift the medium from the paper, or cause the emulsion (in the case of photographs) to become sticky.

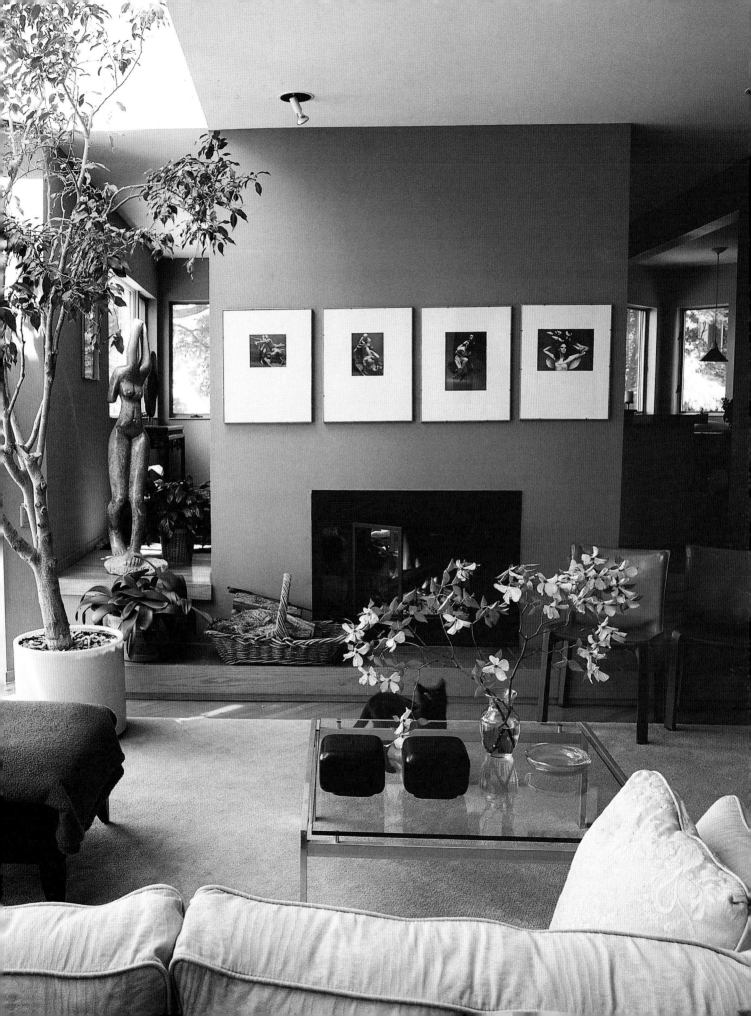

HOW to frame

When deciding on a frame or framing, consider where the art will hang in terms of a) other art b) other styles of framing and c) your style generally. Each display will be different but some general practical advice might be useful. There are basically two reasons to frame: practical and aesthetic. The practical is the device for hanging the painting on the wall and protecting it, and the aesthetic is to act as an integrator between the artwork and the wall and surrounding decor.

Buying in an existing frame The first and most obvious consideration is whether the existing frame is broken or damaged. If so then the painting is, essentially, unframed. The second consideration is whether the frame suits the painting. Whether the frame suits your taste and/or decor is really only a third consideration since it is the art that must come first, though obviously you want to arrive at a frame that works as well for the setting you're going to put it in as for the art itself. Depending on where you bought the painting, you need to know whether the frame was specifically chosen for the art – and by whom. If the artist had constructed, chosen or created the frame as part of the art itself – or an extension of it – then it is important to maintain that integrity. Any frame that has been chosen by a gallery or dealer should have already been chosen with that same respect to the artist. These points can be discussed when buying the painting.

Having assessed the frame and found out what you can about its history and association with the painting or work of art, you might still decide that you don't like it or consider it inappropriate. You might also have some radical idea of how you want it to frame the work. Ultimately you are free to do what you like – there are no absolute rules – only guidelines and suggestions. After all, it is your piece now; you have fewer constraints than a museum curator who is answerable to a critical public and body of art historians. You are free to mix period and style and colour as you like, but it should still be thought out – not arrived at randomly as though the frame is just an inconvenient but practical afterthought.

Buying a painting unframed
Before buying the painting, and whilst you've got the gallery dealer's or assistant's attention – or the artist's – it's worth asking their advice about the framing. What would the artist

have suggested or wanted? What, in the opinion of the seller, would suit the painting best? Armed with their advice, and the painting – go home and think about it before rushing into a decision – especially if the gallery is also a framer or has a pet framer they want to recommend. You might well want to come back and take up their suggestions, but you need to think about this in the context of your home before deciding. Once home, you'll either have a chosen place in mind for the painting or there might be a choice of places you want to try it in terms of subject, expression, focal positioning. Once decided, and with the framing suggestions you have been given – you can see what adjustments you might like to make considering the other materials in the room.

Choice of material This might be influenced by the style of the painting and of your room. For example, a matt aluminium rolled edged frame would be fine for a photograph but might not work with a period oil painting. Artist Paul Riley suggests: "The frame acts as an interface between the painting and the room. A small oil painting often needs a large, strong frame." I like this advice because it brings your attention to a small picture and leads you in.

Look around Take note of other people's art and how they have framed it – decide what you think works and doesn't work. Wander around a few galleries to gather further ideas.

No frame Some large abstract modern art is more simple and effective with no frame at all. If this is the case it's worth ensuring that the edges of the canvas (which would be otherwise hidden by a frame) are painted. But be careful: you don't want to risk damage by scratching or dirty finger marks. An unframed/unprotected oil or acrylic needs to be placed out of reach of pets, small children, candles or too much activity. For oil and

acrylic paintings it is traditional to use a wide moulding and no glass since the oil and acrylic is hard-wearing and easy to clean.

Colour It's important not to make the frame jump out away from the picture. Don't choose a colour too similar to the general colour scheme of the picture but choose a tint that enhances the values and colours of the painting.

Budget Frames are expensive, so hunting in secondhand shops and markets can turn up unexpected treasures which you can clean up or paint. Auction houses now specialise in frames if you want to hunt out something individual – particularly good for finding older or period frames. General furniture auctions also include pictures and frames to suit different budgets. Provincial auction houses are often the best place for these finds – the result of country house sales. Pick the most attractive frame you can afford – but don't make a high price the criterion for your selection. Modestly priced frames are often the best choices.

Conservation Bear in mind the conservation points if you decide to frame it yourself or make sure you let your framer know that you understand the importance of conservation if you take him a frame you have found yourself.

What to expect It is an exceptional framer (or one who knows you and your style) who will offer you something that really works for you. A good framer will advise on suitable framing, but it's useful to be armed with as many informed ideas as possible. If you go with a concept or images of what style you like, you are helping the framer to help you.

And lastly, if you are still in any doubt – then three words are all you need: keep it simple.

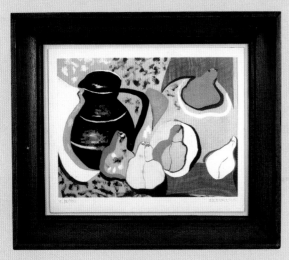

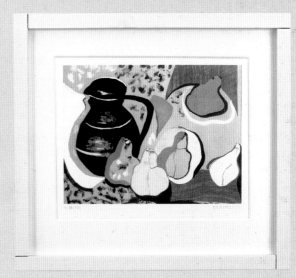

We gave William Campbell, master and bespoke framer, a print by E.Q. Nicholson, and asked him to make up frames to illustrate the different results that can be achieved with the same image.

Top left: An early nineteenth-century carved Italian frame. The combination of classic design and wood (poplar) helps identify where particular frames originate. He chose this one because the pattern on the frame is simple and in scale with the composition of the picture. A modern mid-century print in a classic frame works well. The double mount leads you in. Instead of one big step, two little steps give a better access to the picture.

Top right: A late nineteenth-century French extruded gesso frame, parcel gilt. Good crisp detail here and colouring that picks out the palette of the picture. There are enough 'steps' in the frame, obviating the need for a double mount.

Bottom left: This nineteenth-century English mahogany frame draws on classical architectural details. It is almost like a tray on which the contents of the picture are laid. A very sympathetic frame.

Bottom right: This is a frame William made bearing in mind the association of the artist E.Q. Nicholson to Ben Nicholson (sister and brother-in-law). The latter artist made popular this type of box frame where the joins are on the cross, not mitred, now known as a Nicholson frame. The simple frame was favoured by Mondrian and the constructivists and reflects the clean lines in their style of art.

The results show that each of these frames 'works' equally well for the image, illustrating that there is always more than one choice of frame for a picture. The decision will be influenced by other aspects of the style and design in the room in which it is to hang. The purpose of the frame is to protect the picture, to display the image, but also to integrate the art into the home.

LIGHTING

In the same way that the artist uses his or her relationship with light in a painting or photograph, so we too can develop a keen awareness of light in our homes and how it relates to our art. Unlike seeing art in a museum or gallery, at home we see our art in a series of different lights at different times of the day, or season, through changing weather – as well as in artificial light. We can enhance or affect the art with good lighting and detract from it by unsympathetic lighting.

Natural light (or 'available light' as it is termed in filming) is the source of daylight we have in our homes. How much light is dictated by the size of the windows. Other relevant natural light effects are influenced by the direction of light, the weather, the time of year and the time of day. These ever-changing light patterns are a factor when considering where to place a picture or piece of sculpture, not only for the values they give the art but also how robust or fragile the art is in response to ultraviolet rays. At night, and with artificial lighting, a different atmosphere is created, so bear in mind that the art will be seen in this different light.

Lighting systems Lighting that is too harsh or over-bright can be tiring – you don't want or need to replicate museum or gallery lighting. To get the best out of specifically lit artwork it is worthwhile checking out the different lighting systems available. General overhead light will tend to flatten the atmosphere; sidelights create a good ambience but don't always light art well. Sometimes all that is needed is a small adjustment – a soft accent or enhancer light.

Ways to light A leading lighting specialist suggests that basically there are four ways to light a painting: spotlight, uplight, picture light and framing projector. This last is the most expensive, but produces a beautiful non-intrusive but effective light because it is designed for light to fit the frame exactly. It can also be used to fit the exact shape of a sculpture without casting shadows. "A sculpture looks as though it is lit by magic."

However, it can also be effective to light sculpture especially to cast a shadow – a matter of taste.

Old masters tend to be better lit in a soft ambient light – more suited to the light produced within the painting itself. A harsh spot will pick up and reflect unnaturally on darker oil paint. The frame-mounted light (where the light is attached to the frame or on the wall over the top of the frame and protruding out) is, in my opinion, the least attractive and most distracting.

Wall hangings/large canvases are best lit with the surface-mounted Echo system, which creates a soft, flat, wash effect.

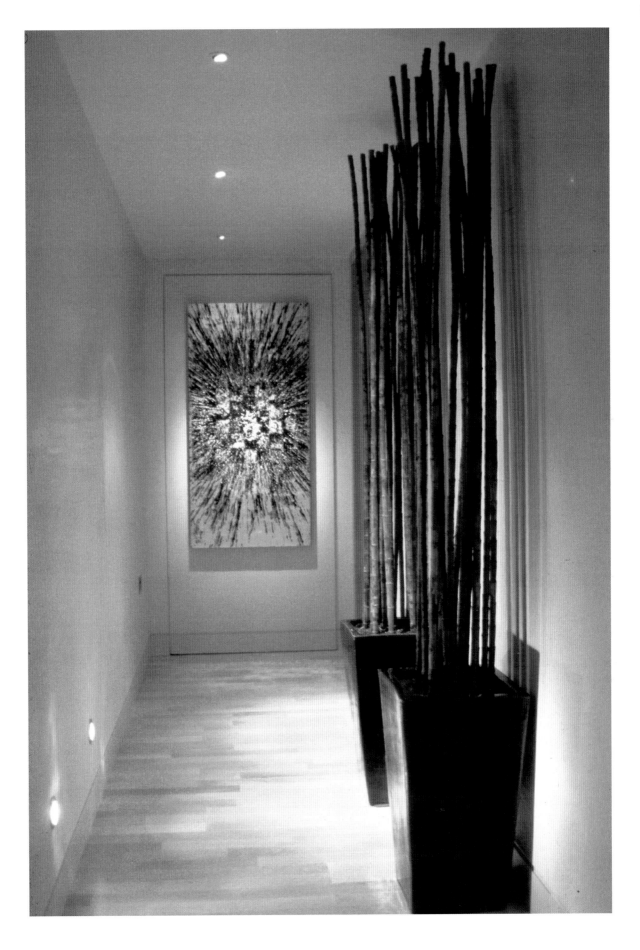

KNOW YOUR MOVEMENTS

Labels and movements in art are created as terms of reference for people other than the artists themselves. The definitions below are the very simplest that can be included in this book and as such it must be noted that dates, eras and the 'movements' themselves are never contained within precise brackets. For example, to refer to the Renaissance period in art is to refer to hundreds of years, thousands of artists across many countries and a reduced definition can never do justice to important studies such as these. The information below is therefore intended as the most basic of guides through the history of art. There are artists who span different 'movements' and there are artists – giants such as Rembrandt and Velasquez – who don't fit into any one particular movement. There are artists around whom a movement has developed such as Andy Warhol and Pop Art – and there are periods of time when no obvious art movement has been named at all.

These terms of reference are coined by writers, critics, art historians and, paradoxically, have little to do with the conception of art. They are terms that are helpful in categorising art for sale at auction, for historical archives or for teaching purposes. The full list of such movements and terms is vastly longer than can be included here. Furthermore the movements most usually referred to, gain currency in the Western art market. Artists from diverse cultures across continents regardless of colour, creed, national boundaries and terminology are all free from classification, united only by the essential spirit of art.

Ancient Art (2000 BC)
Early Egyptian art, pottery and metalwork, predominately found in tombs.

Classical Art (625 BC-200 AD)
Relates to Greek and Roman art of antiquity, principally concerned with architectural symmetry and classical beauty – agreed definitions of beauty.

Byzantine Art (350-1450)
Religious art from the Byzantine Empire, characterised by mosaics, illuminated manuscripts, gold embellishment and domed architecture.

Gothic Art (1200-1600)
Mainly an architectural movement, but also the term used to describe sculpture and painting from the era.

Renaissance (1300-1600)
A big one. Centred in Italy and northern Europe and celebrating the 're-birth' of interest in classical art. The work of Leonardo da Vinci, Michaelangelo, Raphael and Albrecht Durer, were, for centuries, regarded as epitomising the classical notion of beauty, harmony, proportion and balance. This rich period in art reflected the economic growth, social sophistication and advances and spread of education of the time.

Mannerism (1520-1600)
A move away from the harmony and classic proportions of late Renaissance. Identified by harsher lighting, crowded canvasses and contorted physical poses.

Baroque (1600-1700)
More emotionally explicit and more realistic than Mannerism. A return to tradition and spirituality. Caravaggio, Bernini, Lebrun, Rubens.

Rococo (1730-1800)
Originally referred to interiors embellished competitively by French society women in Paris. The elegant, decorative forms were taken up in painting and engraving. Boucher, Watteau.

Neo-Classical (1670-1880)
In reaction to the Baroque/Rococo styles in art, this movement revived the ideals of Greek and Roman art. Classic forms were used to express the artists' (or their patrons') ideas about courage, sacrifice and love of the countryside. Jacques-Louis David, Antonio Canova, Piranesi.

Romanticism (1800-1880)
Following the French Revolution a new passionate energy emerged, full of ideals for a new society. JMW Turner, Caspar David Friedrich. In the United States, the **Hudson River School** movement celebrated landscape painting. Thomas Cole, Thomas Doughty, Asher B. Durand.

Pre-Raphaelite (1848-1920s)
The word stems from the term attributed to the movement by amongst others Holman Hunt and John Millais – denoting the appreciation these artists felt for the style of art preceding and including Raphael. Medieval scenes depicting courage and loss and celebrating nature in a rejection of an industrialised society. Dante Gabriel Rossetti, Edward Burne-Jones, William Morris.

Realism (1830-1870)

Another reactionary movement. The theatrical style of Romanticism was abandoned in favour of representing familiar, everyday scenes. Jean-Francois Millet, James Abbott McNeill Whistler.

Symbolism (1885-1910)

Rooted in literature, especially French Romantic poetry, the Symbolists believed that emotions and ideas could be conveyed through analogous as well as literal words. The proponents of the style of Symbolism in painting were Odilon Redon, Edvard Munch, Gustav Klimt, depicting their fascination with mysticism, eroticism and images with a dreamlike quality.

Impressionism (1867-1886)

Another big one, and generally regarded as the beginning of modern art. Primarily a French movement in art which broke free from the tradition of European painting prior to this time. The rich development in colour, and the portability of paints and equipment led artists to paint outdoors, to paint direct from nature. They had to paint quickly and this led to bright, vibrant, fleetingly caught images and scenes. Paint was applied with quicker, smaller brushstrokes. The results were impressions of the scenes they saw, not detailed realistic images. Edouard Manet, Claude Monet, Pierre-Auguste Renoir, Edgar Degas.

Pointillism (1883-1892)

Within the broad movement of Impressionism smaller movements evolved, including Pointillism – in which small brushstrokes creating dots of colour produced a shimmer effect when viewed from a natural distance. Georges Seurat's *La Grand Jatte* (1886) remains the leitmotiv painting of this style.

Neo-Impressionism (1887-1900)

Another smaller movement under the overall umbrella of Impressionism: Paul Gauguin, Henri Matisse, Henri de Toulouse-Lautrec, Mary Cassatt, Camille Pissaro.

Post-Impressionism (1880-1920)

The English art critic Roger Fry coined the term to attribute the work of painters such as Paul Cézanne, Vincent Van Gogh, Paul Gauguin. These artists had started painting in the Impressionist style but developed their own style depicting their highly charged emotions and responses to the landscape around them – the colours more brilliant, the lines stronger and more vibrant, individual narrative styles emerging. Paul Cézanne is generally heralded as the father of Modernism.

Fauvism (1905-1910)

The first avant-garde movement in 20th-century European art and as such is a major development. The colours became vivid and non-naturalistic, non-representational. Natural forms and landscapes were often distorted. The term arose at an early exhibition by these artists in which a classical sculpture stood – a critic exclaimed "Donatello au milieu des fauves!" meaning "Donatello among the wild beasts!" The term stuck and was enjoyed, especially by the non-conforming artists themselves. Henri Matisse, André Derain, Raoul Dufy.

Modernism (1890-1940)

A development of Fauvism, the movement was characterised by ever bolder departures from tradition in types of paints and the materials used in painting, as well as in styles that expressed emotions and ideas.

Art Nouveau (1890-1914)

Referred more to the decorative arts of glasswork, jewellery, tapestries, hangings and interior design characterised by an elaborate ornamental style depicting flowers, leaves, entwining stems and erotic themes. The style originated in Paris then succeeded in Britain in the **Arts and Crafts** movement (1880 – 1910) led principally by John Ruskin and William Morris. For too long, Victorian over-decorated, ornamented interiors had prevailed in middle-class homes in England and across America – the Arts and Crafts movement developed simpler designs and extolled good craftsmanship in rejection of poor machine-made goods. Art Nouveau flourished all around the world: Gustav Klimt, Aubrey Beardsley, Antonio Gaudi, René Lalique, Louis Tiffany, William Morris.

Ashcan School (1900-1918)

Founded in Philadelphia by artist Robert Henri, this movement was less about style and more about revolutionary subject matter depicted by gritty urban reality, poverty and a disenfranchised society. Colours were dark and subdued, reflecting their commitment to a non-idealised portrayal. Henri was influenced by the work of Goya and Velasquez on a visit to Europe. The principle protagonists of the movement – a hard core of eight artists – organised an exhibition amongst themselves, free of selection and prizes awarded by an external body or committee. It was to become the model for The Armory Show of 1913 in New York which was the most famous exhibition hitherto of Modern Art. Exponents of Ash Can School: Robert Henri, William Glackens, George Bellows, Edward Hopper.

Expressionism (1905-1925)

Mostly associated with northern European art, especially in Germany. This movement represents a very subjective response to the artists' emotions where distortion, exaggeration, primitivism are used to shock or jar the viewer's sensibilities into understanding the meaning the artist wanted to convey. Max Beckmann, Otto Dix, Oskar Kokoschka, Edvard Munch, Wassily Kandinsky. Expressionism reached its peak in the movement termed **Der Blaue Reiter** – the term itself deriving from a drawing by Kandinsky featuring a blue horse. Individual expression was embraced in literature and the arts, summarised by Nietzsche: "He who wishes to be creative must first destroy accepted values."

Cubism (1908-1914)

Led by Pablo Picasso and Georges Braque. Another major art movement in which three-dimensional subjects were fragmented then reconstructed to view the subject from several points of view simultaneously. Also Piet Mondrian, Juan Gris, Fernand Leger.

Futurism (1909-1944)

An Italian art movement inspired by speed, technology, the machine age. Gino Severini, Umberto Boccioni, Giacomo Balla, Filippo Tommaso Marinetti.

Constructivism (1915-1940s)

A movement invented by the Russian avant garde painters but whose philosophy in art spread to Germany, Paris, London and the United States. The form was reductionist; totally abstracted, geometrical imagery without the embellishment of emotion. The artists shared a utopian thread in rejecting the old order and envisaging a world united by peace and understanding. The style and form of this movement is not to be compared with the recent vogue for abstract art where the underlying philosophy is often absent. Ben

Nicholson, Naum Gabo, Laszlo Moholy-Nagy, Wassily Kandinsky, Hans Richter.

Dada (1916-1920s)

Anarchic international movement in art and writing, allowing the absurd and the unpredictable to lead the creative response. Though widely disparaged for flippancy, the Dadaists were also responding to the moral outrage and carnage of World War 1 and many of the ideas were to shock people into a new order of thinking. The term was arrived at by randomly opening the dictionary and letting a penknife pinpoint a word - *dada*. The word translates into English as hobby-horse, pet subject. Kurt Schwitters, Max Ernst, Marcel Duchamp, Hans Arp.

Bauhaus (1919-1930s)

Major school of art, design and architecture founded in Germany in 1919 by Walter Gropius producing architecture, furniture, typography, poster design and textiles and creating a lasting influence on design to the present day. Walter Gropius, Laszlo Moholy-Nagy, Paul Klee, Lyonel Feininger.

Art Deco (1920-1939)

Reflected the emerging age of technology and speed epitomised by sleek, straight lines, slender streamlined forms in architecture, art and design. William van Alan, Tamara de Lempicka.

Surrealism (1920-1930s)

A movement in art and writing using the imagination and subconscious revealed in dreams as its inspiration. The poems of le Comte de Lautréamont (Isidore Ducasse) bewildered his contemporaries but the Surrealists were inspired by his famous quote:

"Beautiful as the chance encounter of a sewing machine and an umbrella on a dissecting table." Marcel Duchamp, René Magritte, Salvador Dali, Pablo Picasso, M.C. Escher, Man Ray.

Social Realism (1930-50)

Social Realism artists focussed specifically on, and were critical of, political issues affecting society and the hardships and social problems experienced through the Depression era of the 1930s. Many were greatly influenced by the Ash Can School as well as by the Mexican painters Diego Rivera, José Clemente Orozco, and David Alfaro Siqueiros. Exponents: Ben Shahn, Jack Levine and Jacob Lawrence.

Abstract Expressionism (1940-1960s) also the New York School

Originating in New York City and often regarded as the golden age of American art. Celebrated painting on a large scale with big canvasses, powerful emotions, bold use of paint and colour. Jackson Pollock, Mark Rothko, Robert Motherwell, Barnett Newman, Clyfford Still, Franz Kline.

Pop Art (1950-1960s)

Post-war society became fascinated with popular culture and renewed affluence. Originating in America and Great Britain, the artists in the movement celebrated everyday objects such as soup cans, washing powder cartons, strip cartoons – thus turning them into icons. Andy Warhol, Richard Hamilton, Roy Lichenstein, Claes Oldenburg, Peter Blake.

Op Art (1963-1971) Also known as Optical Art.

Based on the effects of optical patterns. Bridget Riley, Victor Vasarely, Heinz Mack.

Minimalism (1950s-)

Simplicity in content and form are the main exponents of the movement. Purposely lacking in personal expression, the artists' intention is to allow the viewer to experience the work of form and content without the distraction of theme or emotion. Ellsworth Kelly, Frank Stella, Sol LeWitt.

Post-Modernism (1960s-)

The doors opened yet further to allow a wider freedom, a move away from art rooted in any single philosophy, embracing a more eclectic and populist approach to art. Peter Blake, David Hockney, Jasper Johns, Donald Judd, Jeff Koons.

Conceptual Art (1960s/70s-)

A movement of the 1960s and 1970s that emphasized the artistic *idea* over the art *object*. Its exponents attempted to free art from the confines of the gallery and the pedestal. Again there is no 'end' date – the movement came to prominence in the 60s and 70s but as an art concept (literally) it continues today. Allan Kaprow, Joseph Beuys, Bruce Nauman.

Neo-Expressionism (1980-1985)

A swing away from abstract, highly intellectualised art. The neo-expressionists returned to portraying the human body and contemporary urban life. The ostentatious, power-hungry 1980s which was the backdrop to this largely American and European movement prompted its critics to question the quality of some of the art itself and the highly commercial art market which promoted it. Julian Schnabel, Francesco Clemente, Georg Baselitz.

This list concludes in the last century, but it is only from the perspective of any present day that previous styles or movements can be categorised – only time will tell whether a current artist, or group of artists, will later be judged worthy of mention. No doubt Damien Hirst and the other core YBA's (Young British Artists) that formed part of his exhibition 'Freeze' in London in 1988, will take root as artists of our time – but their debut was nearly twenty years ago, so it is not surprising that the vantage point of time has allowed them to settle. Who and what will be the remembered artists and movements in the future? The present contemporary art scene is exciting, but just because something is new and groundbreaking it does not necessarily have to be admired. The freedom to explore ideas and techniques is potentially challenging for any artist, but, unlike in science and technology, we can never truly speak of 'progress' in art. It simply remains to be seen.

Landscape of Guillin, Fang Zhaoling

"*I believe that if it were left to artists to choose their own labels, most would choose none.*"

BEN SHAHN (1898-1969), AMERICAN PAINTER

SOME ART FACTS

PAINTING

A painting has basically three constituent ingredients: the colour pigments, the binder, and the support. The technique of the painter is in combining these materials. Technique is often confused with style, but the technique is the practical application and the style is the manner or artistic phenomenon of the painter. Technique can be taught, as a craft. Style cannot be taught; it is either inherent or copied.

Until the end of the eighteenth century private studios existed where the master painter had his (and they were nearly always men) apprentices who learned technique and developed style in the manner of, or independently of, the master. The apprentice would learn how to produce colour from raw materials, how to mix the paint with appropriate binders and how to prepare the surface material to achieve a lasting result. Knowledge of related chemistry was essential and secrecy surrounded individual research and development. Art schools and academies began to replace private studios concurrent with industrial production of ready-made painting materials. Quality became sacrificed to quantity as the demand for sales increased. Painting proliferated – no longer the domain of the selected art student or amateur hobbyist – but as a potential means of earning a living or position in society depending on financial status or need. Ready-prepared materials regained quality alongside inferior products to satisfy an ever-growing band of painters.

Whether the 'painting' is a masterpiece on canvas, a child's first splashes, or application of colour to a garden fence – the basic ingredient remains the same – colour powders. These powders are mixed with different binding materials to create paints, or they are bought ready-made in tins, boxes, tubes or blocks. Ordinary hardware stores in Italy often sell these beautiful powders, displaying them in large glass containers. You can buy as much as you want and mix it with whichever binder is appropriate for your domestic or artistic need.

The material on which the paint is applied is called a 'ground'. This can range from traditional canvas, paper, cardboard, wood, cloth or artificial board. With the exception of paper, all grounds need some sort of priming to a) provide a durable white surface and b) to prevent the paint from soaking in to the material.

Oil

Oil paints are made by mixing powdered pigments with oil, linseed being the most traditional. The medium developed in the fifteenth century and became the dominant form of painting for the next couple of centuries. It has never lost its appeal for artists due to its versatility, flexibility and rich colours. Oils are slow to dry and need a final coat of varnish to protect the oil from cracking or sinking into the canvas or prepared ground.

OPPOSITE: *Morning Sun,*
Edward Hopper
RIGHT: *Alley in the Rain,*
Ho Huan-Shuo

Watercolour

Watercolour is, technically, any type of painting medium soluble in water. When people talk about 'a watercolour' it usually refers to works on paper with thin washes of transparent watercolour – but in fact it has a much broader application.

Acrylic

This type of paint medium was developed in the twentieth century. It is a synthetic resin and is made by dispersing pigments in an acrylic emulsion. It is water-soluble, making it a versatile paint and incredibly tough and durable. Unlike oil paints, acrylic is both quick-drying and inexpensive. It is usually thought of as a type of oil paint because – although acrylic is water-based and oil paint is oil-based – the texture out of the tube more closely relates to the technique of oil painting. But, like for like, an oil painting will generally be more expensive than an acrylic.

Gouache

Gouache is a watercolour paint and differs from the more usually referred term of 'watercolour' because it is opaque, not translucent. As such, it produces more definite, intense colours. Good for fine detail. Rather chalky quality made opaque by the addition of Chinese white to the pigment.

Tempera

This is a beautiful medium made of powder pigments mixed with egg yolk and thinned with water. Early Italian painters used this until the development of oil paints replaced its popularity.

Encaustic

Originally a medieval technique, the coloured pigments are mixed with molten wax then 'painted' on to a surface.

Chinese ink

In genuine Chinese ink, carbon is used – it is very fine soot obtained by the incomplete burning of camphor oil. The soot is ground in water with a trace of glue and other ingredients and pressed into a cake or stick. The stick is then ground down in a bowl or pestle and mixed with water to produce the desired consistency. The ink is never used with a steel nib pen – a reed pen can be used but best of all is the Chinese brush – it is so expressive and has an extraordinary range from producing hair-thin lines to very broad strokes.

RIGHT: *Cat Studies*, Christopher Row
OPPOSITE ABOVE: *Ben*, Jane Cope
OPPOSITE BELOW: *Stonehenge*, John Eaves

DRAWING

The classical drawing is in black on a white ground. Pen and ink, charcoal, pastel and coloured pencil are also used in this most basic of art media. Often underrated, or seen as 'sketches' for work produced in another medium, drawing is not simply the first step in making a painting, but a means of artistic expression in a completed picture. Drawing can be, but is not necessarily, a linear activity. It is a form of painting – with similar objectives but with fewer colours. It is not only the oldest form of art, but also a form of communication with which we are all familiar – from childhood and our own primal expressions, to our daily link with the pen and line in some shape or form; from doodles to signatures.

For an art collector, drawings offer a more accessible medium since they are less expensive than painting or sculpture, yet they are unique works of art. It is a way of buying into an artist's work that you like, but whose work might be too expensive in another medium. However, as

the trend for buying drawings accelerates, the prices will inevitably go up. Some have already hit the headlines – a piece by Jasper Johns recently sold for just under $10 million – the most that had ever been paid for a graphic work of art.

The term graphic art extends to all kinds of representations using the principle of the abstracted line and is primarily dependent on line, not on colour.

Buying guidelines: Check for yellowing on the paper or overall darkening of the paper, brittle paper, premature ageing, mould growth, foxing (small circular patches of brownish discoloration) or deterioration due to poor conservation. Ask about the provenance. At what stage of the artist's life or career the drawing was completed. Was it part of a series of drawings? A sketch for work in another medium? Or a completed drawing as an intended complete work of art?

ORIGINAL PRINTS

Any image that is made by pressing an inked or painted surface or object onto paper or other suitable surface (for example wood block printing onto fabric) is a print. There is an understandable amount of confusion surrounding the term print because it covers so many activities. An original print is one that has been created by the artist or has had the involvement of the artist in its production, including:

Lithograph

This form of print is the closest to an artist's painting; a complicated printing process based on the fact that water and oil do not mix. Oily crayons and inks are painted or drawn onto a smooth flat block of limestone. Water is applied to the stone not covered by the crayon. Oil-based ink is then applied with a roller, which is repelled by the wet stone. The resultant image on the paper, which has been pressed against the inked drawing, is a reverse of the original drawing.

Monoprint

In this process an image is drawn onto a thin layer of ink or paint on a screen, plate or piece of glass. It is manipulated in whatever way the artist chooses and then a piece of paper is laid over the ink/image/plate and when peeled back reveals the image. This is a one-off and no editions are made.

Intaglio Process

From the Italian word meaning to incise, this process can include variations but they all share the fact that a design is etched into a plate of some sort and then layered with ink that sinks into the etched marks. The surface of the plate is cleaned and the dampened paper pressed or rolled onto the plate. When the paper is peeled back the inked design is revealed in reverse.

Etching

The plate, either copper or metal, is coated with an acid-resisting wax that the artist draws into. The plate is then immersed in an acid bath, which etches out the areas drawn into. The plate is then inked and wiped clean leaving the ink in the etched marks. Again the paper is pressed or rolled onto the plate, which reveals the inked line when the paper is peeled back. An original etching can be identified by its indented plate-mark, caused by the great pressure needed to print the image.

Drypoint

This is less messy than etching and does not require the use of acid. The artist draws the image with a steel tipped point using it as a pencil directly on to a plate.

Relief Printing Process

This is an inverse method of Intaglio as the technique involves cutting away everything on the surface of a block of material, leaving only the image proud or in relief. The ink or paint is rolled onto the exposed carving and when the paper is peeled from it, only the image remains. The area that has been cut away and not touched by ink produces a blank border to the image. Woodcuts or woodblock prints are the most distinguished of this process and it is the oldest known printing technique. Linocuts, which replaces wood with linoleum, are much easier to manipulate than wood although do not offer the same range in delicacy. Any surface or block can be adapted, e.g. potato prints.

Screenprints, Silkscreen Prints, Serigraphs

Developed in America in the twentieth century. A frame containing a mesh screen of either silk or nylon is the basis of the process. A variety of stencils or resistant emulsions are placed on the screen. Colour is then smoothed over the stencil with a squeegee (a bit like the gadget used to scrape ice off the windscreen), which then deposits itself on the paper below the mesh screen avoiding the stencils or paint-resistant emulsion.

In the case of all the above original print processes, the artist will approve the resultant print, which he or she will then sign in a numbered edition. The first few off the press will be marked simply A.P. denoting Artist's Proof with no number. The number in an edition was traditionally 75. The earlier prints (and therefore the lower numbers) are considered more valuable since they are fresh off the press and there is no sign of weariness of the image or print and the mesh itself is fresh.

Buying guidelines: Prints by masters who are now dead are easily copied, so you need to be careful of not buying something that is worthless when expecting to own a piece of art history. Be especially vigilant when buying a print – which won't be a problem if you are buying from a reputable dealer. Feel the paper, even smell it (any whiff of modern paper or copying ink will be an obvious deterrent). But if in doubt, double check. And never be afraid to ask questions. Especially if investment is a factor in your purchase.

Make sure you save any documents that came with the art work to be framed. Save the Certificate of Authenticity that came with your print. Your framer should be able to create a pocket on the back of the frame in which to store it. Any information on the back of the print or board should be transferred to the back of your new frame. Also save the folder, if any, in which your print arrived. All these items are important if ever you want to re-sell.

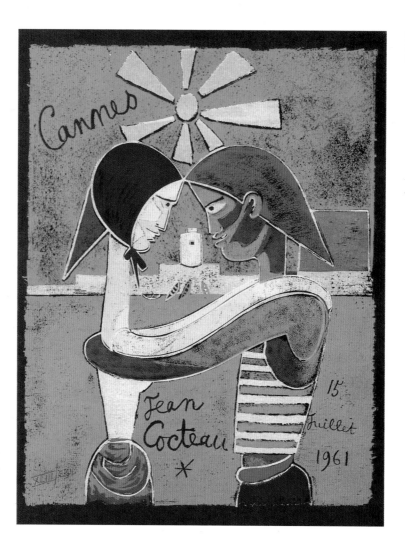

REPRODUCTION PRINTS, POSTERS

Once a print is reproduced mechanically it has a very different value. This could be a reproduction of an original print or of an original painting, photograph or drawing. Whichever the case, it can appear that the reproduced print has a greater value than is the case merely by having a number and an edition on the print. It is easy to see that if a limited edition of, say 500 prints is out there it is possible to produce duplicates of each of the numbers since it is virtually impossible to 'police'. Experience, diligence, buying from reputable dealers and galleries, asking questions and developing a 'nose' will all help distinguish between blurred lines of representation.

Unlimited reproduction prints and posters have and will continue to have a broad appeal because of their accessibility of image and low cost. It goes without saying that there is no value or originality in the print until perhaps time will limit their availability – as in the case of old posters that are now out of print.

Giclée Prints

These are enjoying a vogue with the development and sophistication of printers. Giclée means literally 'squirted' because that is how the ink is projected on to the paper by the 8 – 12 colour printer. Giclée prints are more expensive to reproduce than prints by standard inkjet printers – the machine itself is much larger than those in use when the method initially took off. But with printers becoming increasingly accessible the cost of producing these prints becomes more competitive; the charge on the print bearing the Giclée tag however, remains. It must be stressed though, that expensively produced, quality Giclée prints still abound. Like any easily copied method, there are prints out there that are little better than good photocopies being described as Giclée to justify the price and there are fine quality expensively produced Giclée. The weight and quality of the paper itself is a guideline to the value of a Giclée. In the case of a limited edition, the same rules of diligence as buying any prints apply.

ASSEMBLAGE

This describes pieces of wood, metal, scrap and other everyday found items that are welded or pieced together to make a three-dimensional construction. Favoured by the Cubists, Surrealists and artists of the early twentieth century.

MIXED MEDIA

This is a term that refers to a piece of art that incorporates more than one technique or material – medium. A watercolour with a thin strip of flimsy material laid across it is already mixed media. A collage is also mixed media and often the two terms are interchangeable.

The term collage comes from the craft of 'papiers collés' meaning literally 'stuck paper' and is extended to include not just cut bits of paper, newspaper, magazines but also fabric, cardboard, photographs and indeed anything that will stick with glue. Pablo Picasso and Georges Braque brought collage to attention at the beginning of the twentieth century. Henri Matisse took up making collages in his old age when his failing sight prevented him from painting. He cut up large coloured sheets of paper and stuck them with great effect in his chosen shapes, influenced by a lifetime of line, colour and form.

Collage has now been so absorbed into our contemporary culture that we may hardly notice it. When viewing art it is always interesting to read the wall labels or details of the medium.

HANGINGS

Decorative hangings have a long tradition both culturally and artistically. These might be woven or printed depending on the tradition (for instance, French and English tapestries, American quilting, Indonesian Batik or Ikat). Paintings on silk, hung from a single strut or mounted onto a scroll, are widely used beyond the western tradition of art display.

Rugs have moved on a long way in the last twenty-five years. Previously they were grouped together with carpets as a means to protect and warm the floor and the feet even when cherished as valuable antiques and pieces of cultural heritage.

The crossover into a medium for contemporary art took off when designers in the 1990s produced their own designs and rug manufacturers commissioned well-known artists as well as art college graduates to produce their art on rugs. Using the best materials and traditional hand knotting means these rugs can take up to a year to produce, resulting in an art form which is more often hung on the wall than laid on the floor.

PHOTOGRAPHY

The history of photography is short compared with that of other art forms. It is barely 170 years since Henry Fox Talbot created a permanent negative image using paper soaked in silver chloride, fixed with a salt solution and then making a positive image by contact printing onto another sheet of paper. The first half-tone photograph appeared in a daily American newspaper only 126 years ago and the first Kodak Box Brownie roll-film camera was introduced in 1900.

Today the market in art photography is booming. The same criteria applies to collecting photographs as in any other art buying – buy it because you love it. If the value of your art increases, so much the better. Because the photography market is relatively new, so too is the terminology and vocabulary; guidelines are still being defined. Good sense and research are advised.

Only the briefest guidelines can be included here. Thereafter photography galleries, exhibitions, books, and magazines will be a rich source of enjoyment and knowledge. If it is an area of particular interest then seek out a few specialists from whom you can learn. Ask questions. Particular areas to focus on when buying a print include the following topics.

It is rare today for a photographer not to sign his work either in pencil or ink – either on the front or back of the image. Before photographers were working in the context of the art market they were not so concerned with signatures. Well-documented photographs can be assigned provenance by a dealer or auction house where appropriate. Similarly the idea of print editions has become more usual as a result of photographers developing careers in the gallery art market, and guided by dealers versed in other (non-photographic) print editions. Any

gallery representing or selling the work of a particular photographer should know how many prints remain in an edition and, in the case of open editions, how many prints have been made. Exact numbers can rarely be known. The date of a photograph can usually be determined by the type of paper used, (the condition of the print itself usually develops a sort of patina with age) the quality of the print, and the presence or absence of a signature or stamp.

Understanding the vocabulary helps to demystify the complicated and magical process of photographic development. The following are a few key terms:

Contact print This is produced by placing the negative in direct contact with paper rather than projecting the image through an enlarger. These have a better resolution and sharpness of detail and will always be the size of the negative itself.

Edition This is a limitation on the number of photographic prints from a single negative. As in other printmaking, the limitation number of the edition is written below the number indicating the individual print in the series.

Silver print This is a generic term for all prints made on paper coated with silver salts. Most contemporary black and white photographs are silver prints.

Vintage print This refers to a photograph printed within a close time frame to the making of the negative; generally not more than a few years. If a print is made recently from an old/original negative it is called a 'modern print' irrespective of how old the original negative is.

OPPOSITE: *John Coltrane, 1961*, Robert Freeman
ABOVE: *Ruby Tulips*, Caroline Hyman
BELOW: *France, Brie*, Henri Cartier-Bresson

SCULPTURE

Sculpture is the creation of a three dimensional work of art, especially by carving, modelling or casting. The effect of a sculpture should be that you want to touch it, feel it, handle it – as the sculptor feels when making it.

The influences that changed the course of painting also changed the shape of sculpture at the end of the nineteenth century. Rodin was a contemporary of Cézanne, who is often upheld as the father of modern painting. Despite being a great artist, Rodin was not a groundbreaker in sculpture in the way Cezanne was in painting. He followed and expounded classical traditions in sculpture. It was Picasso and Brancusi who, at the beginning of the twentieth century, broke traditional moulds in sculpture. They were greatly influenced by African and Oceanic sculpture, by cultures beyond the Western tradition. These were also among the influences on cubist art – both in painting and sculpture.

The appeal of this new expression of sculpture and painting came from feeling and instinct – free from the weight of imposed ornate classical art or intellectual restraints. Jean Arp, Henri Matisse, Julio Gonzalez, Naum Gabo, Henri Gaudier-Brzeska, Alexander Calder, Alberto Giacometti, and then Barbara Hepworth, Henry Moore, Antony Caro, Lynn Chadwick, Elizabeth Frink – these are just a few of the influential artists working in this medium during the twentieth century.

Carving

A block is the starting point whereupon the sculptor will chip or carve the image from the material. Wood, marble, stone, alabaster, limestone, granite and sandstone are popular materials.

Casting

The intial cast or mould is made from clay or wax. Then a molten fluid such as bronze, metal, concrete, resin or even plastic is poured into the mould to set. Once set, the mould is chipped away to reveal the form within.

Modelling

A three dimensional form is shaped from clay either free form or, in the case of pottery and bowls, on a potter's wheel. The work is then placed in a kiln, a very hot oven in which the piece is fired and then sets hard.

When buying sculpture more than any other art form – search with your hands as well as your heart and eyes. The feel of a piece is equal to the look of the piece. "Do not touch" notices are there to protect (although they're usually directed at people too young to read), but it is quite acceptable to ask whether you could hold the piece. Most sculptors welcome careful tactile appreciation. When I was working in the gallery, we used to put discreet notices near a piece of sculpture or ceramics, which read: "Please touch".

BELOW LEFT: *Black Swan*, Patricia Low
BELOW RIGHT: *Girl and Dog*, Ann Catherine Low
OPPOSITE: *Jerusalem Tree*, Zadok Ben-David

ART GALLERY

The following pages display a selection of art presented as a mixed exhibition. This is designed to give the viewer a chance to consider aspects of the book, as though strolling through an art gallery or art fair. Why, in theory, to choose certain pictures; where they might fit into a home; what they might express; whether the pictures hang well together — in other words an opportunity to exercise the eye.

ABOVE: *Wave forms of Palm Tree II*, Carol Bruton

OPPOSITE: *Steps Down Symi*, Cynthia Rowan
ABOVE: *Wild Orchid from the Garden of His Holiness the XIVth Dalai Lama*, Jo Self

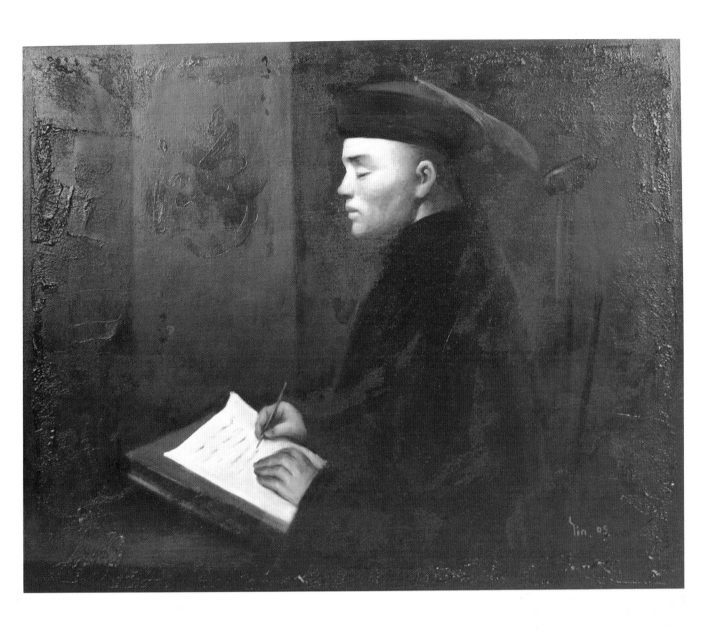

OPPOSITE ABOVE LEFT: *Buzzard,* Sir Kyffin Williams
OPPOSITE ABOVE RIGHT: *On the Edge II*, Lisa Dalton
OPPOSITE BELOW: *Still Life with Blue Basket*, Gail Lilley
ABOVE: *The Draughtsman,* Yin Xin

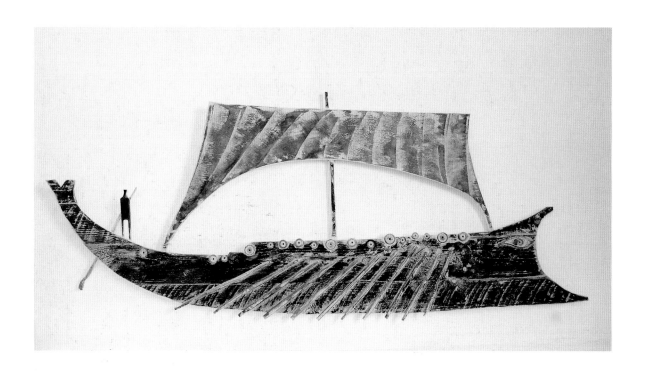

OPPOSITE ABOVE: *Trireme II*, Derek Nice
OPPOSITE BELOW: *Still Life of Bowl and Red Apple #2*, Jo Barrett
ABOVE: *Yellow Eyeshadow*, Annik le Page

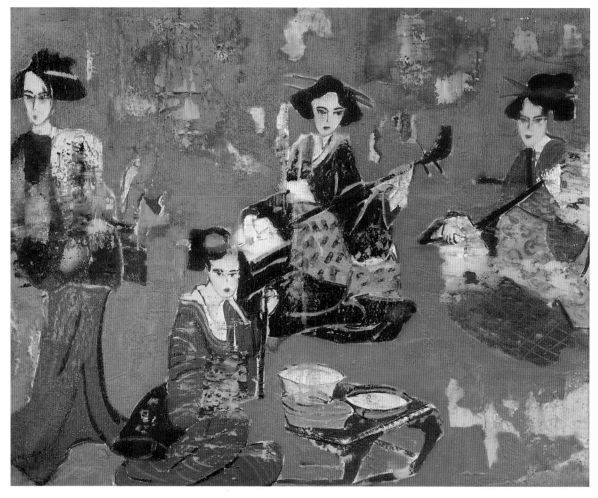

ABOVE: *Equine Grey*, Robert Highton
BELOW: *Musicians*, Annik Le Page

ABOVE: *Idiot Chickens*, Tim Nicholson
BELOW: *Sweet Lucille*, Gemma Jones

OPPOSITE ABOVE: *Spanish Oak*, Sierra de Gredos, Robert Freeman
OPPOSITE BELOW: *Agave*, Chris Lambert
ABOVE: *Poème sur la Colline*, Xiaoyang Galas

OPPOSITE: *Deconstructing Seurat Blue*, Michael Craig-Martin
ABOVE: *We Swam among the Fishes*, Julian Opie

OPPOSITE ABOVE: *Full Bloom*, Bycamera
OPPOSITE BELOW: *Beach River, St Ives*, Elaine Pamphilon
ABOVE LEFT: *Lilies*, Bycamera
ABOVE RIGHT: *Birdwoman*, Christopher Marvell
BELOW: *Bowl of Cherries*, Abbie Young

ART GALLERY

ABOVE: *Chrysler Building*, Michael Kidd
BELOW: *Cloudslope*, Clyde Holmes
OPPOSITE ABOVE: *Lucy Swimming*, Mark Pearson
OPPOSITE BELOW: *Invierno Ruso*, Muhadin Kishev

OPPOSITE: *Heat*, John Eaves
ABOVE: *Great Catch*, Evelyne
Boren
BELOW: *Red Night in St
Tropez*, Carol Bruton

ARTISTS in interiors photographs

The following works appear in the interiors photographs on the pages numbered:

2-3 Sculpture from
The Monsters series
Lionel Bawden;
Three paintings from
Polychrome Poison series
Peter Adsett;
Fish Basket
Rosie Bindal Bindal
courtesy of Maningrida Arts and Culture
www.grantpirrie.com

6 *Wall Painting*
Sol LeWitt
www.barbarakrakowgallery.com

8 *Untitled*
Sol LeWitt
www.pacewildenstein.com

14-15 *Portrait of Lucas*
Chuck Close
Untitled Sculpture
Joel Shapiro
Metropolitan Museum, New York

17 Chinese silk painting
Yew Weng Ho
y.ho@talk21.com

21 Basket Room
Hotel Le Saxon, Johannesburg
designed by Stephen Falck

22 *Bullseye*
Jill Swan
jillswan@hotmail.com

24 *Too Little To Try, No 4*
Edd Pearman
www.eddpearman.co.uk

27 *Flower 146*
digital design
Artcadia.com
www.artcadia.com

30 *Saddles*
Paul Tan
www.poolatwork.com

32 *Garuda*
Aldo Rota
www.aldorota.net

34 *Poppy*
Jose Maria Sicilia
www.valentinamoncada.com

37 *Piscinas II*
Daniel Senise
www.silviacintra.com

49 *Untitled*
Anton Ferrieria & Connor
www.tarchitecure.mwen.co.za

54 *Rabbatt*
IKEA
www.ikea.com

64 *Collage*
Nancy Howard

75 *With Out Title*
Miguel Macaya
www.seneca1919.com

76-77 Mural in Nivola House, US
Le Corbusier

79 *Untitled*
Patrick Heron

83 *Three Shapes on Light Red*, January 1962
Patrick Heron
Photographed at the artist's house,
Eagles Nest, Cornwall
Oil on canvas. 76x36 ins.

84 *Flowers*
Peter Romaniuk

90 *Que Tens Sed*
Josep Moncada
www.franciskylegallery.com

91 *Orchard Tambourines*
Terry Frost
www.beauxartsbath.co.uk

93 *Seed*
Richard Larsen
www.stremmelgallery.com

96 *The Dead Past Lives Again*
Ida Lorentzen
www.bouhlou.no

99 *Untitled*
Amanda Vail
floristonhall@aol.com

100 *Thailand*
Paul Massey
t: 07775 840840

101 Photograph
Emilio Lekuona
www.berini.com

102-103 *Supporting Brothers*
Mike Speller
www.spellersculptures.com

111 On wall: *One Against One*
Michal Rovner
www.shoshanawayne.com
centre on chair: *Oscar Levant*, 1975
Richard Avedon
www.richardavedon.com

112 *Fishermen Cleaning Nets on Aldeburgh Beach*
Jane Wheeler
www.birchamgallery.co.uk

114 Mural
Sacha Cohen
prepared for Akzo Nobel Magazine
www.21carrot.com

115 left print: *Reina Mariana, III*, 2001
right print: *Reina Mariana VIII*, 2001
Manolo Valdés
www.marlboroughgallery.com

116 Photo art
Stephen Inggs
from the *Sensum Series*
www.joaoferreiragallery.com

118 Painting
John Paul Philippé
Arena Gallery, New York
t: 001 646 734 2261

120-121 Upstairs house extension, designed by
Sir Leslie Martin, 1970.
Kettle's Yard, University of Cambridge

122 *Sex*
Morag Myerscough
www.studiomyerscough.com

139 *The Double Gold*
Guido de'Costanzo
www.guidodecostanzo.co.uk

DIRECTORY of artists

The following lists the contact details of the artists whose work appears individually on the numbered pages:

4 Row 1 far left
ROBERT FREEMAN
Spanish Oak, Sierra de Gredos
Photograph
www.robertfreeman.net

4 Row 1 far left
HELEN LOPEZ
Pentraeth Beach
Oil on canvas
www.helenlopez.com

4 Row 1 right
HELEN LOPEZ
Time Out
Oil on canvas
www.helenlopez.com

4 Row 1 far right
JOHN PARSONS
Aegean Goddess
Sculpture
Limestone
Johnnyradium@ukf.net

4 Row 2 far left
WILLIAM SCOTT
Still Life with Frying Pan
Oil on paper
www.waterman.co.uk

4 Row 2 left
RICHARD WINKWORTH
Gold Still Life
9 panels wood, wax, 24ct gold
www.richardwinkworth.com

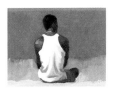

4 Row 2 right
MARK PEARSON
Watching the Waves
Oil on canvas
www.hollywoodroadgallery.com

4 Row 2 far right
LISA DALTON
Tamarillo with Limes on Black
Oil on canvas
www.lisa-dalton.co.uk

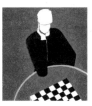

4 Row 3 far left
KEITH BANKS
Chess Player
Oil on canvas
www.hollywoodroadgallery.com

4 Row 3 left
CHRIS LAMBERT
Colle di Val d'Elsa
Pastel on paper
Trifflambert@blueyonder.co.uk

4 Row 3 right
ABBIE YOUNG
Jug and Lemons
Acrylic on paper
Abbieyoung77@hotmail.com

4 Row 3 far right
TIM NICHOLSON
Bird and Nest
Acrylic on paper
www.cranbornechasepictures.com

4 Row 4 far left
MICHAEL KIDD
Morning Light Manhattan
Acrylic on board
www.ronagallery.com

4 Row 4 left
ELAINE PAMPHILON
Bowl, Lemon and Bean Pod
Oil on board
www.elainepamphilon.com

178

4 Row 4 right
NIGEL WAYMOUTH
Tulips on Silk Ikat
Oil on canvas
www.nigelwaymouth.com

4 Row 4 far right
XIAOYANG GALAS
Poème sur la Colline
Oil on canvas
www.artbreath21.com

4 Row 5 far left
MUHADIN KISHEV
Dos, 1999
Collage
www.muhadinkishev.com

4 Row 5 left
MUHADIN KISHEV
Invierno Ruso
Oil on canvas
www.muhadinkishev.com

4 Row 5 right
EVELYNE BOREN
Festive Spirit, Rancho de Chimayo
Watercolour
www.nedramatteuccifineart.com

4 Row 5 far right
JO SELF
Tibetan Lotus with Dragonfly – from the Garden of His Holiness the XIVth Dalai Lama
Oil on canvas
www.redfern-gallery.com

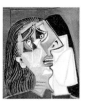

10
PABLO PICASSO
Weeping Woman, 1937
Oil on canvas
National Gallery of Victoria, Melbourne, Australia

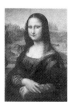

11
LEONARDO DA VINCI
Mona Lisa, 1503-1506
Oil on canvas
Louvre, Paris, France

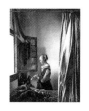

12
JAN VERMEER
A Girl Reading a Letter by an Open Window
Oil on canvas
Gemaeldegalerie Alte Meister, Dresden, Germany

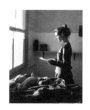

13 left
YIN XIN
Painting of a Lady
Oil on canvas
www.katharinepooley.com

13 right
TOM HUNTER
Woman Reading a Possession Order, 1997
Cibachrome print
www.whitecube.com

25
LEIGH MULLEY
Trainers
Water-based paint
www.wills-art.com

26 above
JO SELF
Pink Tibetan Lotus – from the garden of His Holiness the XIVth Dalai Lama
Oil on canvas
www.redfern-gallery.com

26 below left
ANNIK LE PAGE
Orchard Geisha
Oil on canvas
www.hollywoodroadgallery.com

26 below right
ZACHARY WALSH
Sleepy Soul
Oil on canvas
www.wills-art.com

28 above left
JOHN DEWE MATHEWS
Female Indian Construction Workers
Oil on canvas
www.johndewemathews.com

28 below left
TIDDY ROWAN
Venice Wall
Photograph
www.tiddyrowan.com

APPENDIX

28 right
MELANGI DE MILINGBI
Funeral ceremony
Aboriginal bark painting

31 above
TIM NICHOLSON
Painting by Numbers, No 5
Oil on canvas
www.cranbornechasepictures.com

31 below
MICHAEL HESLOP
Spearmint, Derby Winner, 1906
Oil on canvas
www.michaelheslop.com

33 left
LOUISE BELANGER
Blue Bird
Oil on canvas
www.louisebelanger.com

33 right
CHARLOTTE LYON
Zebra
Oil on canvas
www.hollywoodroadgallery.com

35
JOHN EAVES
Celebration
Watercolour collage
www.innocentfineart.co.uk

36 left
GAIL LILLEY
Harmony IV
Oil on canvas
www.gaillilley.co.uk

36 centre left
RICHARD WINKWORTH
Kyoto Garden II
Oil on linen
www.jmlondon.com

36 centre right
RICHARD BARRETT
First Light
oil on canvas
www.artgroup.com

36 right
PATRICK HAUGHTON
L'Abbaye à Lehon
Gouache and pencil on paper
Patrick.haughton@btinternet.com

39
MUHADIN KISHEV
Tunnels Of The Mind, 2005
Oil on canvas
www.muhadinkishev.com

40
PATRICK CAULFIELD
Sweet Bowl, 1967
Screenprint
www.artgroup.com

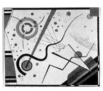

41
WASSILY KANDINSKY
Accompanied Contrast, 1924
Ink and watercolour

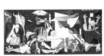

42-3
PABLO PICASSO
Guernica, 1937
Oil on canvas
Museo Nacional Centro de Arte Reina Sofia, Madrid

43
MUHADIN KISHEV
The Dark Dawn
Oil on canvas
www.muhadinkishev.com

45
ROBERT FREEMAN
Andalucia
Sepia photograph
www.robertfreeman.net

46
ANNIK LE PAGE
Violin Blossom
Oil on canvas
www.hollywoodroadgallery.com

47
TETYANA YABLONSKA
Newly Weds, 1966
Oil on canvas
Odessa Fine Arts Museum, Ukraine

56
HISHIKAWA MORONOBU
Picnic Scene
Colour and gold on paper
Museum of Fine Arts, Boston, U.S.

57
EVELYNE BOREN
Spring Blossoms
Watercolour
www.nedramatteuccifineart.com

58 above
ZARA HART
Waves of Green
Photograph
www.zarahart.com

58 below
CHRIS LAMBERT
Dressed Overall
Pastel pn paper
Trifflambert@blueyonder.co.uk

59 above
CAROL BRUTON
La Montagne Sainte-Victoire
Oil and sand on canvas
www.carolbruton.com

59 below
SIMON AVERILL
Nine Feathers
Mixed media on panel
www.jmlondon.com

60
HENRI MATISSE
Still Life with Pomegranates, 1947
Oil on canvas
Museum Matisse, Nice, France

61 centre
ABBIE YOUNG
Jug and Lemons
Acrylic on paper
Abbieyoung77@hotmail.com

61 left
XIAOYANG GALAS
Colour of Interior
Oil on canvas
www.artbreath21.com

61 right
LISA DALTON
Oranges and Lemon on Red and Black
Oil on canvas
www.lisa-dalton.co.uk

62
NIGEL WAYMOUTH
Tulips on Silk Ikat
Oil on canvas
www.nigelwaymouth.com

63 left
GEORGIA O'KEEFFE
Tulips
Oil on cardboard

63 centre
NIGEL WAYMOUTH
Cala Lilies
Oil on canvas
www.nigelwaymouth.com

63 right
BILL PRYDE
Orchid
Screenprint
www.curwengallery.com

64 below
RENÉ MAGRITTE
The Pebble
Oil on canvas
Royal Museum of Fine Arts of Belgium
www.fine-arts-museum.be

66
HOLLY FREEMAN
Tonight's the Night
Collage
www.hollyfreeman.com

67
NATASHA KERR
But Mum Can't Swim
Collage
www.natashakerr.co.uk

68
HELEN LOPEZ
Chef, Beaumaris, Anglesey
Oil on canvas
www.helenlopez.com

69 above left
MARK PEARSON
Watching the Waves
Oil on canvas
www.hollywoodroadgallery.com

69 above right
LISA DALTON
De La Huerta Dogs
Oil on canvas
www.lisa-dalton.co.uk

69 below right
SALLY MILES
Nude No 3
Oil on canvas
Sallyamiles@hotmail.com

69 below left
NIGEL WAYMOUTH
Sanjay and Rinchin
Oil on canvas
www.nigelwaymouth.com

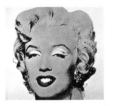

70
ANDY WARHOL
Marilyn Monroe, 1964
Synthetic polymer paint and silkscreen
ink on canvas

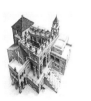

88
M.C. ESCHER
Ascending and Descending
Lithograph, 1960
www.mcescher.com

92 left
GAIL LILLEY
Harmony I
Oil on canvas
www.gaillilley.co.uk

92 right
RICHARD WINKWORTH
Gold Still Life
9 panels; wood, wax, 24ct gold
www.richardwinkworth.com
www.jmlondon.com

97
RENÉ MAGRITTE
Empire of Light, 1953-4
Oil on canvas
Peggy Guggenheim Collection, Venice

103
TRACEY EMIN
I Dream of Sleep, 2002
Blue neon
www.whitecube.com

104 above
MARC CHAGALL
Blue Angel
Oil on canvas

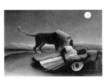

104 below
HENRI ROUSSEAU
The Sleeping Gypsy, 1897
Oil on canvas
Museum of Modern Art, New York

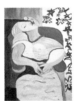

105
HOLLY FREEMAN
Dreaming Girl
Oil on canvas
www.hollyfreeman.com

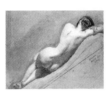

107 above
WILLIAM EDWARD FROST
Life Study of the Female Figure
Oil on canvas
Victoria & Albert Museum, London

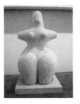

107 below left
JOHN PARSONS
Earth Goddess
Sculpture
Limestone
Johnnyradium@ukf.net

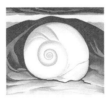

107 below right
GEORGIA O'KEEFFE
Red Hills, White Shell, 1938
Oil on canvas
Museum of Fine Arts, Houston, Texas

108 above
DAPHNE STEPHENSON
The Leopards
Oil on canvas
t: c/o 01264 735620

108 below
JACQUES COETZER
Jungle Jet, 1996
jaak@headlight.co.za

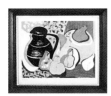

137
E.Q. NICHOLSON
Black Jug
Collage of coloured papers with inks and
gouache. www.cranbornechasepictures.com
Frames by William Campbell
www.williamcampbellframes.com

143
FANG ZHAOLING
Landscape of Guillin, 1979
Chinese ink
www.e-yaji.com

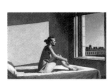

144
EDWARD HOPPER
Morning Sun, 1952
Oil on canvas
www.columbusmuseum.org

145
HO HUAN-SHUO
Alley in the Rain
Chinese ink
www.e-yaji.com

146
CHRISTOPHER ROW
Cat Studies
Ink on paper
www.cranbornechasepictures.com

147 above
JANE COPE
Ben
Pastels
jayecope@btinternet.com

147 below
JOHN EAVES
Stonehenge
Charcoal
www.birchamgallery.co.uk

149
PATRICK PROCKTOR
Still Life, 1999
Screenprint
www.paintingsinhospitals.org.uk

150
JEAN COCTEAU
Cannes Film Festival poster

151
GEES BEND
Quilt
www.quiltsofgeesbend.com

152
ROBERT FREEMAN
John Coltrane, 1961
Photograph
www.robertfreeman.net

153 above
CAROLINE HYMAN
Ruby Tulips
Silver gelatin photograph, selenium toned
www.carolinehymanphotos.co.uk

153 below
HENRI CARTIER-BRESSON
France, Brie, 1968
Photograph
www.magnumphotos.com

154 left
PATRICIA LOW
Black Swan
Hand built pot
www.cranbornechasepictures.com

154 right
ANN CATHERINE LOW
Girl and Dog
Ciment fondue
www.cranbornechasepictures.com

155
ZADOK BEN-DAVID
Jerusalem Tree
Painted stainless steel sculpture
www.zadokbendavid.com

157 left
CAROL BRUTON
Wave forms of Palm Tree II
Oil and sand on canvas
www.carolbruton.com

157 right
CAROL BRUTON
Wave forms of Palm Tree IV
Oil and sand on canvas
www.carolbruton.com

158
CYNTHIA ROWAN
Steps down Symi
Acrylic on board
www.tiddyrowan.com

159
JO SELF
Wild Orchid – from the Garden of His Holiness the XIVth Dalai Lama
Oil on canvas
www.redfern-gallery.com

160 above left
SIR KYFFIN WILLIAMS
Buzzard
Pen and ink
www.albanygallery.com

160 above right
LISA DALTON
On the Edge II
Oil on canvas
www.lisa-dalton.co.uk

160 below
GAIL LILLEY
Still Life with Blue Basket
Oil on canvas
www.gaillilley.co.uk

161
YIN XIN
The Draughtsman
Oil on canvas
www.katharinepooley.co.uk

162 above
DEREK NICE
Trireme II
Assemblage
nices@maltanet.net

162 below
JO BARRETT
Still Life of Bowl and Red Apple #2
Oil on canvas
www.claphamartgallery.com

163
ANNIK LE PAGE
Yellow Eyeshadow
Oil on canvas
www.hollywoodroadgallery.com

164 above
ROBERT HIGHTON
Equine Grey
Digital image
www.roberthightonart.co.uk

164 below
ANNIK LE PAGE
Musicians
Oil on canvas
www.hollywoodroadgallery.com

165 above
TIM NICHOLSON
Idiot Chickens
Acrylic on paper
www.cranbornechasepictures.com

165 below
GEMMA JONES
Sweet Lucille
Print
www.artgroup.com

166 above
ROBERT FREEMAN
Spanish Oak, Sierra de Gredos
Photograph
www.robertfreeman.net

166 below
CHRIS LAMBERT
Agave
Oil on paper
Trifflambert@blueyonder.co.uk

167
XIAOYANG GALAS
Poème sur la Colline
oil on canvas
www.artbreath21.com

168
MICHAEL CRAIG-MARTIN
Deconstructing Seurat Blue
Screenprint
www.alancristea.com

168
MICHAEL CRAIG-MARTIN
Deconstructing Seurat Blue
Screenprint
www.alancristea.com

169
JULIAN OPIE
We Swam among the Fishes
Lambda print mounted on PVA
www.alancristea.com

170 above
BYCAMERA
Full Bloom
Photograph on canvas
www.bycamera.co.uk

170 below
ELAINE PAMPHILON
Beach River, St Ives
Oil on canvas
www.elainepamphilon.co.uk

171 above left
BYCAMERA
Lilies
Photograph on canvas
www.bycamera.co.uk

171 below left
ABBIE YOUNG
Bowl of Cherries
Acrylic on paper
Abbieyoung77@hotmail.com

171 right
CHRISTOPHER MARVELL
Birdwoman
Bronze
www.christophermarvell.com

172 above
MICHAEL KIDD
Chrysler Building
Acrylic on board
www.ronagallery.com

172 below
CLYDE HOLMES
Cloudslope
Oil on canvas
www.clydeholmes.force9.co.uk

173 above
MARK PEARSON
Lucy Swimming
Oil on canvas
www.hollywoodroadgallery.com

173 below
MUHADIN KISHEV
Invierno Ruso
Oil on canvas
www.muhadinkishev.com

174
JOHN EAVES
Heat
Watercolour
www.birchamgallery.co.uk

175 above
EVELYNE BOREN
Great Catch
Oil on canvas
www.evelyneboren.com

175 below
CAROL BRUTON
Red Night in St Tropez
Oil and sand on canvas
www.carolbruton.com

useful addresses

ART GALLERIES

London

Abbott & Holder
30 Museum Street
London WC1A 1LH
t: 020 7637 3981
www.abbottandholder.co.uk

Advanced Graphics London
32 Long Lane
London SE1 4AY
t: 020 7407 2055
www.advancedgraphics.co.uk

Alan Cristea Gallery
31 Cork Street
London W1S 3NU
t: 020 7439 1866
www.alancristea.com

Albemarle Gallery
49 Albemarle Street,
London W1S 4JR
t: 020 7499 1616
www.albemarlegallery.com

Albion
8 Hester Road
London SW11 4AX
t: 020 7801 2480
www.albion-gallery.com

Alexia Goethe Gallery
5-7 Dover Street
London W1S 4LD
t: 020 7629 0090
www.alexiagoethegallery.com

Annely Juda Fine Art
23 Dering Street
London W1S 1AW
t: 020 7629 7578
www.annelyjudafineart.co.uk

Anthony D'Offay Gallery
9 and 20 Dering Street
London W1R 9AA
t: 020 7499 4100
www.doffay.com

Apt Gallery
6 Creekside
Deptford
London SE8 4SA
Tel: 020 8694 8344
www.aptstudios.org

Archeus
3 Albemarle Street
London W1S 4HE
t 020 7499 9755
www.archeus.co.uk

Art First
First Floor, 9 Cork Street
London W1S 3LL
t: 020 7734 0386
www.artfirst.co.uk

Artmonsky Arts
108a Boundary Road
London NW8 0RH
t: 020 7604 3991

The Arts Gallery
University of the Arts London
65 Davies Street
London W1K 5DA
t: 020 7514 8083
www.arts.ac.uk

Austin /Desmond Fine Art
Pied Bull Yard
68/69 Great Russell Street
London WC1B 3BN
t: 020 7242 4443
www.austindesmond.com

Bankside Gallery
48 Hopton Street
London SE1 9JH
t: 020 7928 7521
www.banksidegallery.com

Barbican Gallery
Barbican Centre
Silk Street
London EC2Y 8DS
t: 020 7638 4141
www.barbican.org.uk

Beaconsfield
22 Newport Street
London SE11 6AY
t: 020 7582 6465
www.beaconsfield.ltd.uk

Beaux Arts
22 Cork Street
London W1S 3NA
t: 020 7437 5799
www.beauxartslondon.co.uk

Belgravia Gallery
45 Albemarle Street
London W1S 4JL
t: 020 7495 1010
www.belgraviagallery.com

Ben Uri Gallery
The London Jewish Museum
of Art
108a Boundary Road
London NW8 0RH
t: 020 7604 3991
www.benuri.org.uk

Bernard Jacobson Gallery
6 Cork Street
London W1S 3EE
t: 020 7734 3431
www.jacobsongallery.com

Bloomberg – SPACE
50 Finsbury Square
London EC2A 1HD
t: 020 7330 7959
www.about.bloomberg.com

Bloxham Galleries
129 St. Johns Hill
London SW11 1TG
t: 020 7924 7500
www.johnbloxham.com

Boundary Gallery
98 Boundary Road
London NW8 0RH
t: 020 7624 1126
www.boundarygallery.com

Browse & Darby Gallery
19 Cork Street
London W1X 2LP
t: 020 7734 7984
www.browseanddarby.co.uk

Caroline Wiseman Modern Art
26 Lansdowne Gardens
London SW8 2EG
t: 020 7622 2500
www.carolinewiseman.com

The Catto Gallery
100 Heath Street
London NW3 1DP
t: 020 7435 6660
www.catto.co.uk

Centre of Attention
67 Clapton Common
London E5 9AA
t: 020 8880 5507

Charlotte Street Gallery
28 Charlotte Street
London W1T 2NA
t: 020 7255 2828
www.r-h-g.co.uk

Chris Beetles Gallery
8-10 Ryder Street
London SW1Y 6QB
t: 020 7839 7551
www.chrisbeetles.com

Clapham Art Gallery
61 Venn Street
London SW4 0BG
t: 020 7720 0955
www.claphamartgallery.com

Collins & Hastie Ltd
62 Tournay Road
London SW6 7UF
t: 020 7381 4957
www.collinsandhastie.co.uk

Connaught Brown
2 Albemarle Street
London W1S 4HD
t 020 7408 0362
www.connaughtbrown.co.uk

Contemporary Applied Arts
2 Percy Street
London W1T 1DD
t: 020 7436 2344
www.caa.org.uk

Courtauld Gallery
Somerset House, Strand
London WC2R 0RN
t: 020 7848 2526
www.somersethouse.org.uk

Crane Kalman
178 Brompton Road
London SW3 1HQ
t: 020 7584 7566
www.cranekalman.com

**Curwen and New Academy
Gallery**
34 Windmill Street
London W1T 2JR
t: 020 7323 4700
www.curwengallery.com

The Cynthia Corbett Gallery
15 Claremont Lodge
15 The Downs
Wimbledon Common
London SW20 8UA
t: 020 8947 6782
www.thecynthiacorbettgallery
.com

Daniel Katz Ltd
13 Old Bond Street
London W1S 4FX
t: 020 7493 0688
www.katz.co.uk

**Danielle Arnaud
Contemporary Art**
123 Kennington Road
London SE11 6SF
t: 020 7735 8292
www.daniellearnaud.com

The Drawing Gallery
37 Duke Street St James's
London SW1Y 6DF
t: 020 7839 4539
www.thedrawinggallery.com

Duncan Campbell
15 Thackeray Street
London W8 5ET
t: 020 7937 8665

East West Gallery
8 Blenheim Crescent
London W11 1NN
t: 020 7229 7981
www.eastwestgallery.co.uk

England & Co
216 Westbourne Grove
London W11 2RH
t: 020 7221 0417
www.westbourne-grove.com

**Estorick Collection
of Modern Italian Art**
39a Canonbury Square
London N1 2AN
t: 020 7704 9522
www.estorickcollection.com

f-art
24 Cheshire Street
Bethnal Green
London E2 6EH
t: 020 7729 5411
www.f-art.uk.com

Fairfax Gallery
5 Park Walk
London SW10 0AJ
t: 020 7751 4477
www.fairfaxgallery.com

Feliks Topolski
Memoir of the 20th Century
Royal Festival Hall
Concert Hall Approach
London SE1 8XX
www.felikstopolski.com

Fine Art Commissions Ltd
79 Walton Street
London SW3 2HP
t: 020 7589 4111
www.fineartcommissions.com

Flowers East
82 Kingsland Road
London E2 8DP
t: 020 7920 7777
www.flowerseast.com

Flying Colours Gallery
6 Burnsall Street
London SW3 3ST
t: 020 7351 5558
www.flyingcoloursgallery.com

Francis Kyle Gallery
9 Maddox Street
London W1S 2QE
t: 020 7499 6870
www.franciskylegallery.com

Gagliardi Gallery
509 Kings Road
London SW10 0TX
t: 020 7352 3663
www.gagliardi.org

Gagosian Gallery
6-24 Britannia Street
London WC1X 9JD
t: 020 7841 9960
www.gagosian.com

Gallery 286
286 Earl's Court Road
London SW5 9AS
t: 020 7370 2239
www.gallery286.com

Gallery Kaleidoscope
64-66 Willesden Lane,
London NW6 7SX
t: 020 7328 5833
www.gallerykaleidoscope.com

Gasworks Gallery
155 Vauxhall Street
London SE11 5RH
t: 020 7582 6848
www.gasworks.org.uk

Gimpel Fils
30 Davies Street
London W1K 4NB
t: 020 7493 2488
www.gimpelfils.com

Gordon Reece Gallery
16 Clifford Street
London W1S 3RG
t: 020 7439 0007
www.gordonreecegalleries.com

**Greenwich Printmakers
Gallery**
1A The Market
Greenwich
London SE10 9HZ
t: 020 8858 1569
www.greenwich-
printmakers.org.uk

Grosvenor Gallery
37 Albemarle Street
London W1S 4JF
t: 020 7629 0891
www.grosvenorgallery.com

Hanina Gallery
180 Westbourne Grove
London W11 2RH
t: 020 7243 8877
www.haninafinearts.com

Harlequin Gallery
68 Greenwich High Road
London SE10 8LF
t: 020 8692 7170
www.studio-pots.com

Hart Gallery London
113 Upper Street, Islington
London N1 1QN
t: 020 7704 1131
www.hartgallery.co.uk

Haunch of Venison
6 Haunch of Venison Yard
London W1K 5ES
t: 020 7495 5050
www.haunchofvenison.com

Hayward Gallery
South Bank Centre
Belvedere Road
London SE1 8XZ
t: 020 7960 5226
www.hayward.org.uk

Highgate Fine Art
26 Highgate High Street
London N6 5JG
t: 020 8340 7564
www.oddyart.com

Hollywood Road Gallery
12 Hollywood Road
London SW10 9HY
t: 020 7351 1973
www.hollywoodroadgallery.com

ICA Gallery
The Mall
London SW1Y 5AH
t: 020 7930 3647
www.ica.org.uk

Jill George Gallery
38 Lexington Street
London W1F 0LL
t: 020 7439 7319
www.jillgeorgegallery.co.uk

John Martin Chelsea
6 Burnsall Street
London SW3 3ST and
38 Albermarle Street
London W1S 4JG
t: 020 7351 4818
www.jmlondon.com

**Jonathan Cooper
Park Walk Gallery**
20 Park Walk
London SW19 0AQ
t: 020 7351 0410
www.jonathancooper.co.uk

The Kings Road Gallery
436 Kings Road
London SW10 0LJ
t: 020 7351 1367
www.kingsroadgallery.com

Lena Boyle Fine Art
1 Earls Court Gardens
London SW5 0TD
t: 020 7259 2700
www.lenaboyle.com

The Lennox Gallery
77 Moore Park Road
London SW6 2HH
t: 01488 681379 /
07774 725 823
www.lennoxgallery.co.uk

Lightgallery
5a Porchester Place
London W2 2BS
t: 020 8488 4782
www.lightgallery.net

Lisson Gallery
52-54 Bell Street
London NW1 5DA
t: 0207 724 2739
www.lisson.co.uk

Llewllyn Alexander Gallery
124-126 The Cut, Waterloo
London SE1 8LN
t: 020 7620 1322
www.LlewellynAlexander.com

Long & Ryle
4 John Islip Street
London SW1P 4PX
t: 020 7834 1434
www.longandryle.com

Lupe Gallery
7 Ezra Street
London E2 7RH
t: 020 7613 5576
www.lupegallery.com

The Mall Galleries
The Mall
London SW1
t: 020 7930 6844
www.mallgalleries.org.uk

Mark Jason Gallery
1 Bell Street
London NW1 5BY
t: 020 7258 5800
www.markjasongallery.com

Marlborough
6 Albemarle Street
London W1S 4BY
t: 020 7629 5161
www.marlboroughfineart.com

Mayor Gallery
22a Cork Street
London W1S 3NA
t: 020 7734 3558
www.artnet.com/mayor.html

Medici Gallery
5 Cork Street
London W1S 3LQ
t: 020 7495 2565
www.medicigallery.co.uk

Merrifield Studios
84 Heath Street
London NW3 1DN
t: 020 7431 0794
www.tommerrifield.co.uk

**Michael Hoppen
PhotographicGallery**
3 Jubilee Place
London SW3 3TD
t: 020 7352 3649
www.michaelhoppengallery.com

The National Gallery
Trafalgar Square
London WC2N 5DN
t: 020 7747 2885
www.nationalgallery.org.uk

The National Portrait Gallery
St Martin's Place
London WC2H 0HE
t: 020 7306 0055
www.npg.org.uk

New Grafton Gallery
49 Church Road
Barnes
London SW13 9HH
t: 020 8748 8850
www.newgrafton.com

Northcote Gallery
110 Northcote Road
London SW11 6QP
t: 020 7924 6741
www.northcotegallery.com

October Gallery
24 Old Gloucester Street
London WC1N 3AL
t: 020 7242 7367
www.octobergallery.co.uk

Offer Waterman & Co
11 Langton Street
London SW10 0JL
t: 020 7351 0068.
www.waterman.co.uk

Oliver Contemporary
17 Bellevue Road
London SW17 7EG
t: 020 8767 8822
www.oliverart.co.uk

Osborne Samuel
23a Bruton Street,
London W1J 6QG
t: 020 7493 7939
www.osbornesamuel.com

Panter & Hall
9 Shepherd Market
London W1J 9PF
t: 020 7399 9999
www.panterandhall.com

**Photofusion Photography
Centre and Gallery**
17a Electric Lane
London SW9 8LA
t: 020 7738 5774

Photographers Gallery Ltd
5 & 8 Great Newport Street
London WC2H 7HY
t: 020 7831 1772
www.photonet.org.uk

Piano Nobile Fine Paintings
129 Portland Road
London W11 4LW
t: 020 7229 1099
www.piano-nobile.com

The Piccadilly Gallery
43 Dover Street
London W1S 4NU
t: 020 7629 2875
www.piccadillygall.demon.co.uk

Piers Feetham Gallery
475 Fulham Road
London SW6 1HL
t: 020 7381 3031
www.piersfeethamgallery.com

Plus One Gallery
91 Pimlico Road
London SW1W 8PH
t: 020 7730 7656
www.plusonegallery.com

Portal Gallery
43 Dover Street
London W1S 4NU
t: 020 7493 0706
www.portal-gallery.com

Posk Gallery
238-246 King Street
London W6 0RF
t: 020 8741 1940
www.posk.org

Proud Central
Buckingham Street
London WC2N 6BP

t: 020 7839 4942
www.proud.co.uk

Purdy Hicks Gallery
65 Hopton Street,
London SE1 9GZ
t: 020 7401 9229
www.purdyhicks.com

Rebecca Hossack Gallery
35 Windmill Street
London W1T 2JS
t: 020 7436 4899
www.r-h-g.co.uk

Redfern Gallery
20 Cork Street
London W1S 3HL
t: 020 7734 1732
www.redfern-gallery.com

Riflemaker
79 Beak Street
London W1F 9SU
t: 020 7439 0000
www.riflemaker.org

Rollo Gallery
17 Compton Terrace
London N1 2UN
t: 020 7493 8383
www.rolloart.com

Rona Gallery
1- 2 Weighhouse Street
London W1K 5LR
t: 020 7491 3718
www.ronagallery.com

Rove Projects
17 Britannia Street
London WC1X 9JN
t: 07979 408 914 /
07789 348 584

**Rowley Gallery
Contemporary Arts**
115 Kensington Church Street
London W8 7LN
t: 020 7229 5561
www.rowleygallery.com

Royal Academy Of Arts
Burlington House
Piccadilly
London W1 0BD
t: 020 7300 8000
www.royalacademy.org.uk

The Russell Gallery
12 Lower Richmond Road
London SW15 1JP
t: 020 8780 5228
www.russell-gallery.com

Saatchi Gallery
Duke of York's HQ
Sloane Square
London SW3 4RY
t: 020 7823 2363
www.saatchi-gallery.co.uk

Sadie Coles HQ
35 Heddon Street
London W1B 4BP

t: 0207 434 2227
www.sadiecoles.com

Sarah Myerscough Fine Art
15-16 Brooks Mews
London W1K 4DS
t: 020 7495 0069
www.sarahmyerscough.com

Serpentine Gallery
Kensington Gardens
London W2 3XA
t: 020 7402 6075
www.serpentinegallery.org

The Sheridan Russell Gallery
16 Crawford Street
London W1H 1BS
t: 020 7935 0250
www.sheridanrussellgallery.com

Simon Theobald
180 New Bond Street
London W1S 4RL
t: 020 7629 0629
www.simontheobald.com

Skylark Galleries
Studio 1, Gabriels Wharf
56 Upper Ground and
Unit 1.09 Oxo Tower Wharf
London SE1 9PH
t: 020 7401 9666
www.skylarkgallery.com

Southbank Printmakers
Unit 12, Gabriel's Wharf
56 Upper Ground
London SE1 9PP
t: 020 7928 8184
www.southbank-
printmakers.com

Spectrum Gallery
77 Great Tichfield Street
London W1W 6RF
t: 020 7637 7778
www.spectrumlondon.co.uk

The Strang Print Room
UCL Art Collections
University College London
Gower Street
London WC1E 6BT
t: 020 7629 2821
www.art.museum.ucl.ac.uk

The Studio Glass Gallery
63 Connaught Street
London W2 2AE
t: 020 7706 3013
www.studioglass.co.uk

Tate Britain
Millbank
London SW1P 4RG
t: 020 7887 8008
www.tate.org.uk/britain

Tate Modern
Sumner Street
Bankside
London SE1 9TG
t: 020 7887 8000
www.tate.org.uk/modern

Thackeray Gallery
18 Thackeray Street
London W8 5ET
t: 020 7937 5883
www.thackeraygallery.com

Thirteen Langton Street Gallery
13 Langton Street
London SW10 0JL
t: 020 7352 2772
www.thirteenlangtonstreet.com

Timothy Taylor Gallery
24 Dering Street
London W1S 1TT
t: 020 7409 3344
www.timothytaylorgallery.com

Victoria & Albert Museum
Cromwell Road
London SW7 2RL
t: 020 7942 2000
www.vam.ac.uk

Victoria & Albert Photography Gallery
Cromwell Road
London SW7 2RL
t: 020 7942 2000
www.vam.ac.uk

Victoria Miro Gallery
16 Wharf Road
London N1 7RW
t: 020 7336 8109
www.victoria-miro.com

Waddington Galleries
11 Cork Street
London W1S 3LT
t: 020 7851 2200
www.waddington-
galleries.com

Whitechapel
80-82 Whitechapel High St
London E1 7QX
t: 020 7522 7888
www.whitechapel.org

White Cube Gallery
48 Hoxton Square
London N1 6PB
t: 020 7930 5373
www.whitecube.com

Whitford Fine Art
6 Duke Street St James's
London SW1Y 6BN
t: 020 7930 9332
www.whitfordfineart.com

Will's Art Warehouse
Unit 1 Sadler's House
180 Lower Richmond Road
London SW15 1LY
t: 0208 246 4840
www.wills-art.com

Wimbledon Art Studios
Riverside Yard, Riverside Road
London SW17 0BB
t: 020 8947 1183
www.wimbledonartstudios.co.uk

Wolseley Fine Arts Ltd
12 Needham Road
London W11 2RP
t: 020 7792 2788
www.wolseleyfinearts.com

Zest Gallery
Roxby Place
London SW6 1RS
t: 020 7610 1900
www.zestgallery.com

Yorkshire

Batley Art Gallery
Market Place
Batley WF17 5DA
t: 01484 221964

The Gascoigne Gallery
Royal Parade
Harrogate HG2 0QA
t: 01423 525000
www.thegascoignegallery.com

Godfrey & Watt
7-8 Westminster Arcade
32 Parliament Street
Harrogate HG1 2RN
t: 01423 525300
www.godfreyandwatt.co.uk

Henry Moore Institute
74 The Headrow
Leeds LS1 3AH
t: 01132 467467
www.henry-moore-fdn.co.uk

Leeds City Art Gallery
The Headrow
Leeds LS1 3AA
t: 01132 478248
www.leeds.gov.uk/artgallery

Millenium Galleries
Arundel Gate
Sheffield S1 2PP
t: 0114 278 2600
www.sheffieldgalleries.org.uk

National Museum of Photography Film and Television (NMPFT)
Bradford BD1 1NQ
t: 0870 70 10 200
www.nmsi.ac.uk

North East

Ad Hoc Gallery
Buddle Arts Centre
258b Station Road
Wallsend
Tyne & Wear NE28 8RH
t: 0191 200 7132
www.bacspacefwd.com

BALTIC Centre for Contemporary Art
Gateshead Quays
South Shore Road
Gateshead NE8 3BA
t: 0191 478 1810
www.balticmill.com

Middlesbrough Art Gallery
320 Linthorpe Road
Middlesbrough
Cleveland TS1 4AW
t: 01642 247445

North West

Bend in the River
54 Bridge Street
Gainsborough
Lincolnshire DN21 2AQ
t: 01427 617044
www.bendintheriver.co.uk

Cornerhouse
70 Oxford Street
Manchester M1 5NH
t: 0161 200 1500
www.cornerhouse.org

Djanogly Art Gallery
Lakeside Arts Centre
University Park
Nottingham NG7 2RD
t: 01158 467777
www.lakesidearts.org.uk

Folly Gallery
Unit 6.4.4 Alston House
White Cross
Lancaster LA1 4XQ
t: 01524 388550
www.folly.co.uk

Lady Lever Art Gallery
Port Sunlight
Wirral CH62 5EQ
t: 01514 784136
www.ladyleverartgallery.org.uk

Tate Liverpool
Albert Dock
Liverpool L3 4BB
t: 0151 702 7400
www.tate.org.uk/liverpool

Tregoning Gallery
4 Queen Street
Derby DE1 3DL
t: 01332 242427
www.tregoningfineart.com

View Two Gallery
23 Mathew Street
Liverpool L2 6RE
t: 01512 369444
www.viewtwogallery.co.uk

Walker Art Gallery
William Brown Street
Liverpool L3 8EL
t: 01514 784199
www.thewalker.org.uk

Whitworth Art Gallery
University of Manchester
Oxford Road
Manchester M15 6ER
t: 0161 275 7450
www.manchester.ac.uk/
whitworth

West Midlands

Art Gallery & Museum
The Royal Pump Rooms
The Parade
Royal Leamington Spa CV32 4AA
t: 01926 742700
www.warwickdc.gov.uk

Birmingham Museum and Art Gallery
Chamberlain Square
Birmingham B3 3DH
t: 01213 031966
www.bmag.org.uk

Compton Verney Art Gallery
Compton Verney
Warwick CV35 9HZ
t: 01926 645500
www.comptonverney.co.uk

IKON Gallery
1 Oozells Square
Brindleyplace
Birmingham B1 2HS
t: 0121 248 0708
www.ikon-gallery.co.uk

New Art Gallery Walsall
Gallery Square
Walsall WS2 8LG
t: 01922 654400
www.artatwalsall.org.uk

Number Nine The Gallery
9 Brindleyplace
Birmingham B1 2JA
t: 0121 643 9099
www.numberninethegallery.com

Wenlock Fine Art
3 The Square
Much Wenlock
Shropshire TF13 6LX
t: 01952 728232

Wolverhampton Art Gallery
Lichfield Street
Wolverhampton WV1 1DU
t: 01902 552055
www.wolverhamptonart.org.uk

South West

Adam Gallery
13 John Street
Bath BA1 2JL
t: 01225 480406
www.adamgallery.com

Anthony Hepworth
Fine Art Dealers
3 Margaret's Buildings
Brock Street, Bath BA1 2JL
t: 01225 447480

Arnolfini Gallery
16 Narrow Quay
Bristol BS1 4QA
t: 01179 172300
www.arnolfini.org.uk

Art Space Gallery
The Wharf
St Ives TR26 1PU
t: 01736 799744
www.artspace-cornwall.co.uk

Ashcroft Modern Art
58 Ashcroft Road
Cirencester
Gloucester GL7 1QX
t: 01285 644902
www.ashcroftmodernart.com

Atkinson Gallery
Millfield, Street
Somerset BA16 0YD
t: 01458 444187
www.atkinsongallery.co.uk

Badcock's Galleries Ltd
The Strand, Newlyn
Penzance TR18 5HW
t: 01736 366159
www.badcocksgallery.co.uk

Bay Tree Gallery
48 St Margaret's Street
Bradford on Avon BA15 1DE
t: 01225 864918
www.baytreegallery.co.uk

Beaux Arts Bath
12/13 York Street
Bath BA1 1NG
t: 01225 464850
www.beauxartsbath.co.uk

Belgrave Gallery St Ives
22 Fore Street
St Ives TR26 1HE
t: 01736 794888
www.belgravegallery.com

Beside the Wave
10 Arwenack Street
Falmouth TR11 3JA
t: 01326 211132
www.beside-the-wave.co.uk

Campden Gallery
High Street
Chipping Campden
Gloucester GL55 6AG
t: 01386 841555
www.campdengallery.co.uk

Coombe Gallery
Dittisham
Dartmouth
Devon TQ6 0JA
t: 01803 722352
www.coombegallery.com

Cornerstone Gallery
22a Fore Street
St Ives TR26 1HE
t: 01736 793281
www.cornerstonegallery.co.uk

Edgarmodern Fine Art
Bartlett Street
Bath BA1 2EE
t: 01225 443746
www.edgarmodern.com

Gallery Tresco
New Grimsby, Tresco
Isles of Scilly
Cornwall TR24 0QF
t: 01720 424925
www.gallerytresco.co.uk

Ginger Gallery
84-86 Hotwells Road
Bristol BS8 4UB
t: 0117 9292527

Glass House Gallery
Kenwyn Street
Truro TR26 3DJ
t: 01872 262376
www.glasshousegallery.co.uk

Goldfish Contemporary Fine Art
56 Chapel Street
Penzance TR18 4AE
t: 01736 360573
www.goldfishfineart.co.uk

The Great Atlantic Falmouth Gallery
48 Arwenack Street
Falmouth
Cornwall TR11 3HJ
t: 01326 318452
www.greatatlantic.co.uk/falmouth

Innocent Fine Art Ltd
7a Boyce's Avenue
Clifton Village
Bristol BS8 4AA
t: 01179 732614
www.innocentfineart.co.uk

Jonathan Poole
Compton Cassey Gallery
Compton Cassey House
Cheltenham
Gloucester GL54 4DE
t: 01242 890224
www.jonathanpoole.co.uk

Lander Gallery
Lemon Street Market
Truro
Cornwall TR1 2PN
t: 01872 275578
www.landergallery.co.uk

Lemon Street Gallery
13 Lemon Street
Truro
Cornwall TR1 2LS
t: 01872 275757
www.lemonstreetgallery.co.uk

Penwith Galleries
Back Road West
St Ives TR26 1NL
t: 01736 795579

The Penzance Art Gallery
1 East Terrace
Penzance
Cornwall TR18 2TD
t: 01736 332999
www.thepenzanceartgallery.com

Philip Marlowe Gallery
76 Fore Street, Topsham
Nr Exeter EX3 0HQ
t: 01392 874311

Pierrepoint Gallery
76 South Street
Bridport DT6 3NN
t: 01308 421638
www.pierrepointgallery.co.uk

Polka Dot Contemporary Gallery
67 South Street
Exeter EX1 1EE
t: 01392 276330
www.polkadotgallery.com

Rostra Gallery
5 George Street
Bath BA1 2EH
t: 01225 448121
www.rostragallery.co.uk

Royal Albert Memorial Museum
Queen Street
Exeter EX4 3RX
t: 01392 665858
www.exeter.gov.uk/museums

Royal West of England Academy
Queens Road, Clifton
Bristol BS8 1PX
t: 01179 735129
www.rwa.org.uk

The Salt Gallery
57 Fore Street
Hayle
Cornwall TR27 4DX
t: 01736 753356
www.thesaltgallery.co.uk

Spacex Gallery
45 Preston Street
Exeter EX1 1DF
t: 01392 431786
www.spacex.co.uk

St Ives Society of Artists
Norway Square
St Ives TR26 1NA
t: 01736 795582
www.stisa.co.uk

Summerleaze Gallery
East Knoyle
Salisbury
Wiltshire SP3 6BY
t: 01747 830790

Tate St Ives
Porthmeor Beach
St Ives TR26 1TG
t: 01736 796226
www.tate.org.uk/stives

The Turner Gallery
88 Queen Street
Exeter EX4 3RP
t: 01392 273673
www.thebarnardturnergallery.co.uk

Victoria Art Gallery
Bridge Street
Bath BA1 4AT
t: 01225 477233
www.victoriagal.org.uk

Vitreous Contemporary Art
7 Mitchell Hill
Truro TR1 1ED
t: 01872 274288
www.vitreous.biz

The White Room Gallery
31 Brock Street
Bath BA1 2LN
t: 01225 331500

White Space
72 Fore Street
Totnes TQ9 5RU
t: 01803 864088
www.whitespaceart.com

South East

Barry Keene Gallery
12 Thameside
Henley-on-Thames RG9 1BH
t: 01491 577119
www.barrykeenegallery.com

Bohun Gallery
15 Reading Road
Henley-on-Thames RG9 1AB
t: 01491 576228
www.bohungallery.co.uk

Cass Sculpture Foundation
Goodwood
Chichester
West Sussex PO18 0QP
t: 01243 538449
www.sculpture.org.uk

Chalk Gallery
4 North Street
Lewes BN7 2PA
t: 01273 474477
www.chalkgallery.org.uk

The Contemporary Fine Art Gallery
31 High Street, Eton
Berkshire SL4 6AX
t: 01753 854315
www.cfag.co.uk

Cowfold Gallery & Print Workshop
Cowfold
Horsham
West Sussex RH13 8DU
t: 01403 864237

De La Warr Pavilion
Marina, Bexhill on Sea
East Sussex TN40 1DP
t: 01424 787 949
www.dlwp.com

East Meets West Gallery of Comparative Art
50 High Street
Oxford OX1 4AS
t: 01865 242167

Maltby Art
3A Great Minster Street
Winchester SO23 9HA
t: 01962 877601
www.maltbyart.co.uk

Modern Art Oxford
30 Pembroke Street
Oxford OX1 1BP
t: 01865 722733
www.modernartoxford.org.uk

Modern Artists Gallery
High Street
Whitchurch-on-Thames
Nr Pangbourne
Berkshire RG8 7EX
t: 01189 845893
www.modernartistsgallery.com

Pratt Contemporary Art
The Gallery
Ightham
Sevenoaks
Kent TN15 9HH
t: 01732 882326
www.prattcontemporaryart.co.uk

Red Biddy Gallery
7 Kings Road
Shalford
Surrey GU4 8JU
t: 01483 303346
www.redbiddygallery.co.uk

The Robert Phillips Gallery
Riverhouse
Manor Road
Walton on Thames KT12 2PF
t: 01932 254198
www.riverhousebarn.co.uk

Saltgrass Gallery
1 Angel Courtyard
Lymington
Hampshire SO41 9AP
t: 01590 678148
www.saltgrassgallery.co.uk

Zimmer Stewart Gallery
29 Tarrant Street
Arundel
West Sussex BN18 9DG
t: 01903 885867
www.zimmerstewart.co.uk

East Anglia

Artshed – Ware Ltd
Westmill Farm
Westmill Road
Ware
Hertfordshire SG12 0ES
t: 01920 466446
www.artshed-ware.com

Bircham Gallery
14 Market Place
Holt
Norfolk NR25 6BW
t: 01263 713312
www.birchamgallery.co.uk

Broughton House Gallery
98 King Street
Cambridge CB1 1LN
t: 01223 314960
www.broughtonhousegallery.
co.uk

Buckenham Galleries
81 High Street
Southwold
Suffolk IP18 6DS
t: 01502 725418
www.buckenham-
galleries.co.uk

Chappel Galleries
15 Colchester Road
Chappel
Essex CO6 2DE
t: 01206 240326
www.chappelgalleries.co.uk

Christchurch Mansion
Christchurch Park
Ipswich IP4 2BE
t: 01473 433554
www.visualarts-ipswich.org.uk

Fermynwoods Contemporary
Art
The Water Tower
Brigstock
Kettering NN14 3JA
t: 01536 373469
www.fermynwoods.co.uk

Grapevine
109 Unthank Road
Norwich NR2 2PE
t: 01603 760660
www.grapevinegallery.co.uk

Head Street Gallery
1 Head Street
Halstead
Essex CO9 2AT
t: 01787 472705
www.headstreetgallery.co.uk

The Hunter Gallery
9 Hall Street
Long Melford
Sudbury
Suffolk CO10 9JF
t: 01787 466117
www.thehuntergallery.com

Kettle's Yard
Castle Street
Cambridge CB3 0AQ
t: 01223 352124
www.mail@kettlesyard.cam.ac.
uk

Milton Keynes Gallery
900 Midsummer Boulevard
Milton Keynes MK9 3QA
t: 01908 676900
www.mk-g.org

Primavera
10 Kings Parade
Cambridge CB2 1SJ
t: 01223 357708
www.primaverauk.com

Sainsbury Centre for Visual
Arts
University of East Anglia
Norwich NR4 7TJ
t: 01603 592470
www.scva.org.uk/

Wildwood Gallery
40 Churchgate Street
Bury St Edmunds
Suffolk IP33 1RG
t: 01284 752938
www.wildwoodgallery.co.uk

Woodbine Contemporary
Arts
21 The Crescent
Spalding
Lincolnshire PE11 1AF
t: 01775 710499
www.woodbinecontemporary
arts.co.uk

Channel Islands

Coach-House Gallery
Les Islets
St Peters
Guernsey GY7 9ES
t: 01481 265339

Scotland

Bourne Fine Art
6 Dundas Street
Edinburgh EH3 6HZ
t: 01315 574050
www.bournefineart.co.uk

City Art Centre
2 Market Street
Edinburgh EH1 1DE
t: 01315 293993
www.cac.org.uk

Compass Gallery
178 West Regent Street
Glasgow G2 4RL
t: 01412 216370
www.compassgallery.co.uk

Cyril Gerber Fine Art
148 West Regent Street
Glasgow G2 2RQ
t: 01412 213095
www.gerberfineart.co.uk

Fruitmarket Gallery
45 Market Street
Edinburgh EH1 1DF
t: 01312 252383
www.fruitmarket.co.uk

Gallery Heinzel
24 Thistle Street
Aberdeen AB10 1XD
t: 01224 625629
www.galleryheinzel.com

Gallery of Modern Art
Royal Exchange Square
Glasgow G1 3AH
t: 0141 229 1996
www.glasgowmuseums.com

The Gatehouse Gallery
Roukenglen Road
Giffnock
Glasgow G46 7UG
t: 01416 200235
www.gatehousegallery.co.uk

The Leith Gallery
65 The Shore
Edinburgh EH6 6RA
t: 01315 535255
www.the-leith-gallery.co.uk

Louise Kosman
8 Burgess Terrace
Edinburgh EH9 2BD
t: 01316 629990
www.louisekosman.com

Maclaurin Art Gallery
Rozelle Park
Monument Road
Ayr KA7 4NQ
t: 01292 443708
www.south-ayrshire.gov.uk

Roger Billcliffe Fine Art
134 Blythswood Street
Glasgow G2 4EL
t: 01413 324027
www.billcliffegallery.com

Royal Scottish Academy
The Mound
Edinburgh EH2 2EL
t: 01312 256671
www.royalscottishacademy.
org

The Scottish Gallery
16 Dundas Street
Edinburgh EH3 6HZ
t: 01315 581200
www.scottish-gallery.co.uk

Scottish National Gallery of
Modern Art
75 Belford Road
Edinburgh EH4 3DR
t: 01316 246200
www.nationalgalleries.org

Scottish National Portrait
Gallery
1 Queen Street
Edinburgh EH2 1JD
t: 01316 246200
www.nationalgalleries.org

Stenton Gallery
Stenton
East Lothian EH42 1TE
t: 01368 850256
www.stentongallery.com

Stills
23 Cockburn St
Edinburgh EH1 1BP
t 0131 622 6203
www.stills.org

Wales

Aberystwyth Arts Centre
University College of Wales

Penglais
Aberystwyth
Dyfed SY23 3DE
t: 01970 622893
www.aber.ac.uk

The Albany Gallery
74b Albany Road
Cardiff CF2 3RS
t: 029 2048 7158
www.albanygallery.com

Llwyngwril Gallery
The Church Room
Llwyngwril
Gwynedd LL37 2JB
t: 01341 250054
www.llwyngwril-gallery.co.uk

Martin Tinney Gallery
18 St Andrew's Crescent
Cardiff CF10 3DD
t: 029 2064 1411
www.artwales.com

MOMA Wales
Y Tabernacl
Heol Penrallt
Machynlleth
Powys SY20 8AJ
t: 01654 703355
www.momawales.org.uk

National Museum & Gallery
Cardiff
Cathays Park
Cardiff CF10 3NP
t: 029 2039 7951
www.museumwales.ac.uk

Newport Museum & Art
Gallery
John Frost Square
Newport NP20 1PA
t: 01633 840064
www.newport.gov.uk

Oriel Mostyn Gallery
12 Heol Vaughan
Llandudno LL30 1AB
t: 01492 879201
www.mostyn.org

Oriel Plas Glyn-Y-Weddw
Llanbedrog
Pwllheli
Gwynedd LL53 7TT
t: 01758 740763
www.oriel.org.uk

Oriel Ynys Mon
Llangefni
Anglesey
North Wales LL77 7TQ
t: 01248 724444
www.anglesey.gov.uk

The Royal Cambrian
Academy/Academi Frenhinol
Gymreig
Crown Lane
Conway LL32 8AN
t: 01492 593413
www.rcaconwy.org

Northern Ireland

Annexe Gallery
15 Main Street
Eglinton BT47 3AA
t: 028 718 10389
www.annexegallery.co.uk

Armagh County Museum
The Mall East
Armagh BT61 9BE
t: 028 375 23070
www.armaghcountymuseumc.
org.uk

Bell Gallery
13 Adelaide Park
Lisburn Road
Belfast BT9 6FX
t: 028 906 62998
www.bellgallery.com

Eakin Gallery Armagh
3 Cloughan Road
Portadown Road
Armagh BT61 8RF
t: 028 388 72013
www.eakingalleryarmagh.co.uk

Stables Gallery
Ballywindland House
27 Ballywindland Road
Ballmoney BT53 6QT
t: 028 276 65919
www.stablesgallery.co.uk

Townhouse Gallery Portrush
6 Bath Street
Portrush BT56 8AW
t: 028 708 22826
www.townhousegalleryportrush
.com

Ireland

Apollo Gallery
51C Dawson Street
Dublin 2
t: 00 3531 671 2609
www.apollogallery.ie

Dublin City Gallery
The Hugh Lane
Charlemont House
Parnell Square
North Dublin 1
t : 00 3531 222 5550
www.hughlane.ie

The Irish Museum of Modern
Art
Royal Hospital
Military Road
Kilmainham
Dublin
t: 00 3531 612 9900
www.modernart.ie

The Solomon Gallery
Powerscourt Townhouse
South William Street
Dublin 2
t: 00 3531 679 4237
www.solomongallery.com

ART FAIRS

London

20/21 British Art Fair
Royal College of Art
Kensington Gore
London SW7
www.britishartfair.co.uk

Affordable Art Fair London
Battersea Park, London
t: 0208 246 4848
www.affordableartfair.co.uk

Art London
Burton's Court
St Leonard's Terrace
London SW3
www.artlondon.net

Art in Action
96 Sedlescome Road
London SW6 1RB
t: 020 7381 3192
www.artinaction.org.uk

Art on Paper Fair
Royal College of Art
Kensington Gore
London SW7 2EU
www.artonpaper.co.uk

Asian Art in London
Various locations in London
www.asianartinlondon.com

Chelsea Art Fair
Chelsea Old Town Hall
Kings Road
London SW3
www.penman-
fairs.co.uk/chelsea

Frieze Art Fair
Regent's Park London
www.friezeartfair.com

Inspired Art Fair
Christchurch
Commercial Street
Spitalfields, London E1
www.inspiredartfair.com

**The Islington Contemporary
Art and Design Fair**
Candid Arts Trust
3 Torrens Street
London EC1V 1NQ
t: 020 7837 4249
www.candidarts.com

The London Art Fair
Business Design Centre
Islington
London N1
www.londonartfair.co.uk

London Original Print Fair
Royal Academy of Arts
Burlington House
Burlington Gardens
London W1
www.londonprintfair.com

Photo-london
Burlington Gardens
London W1
www.photo-london.com

**Watercolours and Drawings
Fair**
The Royal Academy
6 Burlington Gardens
London W1S 3EX
www.watercoloursfair.com

Zoo Art Fair
London Zoo
Prince Albert Gate
Outer Circle, Regent's Park
London NW1
t: 07956 623 123
www.zooartfair.com

UK

Edinburgh Art Festival
Various locations
www.edinburghartfestival.org

Glasgow Art Fair
George Square
Glasgow
www.glasgowartfair.com

Liverpool Biennial
The Tea Factory
82 Wood Street
Liverpool L69 1XB
t: 0151 709 7444
www.biennial.com

Manchester Art Show
MICC-GMEX
Manchester
www.manchesterartshow.co.uk

Norwich Print Fair
Various locations
www.norwichprintfair.co.uk

**Somerset Art Week – Arts
Festival**
Various locations
www.somersetartweek.org.uk

Pittenweem Arts Festival
www.pittenweemartsfestival.
co.uk

International

Affordable Art Fair New York
Metropolitan Pavilion,
125 West 18th Street,
New York City
t: 212 255 2003
info@aafnyc.com

ARCO
Feria de Madrid
Madrid, Spain
www.arcospain.org

Art Athina
Hellinikon Airport
Athens
Greece
www.artathina.gr

Art Basel
Swiss Exhibition Center in the
City of Basel (Jun)
Miami Beach
Florida, USA (Dec)
www.art.ch

Art Brussels
Brussels Expo Halls 11 & 12
Place de Belgique
11020 Brussels
www.artbrussels.be

Art Cologne
Cologne Exhibition Centre
Eastern Halls Cologne
Germany
www.artcologne.com

Artexpo New York
Jacob K. Javits Convention
Center
www.artexpos.com

Arte Fiera
Various locations
www.artefiera.bolognafiere.it

Art Forum Berlin
Exhibition Grounds Messe
Halls 18-20, Entrance 19
Berlin, Germany
www.art-forum-berlin.de

Art Frankfurt
Frankfurt Fairgrounds, Hall 9.0
Entrance Japanisches Tor
Frankfurt
Germany
www.fineartfairfrankfurt.info

ARTissima
Lingotto Fiere Exhibition
Centre
Turin
Italy
www.artissima.it

Art Miami
Miami Beach Convention
Center
Miami, USA
www.art-miami.com

Art Paris
Grand Palais, Champs-Elysees
Avenue Winston Churchill
75008 Paris, France
www.artparis.fr

Art Prague
Manes Building, Prague
Czech Republic
www.art-prague.cz

Art Rotterdam
Cruise Terminal Rotterdam.
Rotterdam
The Netherlands
www.artrotterdam.nl

Art Santa Fe
Santa Fe Convention Centre
Santa Fe, US
www.artsantafe.net

**Berlin Biennial for
Contemporary Art**
KW Institute for
Contemporary Art
Auguststraße 69
and surrounding venues
D-10117 Berlin-Mitte
Germany
t: 0049 030 24 34 59 70
www.berlinbiennale.de

Fiac
Grand Palais & Cour Carree
Du Louvre
Paris, France
www.fiacparis.com

FotoFest
Houston
Texas USa
www.fotofest.org

Kunstrai
Amsterdam RAI
Parkhal (Hall 8)
Amsterdam
The Netherlands
www.kunstrai.nl

Kunst Zeurich
ABB Building
550 Zürich-Oerlikon
Zürich
Switzerland
www.kunstzuerich.ch

Liste
Burgweg 15
CH-4058 Basel
Switzerland
www.liste.ch

Maastricht Art Fair
MECC (Maastricht Exhibition
& Congress Centre)
Forum 100
6229 GV Maastricht
The Netherlands
www.tefaf.com

Mac21
Exhibition and Congress
Centre of Marbella,
Marbella
Spain
www.mac21.com

Melbourne Art Fair
Royal Exhibition Building
Melbourne
Australia
www.artfair.com.au

Mexico Arte Contemporaneo
Expo Reforma Convention
Center
Mexico City
www.macomexico.com

MiArt Milan
Fiera Milano International Spa
Via Varesina 76
20156 Milan
Italy
www.miart.it

**Moscow International Art
Fair**
Central House of Artists
Moscow
www.art-moscow.ru

PalmBeach3
Palm Beach County
Convention Center
650 Okeechobee Blvd.
West Palm Beach
Florida. USA
www.palmbeach3.com

St-Art
Strasbourg Expo-Congrès
place de Bordeaux – Wacken
67082 Strasbourg
France
www.st-art.com

Toronto International Art Fair
Metro Toronto Convention
Centre. South Building
Toronto
Canada
www.tiafair.com

Venice Biennale
Venice
Italy
www.labiennale.org

INTERNET SITES

www.art.com

www.artart.co.uk

www.artbank.com

www.artcourses.co.uk

www.artfacts.net

www.artguide.org

www.artgroup.com

www.artinfo.com

www.a-n.co.uk

www.artmatters.co.uk

www.artscouncil.org.uk

www.axisartists.org.uk

www.britisharts.co.uk

www.newexhibitions.com

www.picassomio.com

www.saatchigallery.com

www.stot.org

www.tiddyrowan.com

www.ucanbuyart.com

www.untitled-gallery.co.uk

photographic credits

2-3 © Vogue Living /Tony Amos/GRANTPIRRIE.com; 4 1st row far left Robert Freeman; 4 1st row left & right Helen Lopez; 4 1st row far right John Parsons; 4 2nd row far left Offer Waterman Gallery; 4 2nd row left Richard Winkworth; 4 2nd row right Hollywood Road Gallery; 4 2nd row far right Lisa Dalton; 4 3rd row far left Hollywood Road Gallery; 4 3rd row left Chris Lambert; 4 3rd row right Abbie Young; 4 3rd row far right Cranborne Chase; 4 4th row far left Rona Gallery; 4 4th row left Elaine Pamphilon; 4 4th row right Nigel Waymouth; 4 4th row far right Xiaoyang Galas; 4 5th row far left & left Muhadin Kishev; 4 5th row right Evelyne Boren; 4 5th row far right Redfern Gallery; 6 Courtesy Edition Schellmann, Munich – New York/ARS New York and DACS London 2006; 8 Zapa Images/Reto Guntli/Collections Casagrande, Rome/ARS, New York and DACS, London 2006; 10 Bridgeman Art Library/© National Gallery of Victoria, Melbourne, Australia/© Succession Picasso/DACS, 2006; 11 © Photo SCALA, Florence/Paris, Louvre; 12 Bridgeman Art Library/ Gemaeldegalerie Alte Meister, Dresden Germany/ © Staatliche Kunstsammlungen Dresden; 13 left www.katharinepooley.com; 13 right White Cube (London)/© Tom Hunter. Courtesy of Jay Jopling; 14-15 Alamy.com/Visual & Written SL/sculpture by Joel Shapiro © ARS, New York and DACS, London 2006; 16 left Mainstreamimages/Paul Massey; 16 right Photozest/© H & L/Dook; 17 Mainstreamimages/Ray Main/Yew Weng Ho; 18 www.redcover.com/Winfried Heinze; 19 Photozest/B Limbour; 21 Camera Press/© Madame Figaro/Beatrice Amagat; 22 Mainstreamimages/Ray Main; 24 Zapa Images/Conrad White; 25 Wills-Art.com; 26 left Hollywood Road Gallery; 26 above right Redfern Gallery; 26 below right Wills-Art.com; 27 Mainstreamimages /Ray Main; 28 above left John Dewe Mathews; 28 below left Tiddy Rowan; 28 below right The Art Archive/Musée des Arts Africains et Océaniens/Dagli Orti; 29 Andreas von Einsiedel; 30 www.redcover.com/Henry Wilson; 31 above Cranborne Chase; 31 below Michael Heslop; 32 Zapa Images/Reta Guntli; 33 left Louise Belanger; 33 right Hollywood Road Gallery; 34 The Interior Archive/Simon Upton/architect Enrico Carlo Saraceni; 35 John Eaves; 36 far left Gail Lilley; 36 left Richard Winkworth; 36 right Artgroup.com; 36 far right Patrick Haughton; 37 Andreas von Einsiedel; 38 Alamy.com/Beateworks/Claudio Santini; 39 Muhadin Kishev; 40 Artgroup.com/© The Estate of Patrick Caulfield/DACS 2006; 41 Superstock.com/© ADAGP, Paris and DACS, London 2006; 42-43 © Photo SCALA, Florence/Madrid, Museo Nacional Cetro de Arte Reina Sofia © 2003, Foto Art Resource/John Bigelow Taylor/© Succession Picasso/DACS, 2006; 43 Muhadin Kishev; 44 Camera Press/© Marie Claire Maison/ Daniel Rozensztroch/Mai-Linh; 45 Robert Freeman; 46 Hollywood Road Gallery; 47 Bridgeman Art Library/© Odessa Fine Arts Museum, Ukraine; 49 Photozest/© H & L/Ryno; 50 Photozest/B Limbour/Architect P Simeon; 52 Photozest/Tito; 53 Photozest/John Hall; 54 IPC Syndication/© Marie Claire/Rebecca Duke; 55 Camera Press/© Marie Claire Maison/Dan Tobin Smith; 56 The Art Archive/Museum of Fine Arts Boston/Laurie Platt Winfrey; 57 Evelyne Boren; 58-59 photograph by Minh + Wass; 58 www.redcover.com/Verity Welstead; 59 above Carol Bruton; 59 below Simon Averill; 60 The Bridgeman Art Library/© succession H Matisse/DACS 2006; 61 left Xiaoyang Galas; 61 centre Abbie Young; 61 right Lisa Dalton; 62 Nigel Waymouth; 63 left Superstock.com/© ARS, New York and DACS, London 2006; 63 centre Nigel Waymouth; 63 right Bill Pryde; 64 above Nancy Howard; 64 below Royal Museum of Fine Arts of Belgium/© ADAGP, Paris and DACS, London 2006; 65 Camera Press/© Maison Madame Figaro/Emilie Lebeuf; 66 Holly Freeman; 67 Natasha Kerr; 68 Helen Lopez; 69 above left Hollywood Road Gallery; 69 above right Lisa Dalton; 69 below left Nigel Waymouth; 69 below right Sally Miles; 70 © Photo SCALA, Florence/© Licensed by the Andy Warhol Foundation for the Visual Arts, Inc./ARS, New York; /TM 2006 Marilyn Monroe LLC by CMG Worldwide www.MarilynMonroe.com and DACS, London 2006; 71 Photozest/M Roobeart/architect F Marcq; 73 Mainstreamimages/Ray May; 75 Lluis Casals/architect Jordi Garcés; 76-77 The Interior Archive/Christopher Simon-Sykes/mural in Nivola House, USA by Le Corbusier/© FLC/ADAGP, Paris and DACS, London 2006; 78 The Interior Archive/Edina van der Wyck; 79 www.elizabethwhiting.com/Mark Luscombe-Whyte/© The Estate of Patrick Heron/ DACS, 2006; 80 Photozest/S Clement; 81 www.redcover.com/Ken Hayden/designer Jonathan Reed; 82 Solvi dos Santos; 83 The Interior Archive/Christopher Simon-Sykes/© The Estate of Patrick Heron/DACS, 2006; 84 View/Dennis Gilbert; 85 IPC Syndication/© Ideal Home/Spike Powell; 86 Camera Press/© Visi; 87 Lluis Casals/architect Mora-Sanvisens; 88 © 2006 The M.C. Escher Company – Holland. All rights reserved; 89 IPC Syndication/© Living Etc./Paul Massey; 90 Andreas von Einsiedel/artist courtesy of Francis Kyle Gallery; 91 www.redcover.com/Verity Welstead; 92 left Gail Lilley; 92 right Richard Winkworth; 93 Undine Pröhl; 94 Undine Pröhl; 95 The Interior Archive/Luke White; 96 Solvi dos Santos; 97 Bridgeman Art Library/Peggy Guggenheim Collection, Venice (Solomon R Guggenheim Foundation,, NY/© ADAGP, Paris and DACS, London 2006; 98 www.redcover.com/Andrew Twort/designer Michael Reeves; 99 www.redcover.com/Mike Daines/www.boxinthepost.com; 100 www.redcover.com/Paul Massey; 101 Lovatt-Smith Interiors/Dexter Hodges; 102-103 www.redcover.com/Dan Duchas; 103 White Cube (London)/© Tracey Emin/courtesy Jay Jopling/photo Stephen White; 104 above The Art Archive/Laurie Platt Winfrey/© ADAGP, Paris and DACS, London 2006; 104 below Superstock.com; 105 Holly Freeman; 106 Camera Press/© Visi/Adriaan Vorster; 107 above Bridgeman Art Library/Victoria & Albert Museum, London; 107 below left John Parsons; 107 below right Bridgeman Art Library/© Museum of Fine Arts, Houston, Texas, USA., Gift of Isabel B Wilson in memory of Alice Pratt Brown/© ARS, New York and DACS, London 2006; 108 above Daphne Stephenson; 108 below Jacques Coetzer; 109 Narratives/Kate Gadsby; 111 Photozest/A Baralhe/architect Vincente Wolf/photograph on wall by Michal Rovner © ARS,, New York and DACS, London 2006; 112 Mainstreamimages/Ray Main; 114 Alamy.com/© Key Collection/21 Carrot; 115 Fabpics/Eugeni Pons/© Manolo Valdes, courtesy of Marlborough Gallery, New York; 116 Photozest/© H & L/M Williams; 117 The Interior Archive/Tim Clinch; 118 Camera Press/© Marie Claire Maison/David Souffain and © Douglas Friedman/courtesy of ARENA; 119 Minh + Wass; 120-121 Kettle's Yard/Upstairs house extension designed by Sir Leslie Martin, 1970, University of Cambridge; 122 www.redcover.com/Wayne Vincent; 124 Guy Obijn; 125 International Interiors/Paul Ryan; 126 Photozest/L.Wauman; 127 left Solvi dos Santos; 127 right www.redcover.com/Chris Drake/design by Lena Proudlock; 128 www.redcover.com/Alun Callender; 129 Photozest/J de Villiers/© H & L/designer J Hemingway; 130 The Interior Archive/Christopher Simon-Sykes; 132 The Interior Archive/Luke White; 133 The Interior Archive/Luke White; 135 Solvi dos Santos; 137 Cranborne Chase, framing by William Campbell; 138 left www.redcover.com/Wayne Vincent; 138 right John Cullen Lighting; 139 John Cullen Lighting, London and Taylor Howes Designs; 143 Hugh Moss; 144 Columbus Museum of Art, Ohio, USA; 145 Hugh Moss; 146 Cranborne Chase; 147 above Jane Cope; 147 below John Eaves; 149 Paintings in Hospitals; 150 Advertising Archive/Jean Cocteau © ADAGP, Paris and DACS, London 2006; 151 Gees Bend; 152 Robert Freeman; 153 above Caroline Hyman; 153 below Magnum Photos/Henri Cartier-Bresson; 154 Cranborne Chase; 155 Cass Sculpture; 157 Carol Bruton; 158 Cynthia Rowan; 159 Redfern Gallery; 160 above left Sir Kyffin Williams; 160 above right Lisa Dalton; 160 below Gail Lilley; 161 www.katharinepooley.com; 162 above Derek Nice; 162 below Clapham Art Gallery; 163 Hollywood Road Gallery; 164 above Robert Highton; 164 below Hollywood Road Gallery; 165 above Cranborne Chase; 165 below Artgroup.com; 166 above Robert Freeman; 166 below Chris Lambert; 167 Xiaoyang Galas; 168-169 Alan Cristea Gallery; 170 above Bycamera; 170 below Elaine Pamphilon; 171 above left Bycamera; 171 below left Abbie Young; 171 right Christopher Marvel; 172 above Rona Gallery; 172 below Clyde Holmes; 173 above Hollywood Road Gallery; 173 below Muhadin Kishev; 174 John Eaves; 175 above Evelyne Boren; 175 below Carol Bruton.

Every effort has been made to trace the copyright holders, architects and designers at the time of going to press. We apologise for any unintentional omission and would be pleased to insert the appropriate acknowledgement in all subsequent editions.

author's acknowledgements

There are many people I wish to acknowledge for their support and involvement in this book and I owe them a huge debt of gratitude, for without them the book would have been only half the book, half the fun – and twice the labour. To Anne Furniss, first and foremost, thank you for picking up on the spark of an idea, and to all at Quadrille for making it happen: to Helen Lewis for early inspired design; to Gabriella Le Grazie, for gracefully taking it to its completion; to Nadine Bazar for masterminding the picture research; to Sarah Airey for the near endless amount of work sourcing the pictures; to Samantha Rolfe and her team for keeping track of the images; and to Ruth Deary for her dogged pursuit of excellence in colour matching. A huge thank-you to all the artists who so generously contributed their work – without their art the book would be a dull and lifeless one. To some artists in particular I owe an extra 'thank you' for their advice, support, encouragement and patience, namely Lisa Dalton, Muhadin Kishev and his wife Jacqueline Moss, Tim Nicholson, John Eaves, Richard Winkworth, Derek Nice. Thanks also to Robert Freeman, for his superb photographs; to Victoria O'Brien, for sharing her ideas on family photographs; to William Campbell for providing beautiful frames and sharing his knowledge; to Catharine and Patrick Kennaugh at Hollywood Road Gallery for their assistance. To Hugh Moss, Blossom and Nick, thank you for letting me include some of the best of contemporary Chinese painting; to Jake Bell for introducing me to Kettles Yard and to new artists and anecdotes that always make me smile; to Sheila Ableman for keeping an eye on the elephant, and to my teachers, Professor Gombrich, Herbert Read, Norbert Lynton and Robert Hughes. Thank you to Peter for his encouragement, and to my long-suffering friends and family for standing by me through months of self-imposed solitude while writing the book, for keeping in touch, making me laugh and cheering me on. To them I say: the ice bucket is ready, the kettle is on and the door wide open again. Especial thanks to my daughter, Holly, for her inspiring art and wisdom and to my mother and artist, Cynthia Rowan, who taught me not just to look – but also to see.

This paperback edition first published in 2007 by
Quadrille Publishing Limited
Alhambra House
27-31 Charing Cross Road
London WC2H 0LS

Project Director: Anne Furniss
Creative Director: Helen Lewis
Design: Gabriella Le Grazie
Picture Research: Nadine Bazar, Sarah Airey
Picture Assistants: Samantha Rolfe, Katie Horwich
Editorial Assistant: Andrew Bayliss
Editorial Research: Elizabeth Fraser-Betts
Production: Ruth Deary, Vincent Smith

British Library Cataloguing Publication Data
A catalogue record for this book is available from the British Library

ISBN: 978 184400 515 4

Printed and bound in Singapore .
10 9 8 7 6 5 4 3 2